AMY WEINSTEIN

ONCE UPON A TIME

Illustrations from
FAIRYTALES, FABLES, PRIMERS, POP-UPS
and other **CHILDREN'S BOOKS**

PRINCETON ARCHITECTURAL PRESS

NEW YORK

PUBLISHED BY

Princeton Architectural Press

37 East Seventh Street

New York, New York 10003

For a free catalog of books, call 1.800.722.6657.

Visit our web site at www.papress.com.

All of the books illustrated in this volume are held in the collection and reproduced through the generosity of Ellen Liman.

EDITING: Nancy Eklund Later

EDITORIAL ASSISTANCE: Dorothy Ball

DESIGN: Sara E. Stemen

PHOTOGRAPHY: Nicola Bednarek

SPECIAL THANKS TO: Nettie Aljian, Janet Behning, Megan Carey, Penny (Yuen Pik) Chu, Russell Fernandez, Jan Haux, Clare Jacobson, John King, Mark Lamster, Linda Lee, Katharine Myers, Lauren Nelson, Jane Sheinman, Scott Tennent, Jennifer Thompson, Joseph Weston, and Deb Wood of Princeton Architectural Press —Kevin C. Lippert, publisher

LIBRARY OF CONGRESS CATALOGING-IN-PUBLICATION DATA

Weinstein, Amy, 1957–

 Once upon a time : illustrations from fairytales, fables, primers, pop-ups, and other children's books / Amy Weinstein.--1st ed.

 p. cm.

 ISBN 1-56898-541-X (hardcover : alk. paper) -- ISBN 1-56898-564-9 (pbk. : alk. paper)

 1. Illustrated children's books--United States. 2. Illustration of books--United States--19th century. 3. Liman, Arthur L.--Art collections. 4. Liman, Ellen--Art collections. 5. Illustrated books--Private collections--United States. I. Title.

 NC975.W45 2005

 741.6'42'0973--dc22

 2005012524

CONTENTS

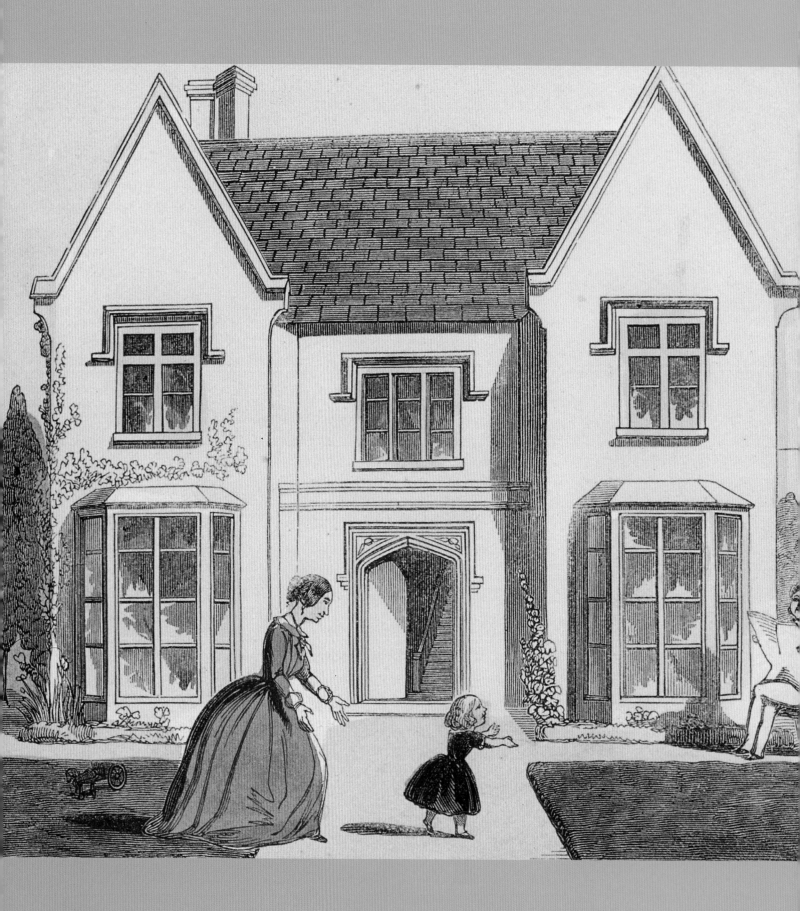

PREFACE

THE 1905 OBITUARY of John McLoughlin, Jr., in *Publisher's Weekly* declared, "Every child in the land knows the McLoughlin books.... In fact, the history in the last decade of colored toy books for youngsters is the history of Mr. McLoughlin and his firm." McLoughlin Brothers held an important role in the children's book publishing world. In fact, as my husband, the late Arthur Liman, and I discovered in our research, the firm was instrumental in creating it. The publisher's preeminence in the field was the result of its entrepreneurial spirit, creativity, competitiveness, foresight, and perseverance

How was it, then, that Arthur—an intense attorney with characteristics similar to that of McLoughlin Brothers—ended up sitting behind a collectors' convention booth selling children's books and games, all the while reading a brief? Or charging at lightning speed, flashlight in hand, amidst rain and mud in the early morning hours, through a remote country antiques fair? Or mysteriously vanishing from a critical corporate conference to negotiate, instead, with a slightly disheveled dealer waiting in his office, or to aggressively bid by phone at a London auction? And what were all those mail order catalogs, letters of offerings, and bills of sale for McLoughlin Brothers books doing commingled with court papers?

For twenty years, Arthur was this crazy closet collector. His big-deal clients could never have imagined where or how he spent his weekends. A tough lawyer with a soft center, he was enjoying a second childhood. But demanding and focused, he always wanted to "win" in the collecting arena, as much, if not more, than in the court room.

Over the years, a little, innocent interest in collecting children's books and games became an all-consuming challenge for Arthur and me. Why did we choose to focus on McLoughlin Brothers and, to a lesser degree, other American publishers of its era? There was a lot of pleasure here, but no prestige or profit—the impetus for many collectors. McLoughlin Brothers books were scarce, making the hunt intense and discovery all the more exciting. Made from paper during the late

AUNT MAVOR'S PRESENT
FOR A GOOD LITTLE GIRL
Published by George Routledge & Co.,
London and New York
1856

Publishers in England and America frequently employed the device of a kindly female storyteller, including Aunt Mavor, Aunt Louisa, Mother Bunch, Mother Bantry, and Dame Wonder. Here, Aunt Mavor's "present" is a collection of short stories and verse. "Little Polly's Doll House" tells of a girl's joy upon selecting a furnished doll's house, taller than she, a spectacular gift at the time.

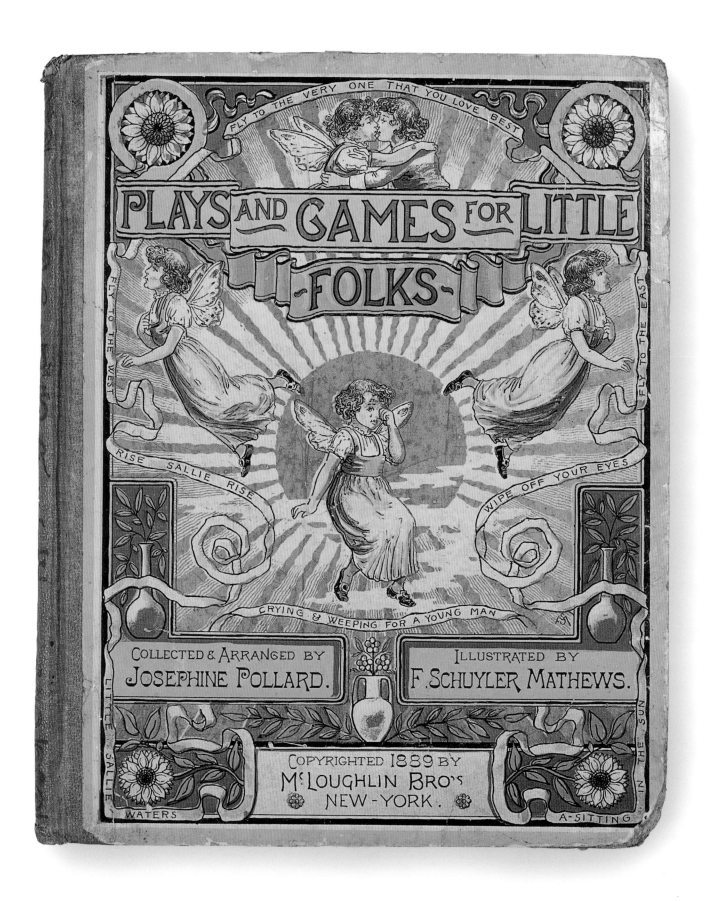

nineteenth and early twentieth centuries, these ephemeral objects were often too fragile or damaged to survive. Many were also so inexpensive that they were not considered worth saving or, from a dealer's perspective, selling. But it was for different reasons, which reflected our disparate interests, that we became attracted to and enchanted by McLoughlin Brothers books.

The appeal of the books for Arthur lay in their subject matter, which he viewed as a reflection of the history and culture of the times in which they were published. For example, the education of children was a national priority, so there was an abundance of alphabet books. Teaching about morals became a paramount concern: in *Jack and the Beanstalk*, good triumphs over evil; in *Cinderella*, virtue is rewarded; in *Little Red Riding Hood*, the company you keep proves to be potentially dangerous; and in *Puss in Boots*, faithful friends are recognized as the best type of friends.

As an artist, I was personally drawn to the magnificent aesthetic of McLoughlin's books, to their extraordinary design and sophisticated, dazzling color, which was made possible by the perfection of the chromolithographic printing process in the late nineteenth century. In addition to the beautiful, imaginative graphics and fine workmanship of the books, I loved their charm and humor.

Like many collectors, we did not collect with any grand plan. The collection just grew and grew and grew. We tried to make it comprehensive. If books were published as part of a series, assembling the complete set became a priority. If McLoughlin created a game using a plate that also appeared in a book, we searched for both. Ultimately we discovered, as many collectors do, that there is real satisfaction in creating and caring for a collection—in carefully conserving and meticulously cataloging each item—and in knowing that you have preserved the past for the future.

I hope that while reading this book the message comes through to readers young and old, especially our grandchildren, that books are beautiful, that learning is exciting, and that collecting for us was a wonderful collaboration. Behind every purchase there is a personal adventure, and for each of the images depicted here there is a precious memory.

—ELLEN LIMAN

OPPOSITE

PLAYS AND GAMES
FOR LITTLE FOLKS:
SPORTS OF ALL SORTS,
FIRESIDE FUN, AND
SINGING GAMES
Illustrated by Schuyler Mathews
Collected and arranged by
Josephine Pollard
Published by McLoughlin Brothers,
New York
Copyright 1889

This collection of diversions includes many games and songs still enjoyed by young children today, including musical chairs, Pop Goes the Weasel, and London Bridge, as well as some less commonly recalled, such as *Draw a Bucket of Water*. The hefty volume also includes directions for making shadow pictures and for playing conversation and fortune-telling games.

Home Kindness

A Picture Gift Book

FOR THE

CHILDREN

McLoughlin Bros. Publishers New York.

ACKNOWLEDGMENTS

I CANNOT REMEMBER a time when I did not love to read. Examining the magnificent collection of children's books acquired by Ellen and Arthur Liman reawakened the joys of childhood reading and the pleasure of seeing a story come alive in words and pictures on the page, as it does in the imagination.

Many people were instrumental in seeing this book to fruition, chief among them Jan Seidler Ramirez and Margi Hofer, who first urged me to pursue this project. Paula Kelberman shared her passion for children's literature and her knowledge of the form. Steve Jaffe, Craig Williams, and Kathleen Hulser, colleagues in the museum community with a special interest in the history of childhood and nineteenth-century American life, lent expertise and thoughtful comment. Staff at the New-York Historical Society and New York State libraries, both of which house marvelous collections of children's literature, were all generous with their time and resources. Nancy Eklund Later was not only an excellent editor but also a wonderful partner. Grateful thanks are also due to Beth Kelley, Laura Handlin, and Mina Weiner. I am especially appreciative of the unwavering words of encouragement and support offered by my friend Steven Taylor.

TO AMUSE AND INSTRUCT
AN INTRODUCTION TO ILLUSTRATED CHILDREN'S BOOKS

HO would not give libraries for that dancing buoyancy of attention, and intensity of delight with which the first story-book of childhood is read?" This rhetorical question was posed by a writer for *The New York Daily Times* charged with reviewing the array of books published for "juveniles" in time for Christmas giving in 1852. He went on to describe a bounty of books, "ornamented so profusely, and gilded and silvered so prettily—to say nothing of the variegated contents, stories, facts, and fables." Such a wealth of children's books was a new cultural phenomenon, and from mid-century on, American children were the beneficiaries of a blossoming trade in illustrated books created expressly for their enjoyment. Prior to this time, children's reading had generally been limited to the Bible, schoolbooks, and, for those from wealthier families, books written for adults.

Illustrated children's books flourished at a time when educational theories inspired by the eighteenth-century Enlightenment and evolving concepts of childhood innocence took firm root in the growing American middle class. In the introduction to their 1855 *Painted Picture Play Book*, London-based publisher Dean and Sons advised parents that leisure-time reading was a valuable pastime for children, suggesting that,

> *Like a tender plant, the Infant Mind requires the aid of watchful care;*
> *Direct its early thoughts aright, the good effects will soon appear.*
> *With pleasing pastimes now and then the leisure moments pass away,*
> *The more important tasks may well engage the mind of riper day.*

1

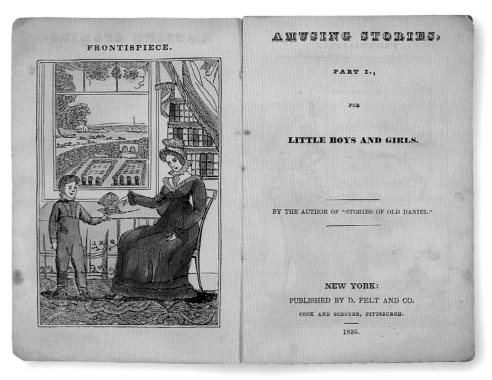

AMUSING STORIES FOR
LITTLE BOYS AND GIRLS,
PART I
*Published by David Felt and Co.,
New York; Cook and Schoyer,
Pittsburgh; and N. and G. Guilford,
Cincinnati*
1835

Using examples drawn from
everyday life, these short stories
reveal how ordinary children
learn good behavior. Unlike many
cautionary tales of the period that
exaggerate the consequences of
bad behavior, these stories adopt
a gentle tone.

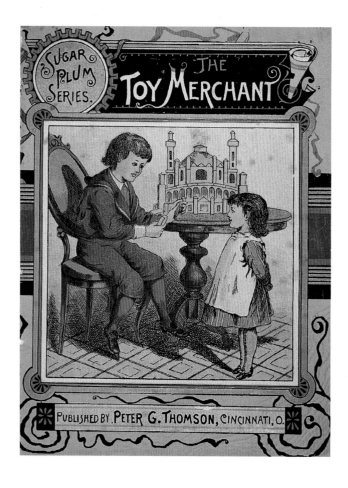

The publisher's choice of words reflects the pervasive influence of philosophers John Locke (1632-1704) and Jean Jacques Rousseau (1712-1778), whose revolutionary principles of education and child-rearing were instrumental in radically altering established doctrine that regarded children as miniature adults, sinful creatures whose innate propensity for evil demanded eradication through stern discipline. In *Some Thoughts Concerning Education,* Locke proposed that a child was a *tabula rasa,* or blank slate, upon which ideas and principles could be imprinted. He coupled learning to read with notions of play, recommending that a child be given an "easy, pleasant book, suited to his capacity ... wherein the entertainment that he finds might draw him on, and reward his pains in reading." Believing in the inherent goodness of children, Rousseau advocated that they be given the opportunity for their innate love of virtue to emerge and mature naturally, with gentle adult guidance and age-appropriate activities. Both philosophers observed the paucity of reading material for children in their day. Although their writings were directed at the education of upper-class children (especially boys), their theories ultimately helped foster a thriving British and American publishing industry catering to children as children, with unique needs and abilities.

The antecedents of illustrated children's books may be traced to several intertwined sources. With his first printing in 1744 of *A Little Pretty Pocket-Book: Intended for the Instruction and Amusement of Little Master Tommy and Pretty Miss Polly,* Britain's John Newbery (1713-1767) is generally credited as the originator of illustrated books created expressly for children. Each page of his innovative volume featured a letter of the alphabet, a picture, and two verses, one describing the picture and the other containing a moral precept. Newbery embraced Locke's tenet that learning should be an agreeable exercise, not an activity filled with the dread of punishment.

Newbery was also a brilliant marketer, whose innovative techniques influenced American printers of children's books more than a century later. A letter from the fairytale hero Jack, the Giant Killer, and the alluring possibility of buying a ball or pincushion for an additional sum, came with early printings of *A Little Pretty Pocket-Book.* McLoughlin

OPPOSITE, BOTTOM

THE TOY MERCHANT

Sugar Plum Series
Published by Peter G. Thomson, Cincinnati
copyright 1884

Anticipating the reward of toys, Peter overcomes laziness and learns his multiplication tables. His mastery of arithmetic comes too late, however, to earn the toys for which he yearns. Although the story ends with advice to the young reader to study hard and "you will be rewarded in the end," this volume is actually little more than a brazen attempt to market the publisher's line of games, blocks, magic lanterns, and Jack-in-the-Box wind-ups generously illustrated throughout its pages.

Brothers, a firm that would come to dominate the American illustrated book industry, took a similar approach, selling nesting blocks papered with illustrated scenes from its editions of *Old Mother Hubbard, Jack & the Bean-Stalk, Little Red Riding Hood,* and other fairytales and nursery rhymes. The company's name and suggestions to buy the book were discreetly but deliberately printed in a corner of the blocks.

While Newbery added the critical dimension of pleasure to children's books, his accomplishment was foreshadowed a century earlier by the innovative educational theorist Johann Amos Comenius (1592-1672). In 1658, Comenius included images of "the world around us" in his Latin textbook for German schoolboys. Reflecting Comenius's belief that children should learn about the world in their own language, and not solely in the Latin of scholars, each page of his *Orbis Sensualim Pictus* featured a picture of an object or idea with an explanation in both Latin and German. Editions in English and Latin were soon published, and the book became known in the United States not long after. Reprinted throughout the eighteenth and nineteenth centuries, his groundbreaking volume was used by students of all ages, from young children learning to identify objects to older pupils and adults studying Latin. Comenius's revolutionary pairing of picture and text would become the norm two hundred years later with a profusion of illustrated books teaching the alphabet to American children.

Also bearing directly on the creation of illustrated children's books were their immediate predecessors—chap books, sold by traveling peddlers in Britain and America in the eighteenth and early nineteenth centuries. These inexpensive four- (or multiples of four-) page pamphlets featured folktales, Biblical stories, nursery rhymes, and topics of mass appeal, all of which eventually were adopted by children's book publishers. Chapbooks were illustrated with crudely printed, occasionally hand-colored, woodcuts. Often, the wood blocks had been recycled from other chapbooks so that the images did not fit the stories. Not specifically intended for children, they were enjoyed by both young and old: in his autobiography, Benjamin Franklin, who described himself as "bookish" from an early age, recalled purchasing a collection of "small chapmen's books, and cheap" as a youth.

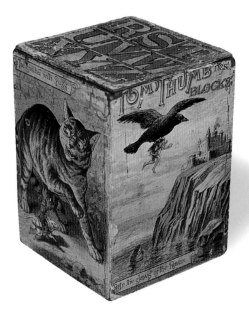

TOM THUMB NESTING BLOCKS
Manufactured by McLoughlin Brothers, New York
Copyright 1889

Building upon the 1881 invention of a new children's toy—lightweight, hollow wooden nesting blocks—McLoughlin Brothers added brightly colored chromolithographed images to sets of blocks. Pushing the firm's marketing ingenuity to new heights, blocks with scenes recycled from *Tom Thumb, Goody Two Shoes, Puss in Boots,* and *Jack and the Bean Stalk* carried the enticement, "Get the Story Book."

If the concept of uniting words and pictures in books created especially for children was revolutionary, then John McLoughlin, Jr. (1827–1905) may be considered the movement's great American general. At the creative and commercial helm of McLoughlin Brothers from the 1850s until the early years of the twentieth century, a period often described as the golden age of children's literature, McLoughlin employed innovative production and marketing techniques to bring a bestseller's list of titles to the juvenile market. Like other successful entrepreneurs and industrialists of the era, McLoughlin was ahead of the curve in adopting new technology. Among the first American publishers to issue books with colored, rather than black and white, illustrations, the firm also embraced chromolithography early on to enliven the pages of its inexpensive books with a vibrant color palette.

Early children's books tended to be small, often measuring no more than a few inches along each side. Illustrations were few and were created through the traditional printmaking techniques of woodcutting and wood engraving. In each process, a design is cut into a block of wood, ink is applied, and the design transferred from wood to paper. The earliest and least expensive of such illustrations were printed in a single color, usually black. A book issued in honor of John McLoughlin, Sr.'s entry into the new field of children's publishing in 1828 (with a second-hand press on Tryon Row, the heart of New York City's newspaper and printing industries) described the process of hand-coloring the black and white wood engravings adopted by McLoughlin Brothers in the 1850s and early 1860s. Using a stencil printed and cut from the same engraving, colored ink was applied with a paintbrush. Each color required its own stencil. The individual character of each hand-tinted picture, generally executed by girls and young women, lends an air of charm and naïve beauty to the illustrations.

Brighter areas of solid color replaced the unique and idiosyncratic effects of hand-coloring when two-color wood block illustration was adopted later in the 1860s. That innovation, also taken up by McLoughlin Brothers, brought a new boldness to the design of the firm's books. It led the way for continuing experimentation with color printing and for the expansion of the firm's business, including, in 1871, construction of its own color printing factory in Williamsburg, Brooklyn.

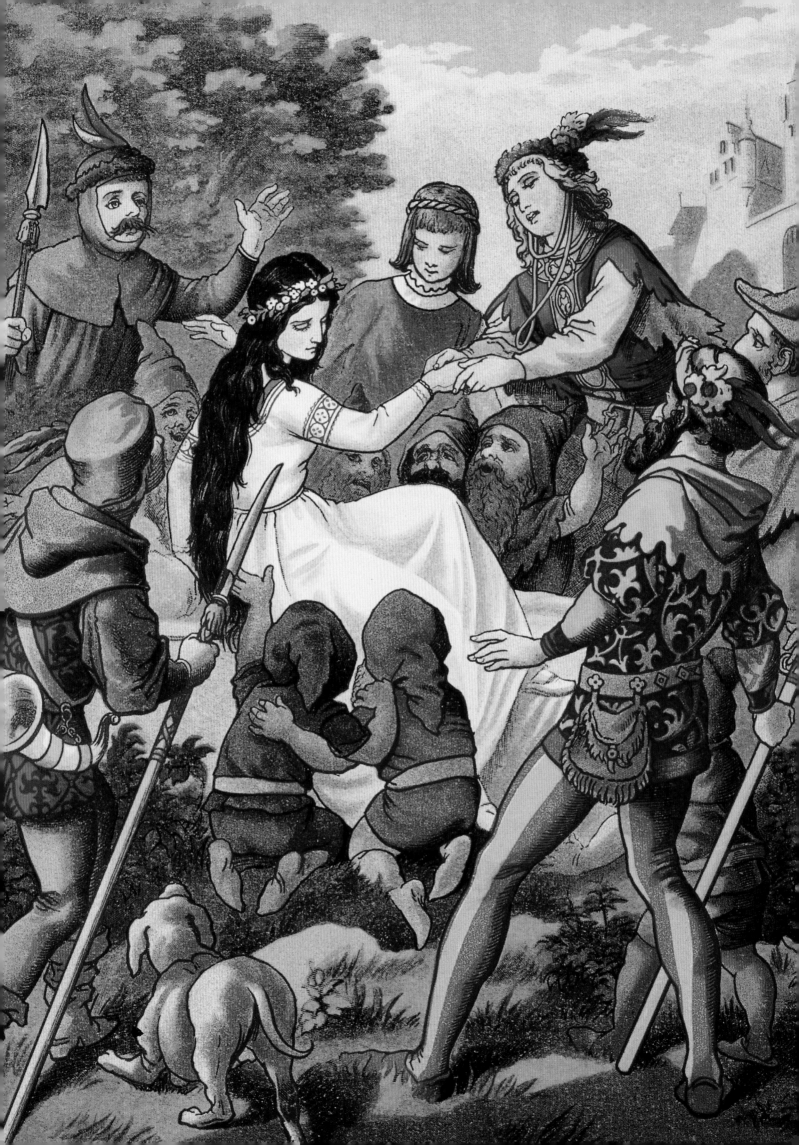

OPPOSITE

TALES OF THE FAIRY WORLD,
BONNYBELL, BRAVE LITTLE
TAILOR, SNOW WHITE:
SELECTIONS FROM GRIMM
Published by McLoughlin Brothers,
New York
Copyright 1883

The vivid reds and yellows of this illustration, created through the process of chromolithography, set off the figure of Snow White.

For the next three decades, McLoughlin Brothers enjoyed a heyday of industrial-age success, bringing out new titles and re-releasing proven sellers, sometimes changing little more than a book's title or cover. This practice, engaged in by other children's publishers of the day, makes it difficult to precisely date children's books of this era. In the case of McLoughlin Brothers, this dilemma is somewhat eased by the presence of the company's street address on the covers of many of its books. New York City Directories list a business address for John McLoughlin at 24 Beekman Street from 1857 through 1863, engaged variously in the book, printing, and publishing businesses. Thirty Beekman and 80 Beekman Street appear from 1864 through 1870, followed by other addresses on Greene and Duane streets, and later, on Broadway. (For a complete list of McLoughlin Brothers addresses, see the last page of this introduction.) In some books, it is the presence of cultural clues that provide vital information about publication dates: Z stands for Zouave in some alphabet books printed in the 1860s, when volunteer units on both sides of the Civil War adopted the name and dashing uniform of the elite Zouave battalion of the French Army of the 1830s.

McLoughlin Brothers emerged as the largest force in publishing inexpensive illustrated books for children, but it was not the only competitor in this market. Boston's DeWolfe, Fiske and Company and Cincinnati, Ohio-based publisher and toy manufacturer Peter G. Thomson, among other others, offered similar titles. Thomson's inventory included literary classics, fairytales, and other favorites like *Children in the Wood* and *The Night Before Christmas*. The firm also followed the practice of issuing its children's books in series, under names such as "The Chimney Corner" and "Little Mary Bell's." As in preceding centuries, books by British publishers held a large place on the shelves of American booksellers as well.

McLoughlin Brothers' success in creating a market for affordable, lavishly illustrated children's books was buoyed in no small part by a stable of talented illustrators, ranging from anonymous copyists of illustrations pirated from more luxurious publications to the most well-known providers of pictures to the popular press. Further enabling the firm's vast commercial success was a business climate that permitted great

license in reproducing the work of others. Although copyright protection had existed in the United States since colonial times, its enforcement—especially international enforcement of the copyright of writers and artists—was neither active nor universal. Thus, many American publishers offered complete and abridged versions of classics such as Paul Bunyan's *Pilgrim's Progress,* as well as unauthorized versions of new titles such as *Alice's Adventures in Wonderland,* without crediting the author or copyright holder. Nonetheless, publishers took the precaution of copyrighting their own publications as well as pirated works, audaciously printing the copyright date on their book covers. One of the most blatant instances of such design piracy was the wholesale American appropriation of the drawings of English illustrator and writer Kate Greenaway (1846-1901). Her drawings for British editions of fairytales and nursery rhymes were steadily reproduced in the United States, frequently without the sensitive and painstaking attention to color and line exercised by Edmund Evans (1826-1905), who engraved her designs for their initial publication. McLoughlin Brothers in particular assumed the marketable assets of Greenaway's name and the whimsical imagery associated with it, even using the title of her first book, *Under the Window,* as the name of a series of books it offered to growing numbers of her American fans.

A major shift in the appearance of illustrated children's books occurred late in the nineteenth century, with implementation of the technique of chromolithographic printing. Invented in Europe at the close of the eighteenth century, chromolithography employed oil-based inks to produce vibrant, deeply saturated colors. When perfected and adopted for production on a large scale in the 1870s, it created an explosion in vividly colored books. Illustrated verses and stories, from moral tales to nursery rhymes, became widely available to American consumers as printing processes improved, making it possible to produce attractive volumes in quantity. Books grew larger and their illustrations more numerous. Strategic use of metallic ink lent additional eye-appeal, and enticements such as "printed in gold" were highlighted on the covers of books. As middle-class prosperity reached growing numbers of Americans, they were able to select from a wide variety of titles available in editions ranging from luxurious bound volumes to inexpensive and ephemeral pamphlets.

STEPS TO ART,
AFTER KATE GREENAWAY
Published by McLoughlin Brothers,
New York
1882

Precursors of coloring books and paint-by-number kits taught children to draw and paint. Tracing paper bound into the spine of the book allowed children to copy images, just as the publisher copied Kate Greenaway's work to illustrate this book.

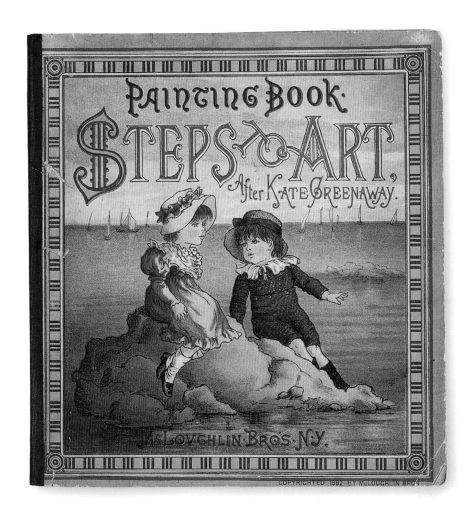

The marriage of visual pleasure and utility became a major selling point for illustrated children's books. McLoughlin Brothers adopted the catchphrase "amusing and instructive" and frequently incorporated it into advertisements for titles in its inventory, which were often printed on the back covers of its books. As early as 1830, however, authorities were advising parents not to tip the balance on the side of amusement. Lydia Maria Child (1802–1880), an American novelist, abolitionist, and author of books of practical advice for women, recommended in *The Mother's Book* that reading material "chosen for young people should as far as possible combine amusement with instruction; but it is very important that amusement should not become a necessary inducement."

One must conclude that Child would have been dismayed by the proliferation of books containing "magic transformations," "dissolving circles," and other moving parts in which the balance tips in favor of amusement for its own sake. Although some of these devices were ingen-

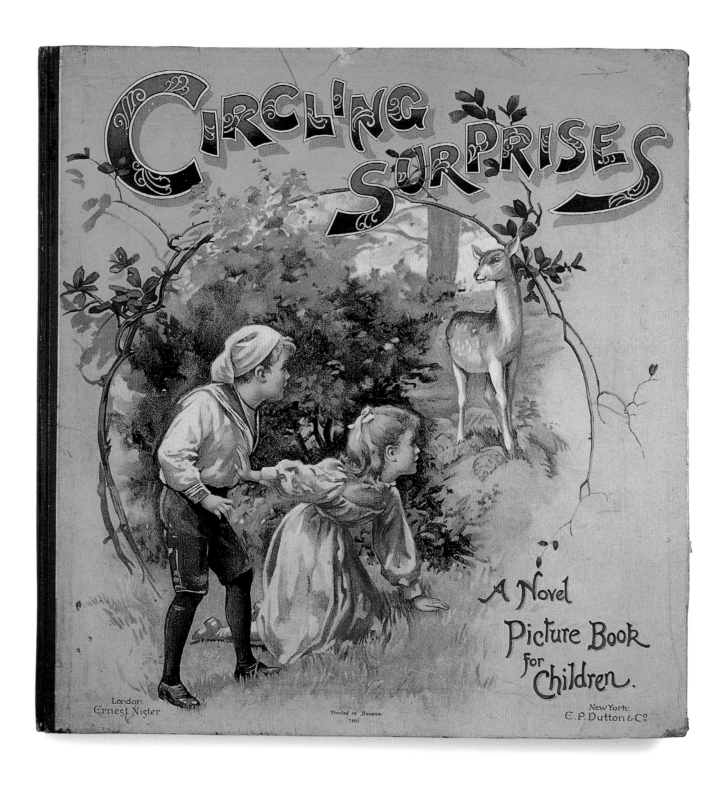

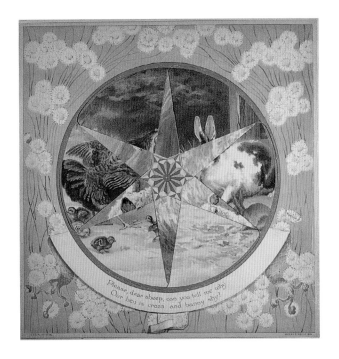
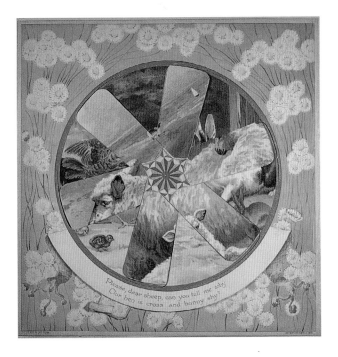
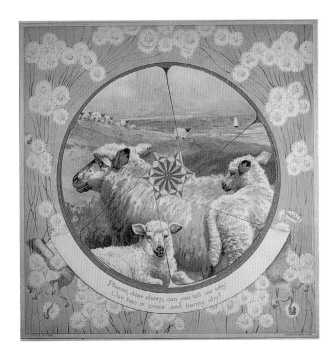

CIRCLING SURPRISES:

A NOVEL PICTURE BOOK FOR CHILDREN

Verses by H. M. Burnside

Illustrated by H. K. Robinson

Published by E. P. Dutton & Co., New York, and Ernest Nister, London

ca. 1890s

One picture appears to "dissolve" into another when a child
pulls the "magic tab" and reconfigures the illustration.

iously used to illustrate difficult concepts in scientific manuscripts as early as the thirteenth century, they were not generally deployed for the delight of children until the eighteenth century, after London printer Robert Sayer introduced *The Harlequinades* around 1765. Layering a group of printed images and splitting them in half, Sayer gave children the opportunity to create new scenes as they turned the upper or lower half of each page. With greater emphasis on notions of play, books that "metamorphosed" and "transformed" gained a greater presence among the array of illustrated children's books and toys available to American children by the 1870s. Providing amusement for its own sake, accordion folds, flaps, rollers, three-dimensional peep-show effects, and dissolving circles engaged children on a kinetic as well as intellectual level and added a lighter note to traditional stories. In some cases their novelty overshadowed the text completely.

McLoughlin Brothers also offered a variety of fairytales and other stories in a format that resembled a theater between book covers. Closed, the volumes give the appearance of a performance about to begin, moments before the curtain rises over the proscenium arch. The footlights are glowing and the orchestra has just begun to play. A vertical slit down the center of the cover and each successive page allows the reader to direct the action; turning the pages reveals a sequence of lavishly illustrated scenes to a full audience, which enjoys the performance from tiered boxes.

The books that appear throughout *Once Upon a Time* are drawn from the collection of Ellen Liman. Assembled by the artist and her husband, the late Arthur Liman, they reflect the great diversity of books read by American children throughout the nineteenth century and are a treasure trove of visual culture. Turning the pages of the fairytales, fables, alphabets, and other books, the tone and texture of the daily lives of the children who read them is revealed. But beyond the particulars of time and place, what emerges most clearly is the timeless passion uniting all who have loved to read since childhood.

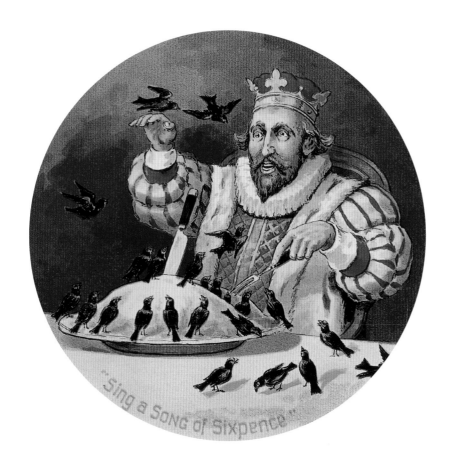

MCLOUGHLIN BROTHERS ESTABLISHMENTS, 1850-1905

from New York City Directories

6 Spring Street	listed as printer, 1850–54
18 Division Street	listed as books, 1851–52
3 Tryon Row	listed as books, 1852–53
265 Bowery Street	listed as printer, 1855–56
24 Beekman Street	listed as books, 1854–55, 1857, 1858–63
	listed as publisher, 1855–56, 1857–58
30 Beekman Street	listed as publisher, 1863–64
	listed as books, 1864–66, 1867–69
80 Beekman Street	listed as books, 1866–67, 1869–70
52 Greene Street	listed as books, 1870–71
73 Duane Street	listed as books, 1872–74, 1878–81, 1883–84
	listed as toys, 1874
	listed as publisher, 1877–78, 1882–83, 1884–86
71 Duane Street	listed as publisher, 1876–77, 1881–82
623 Broadway	listed as publisher, 1886–92
874 Broadway	listed as publisher, 1892–98
890 Broadway	listed as publisher, 1898–1905

ABOVE

MOTHER GOOSE MELODIES

Published by McLoughlin Brothers

Copyright 1894

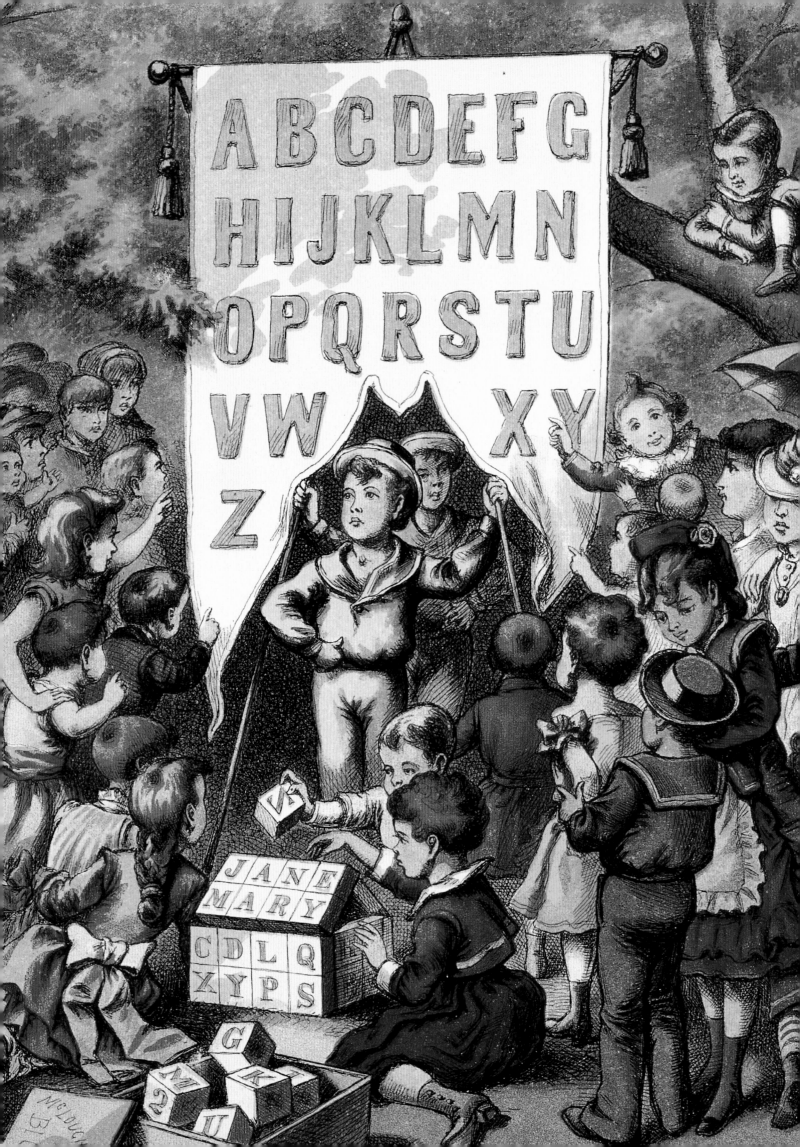

FROM APPLE TO ZOUAVE
LEARNING THE ABCS

"A: In Adam's fall we sinned all" was the opening line of many editions of *The New England Primer*, the book used by young children in the English colonies of North America to learn their letters. Having its origins in medieval devotional books, the primer also contained prayers. Next to the Bible, it was the book most frequently read by American children well into the nineteenth century.

One of the first editions of *The New England Primer* was printed in about 1690 by Boston publisher Benjamin Harris. Based upon English antecedents, its tone was harsh and puritanical. A less-severe approach to teaching children the basics began to evolve around the middle of the eighteenth century, and by the end of the nineteenth century, prayers were no longer part of the primer's content. The book still adhered to the same general format, however, with the alphabet appearing first, in upper- and lower-case letters, followed by an illustrated alphabet accompanied by verse. Often Arabic numerals from zero to nine appeared on the primer's final page.

Colonial-era American children also learned their letters from hornbooks, which were not actually books at all but rather wooden paddles. At a time when paper was expensive and scarce, the alphabet was written on a single sheet, which was then pasted to a wooden board and covered with a translucent layer of horn. Not surprisingly, children devised other functions for the paddles in the schoolyard.

Illustrated alphabet books transformed the straightforward teaching of the primer. Stern verses like "F the Idle Fool is Whipt at School" (a

15

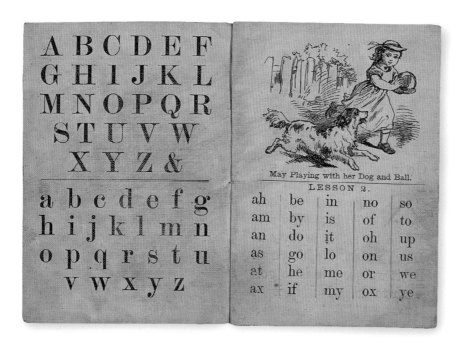

visceral reminder that corporal punishment was a well-established form of disciplining minors) eventually gave way to more light-hearted verses, such as "A was an Apple Pie, B baked it, C cut it." Following on the heels of its first publication in London in 1823, *The History of an Apple Pie* and numerous imitators were frequently issued in the United States, where the baker of the pie was sometimes pictured as a smiling Mammy figure, complete with signature headwrap. Virtually any topic, however, could serve as the thematic basis around which letters might be taught in an entertaining fashion. The names of children typical and distinctive, of animals domestic and exotic, and of places distant and close to home provided subject matter for children's alphabet books. Bird and animal alphabets were widely published in the mid- to late-nineteenth century— perhaps a reflection of the growing popularity of natural history and heightened concern for the compassionate treatment of animals. And although today they seem unlikely choices, sophisticated multi-syllabic words with complex social meanings such as "urchin" and "miser" also frequently graced the pages of children's ABCs.

In addition to books, children's publishers created and sold nesting toy blocks featuring letters of the alphabet and related pictures. Probably evolved from the "dice alphabets" proposed by John Locke as a way of teaching through play, these toys, in turn, appear on the covers and pages of many illustrated alphabet books.

PAGE 14

THE DOINGS OF
THE ALPHABET
*Published by McLoughlin Brothers,
New York
ca. 1880s*

ABOVE

LITTLE LINEN PRIMER
*Published by McLoughlin Brothers,
New York
ca. 1880s*

Though it includes no prayers, this book relates to the *New England Primer* in both its title and content. As the title suggests, it is printed on coated linen fabric, intended to repel spills and stains from dirty hands.

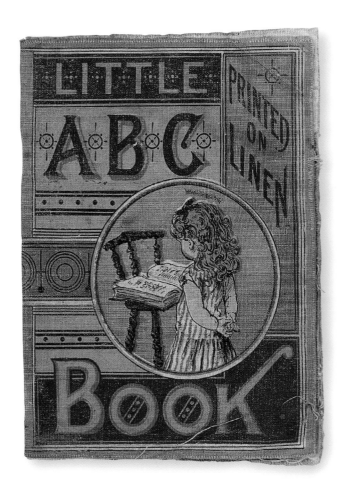

LITTLE ABC BOOK
Published by McLoughlin Brothers, New York
ca. 1880s

Autobiographies reveal that girls enjoyed many of the same kinds of active, outdoor play as boys during the nineteenth century, but the pictures in children's books portray a different story. Here the letter H shows a little soldier playing with a hoop and stick—a popular and inexpensive toy—while a girl performing one of her chores with an accommodating goat illustrates the letter G.

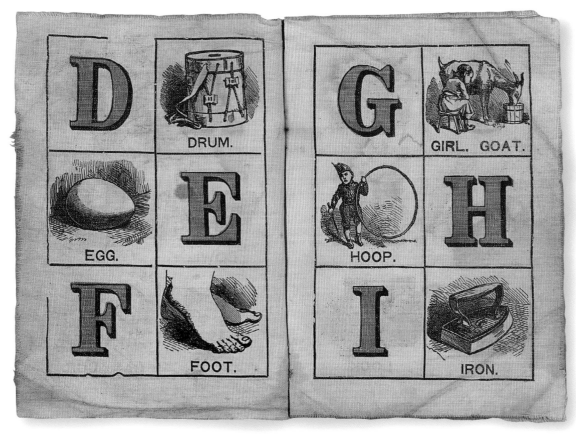

GIRLS & BOYS
NAME
ABC

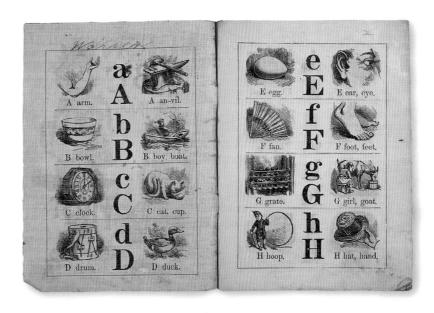

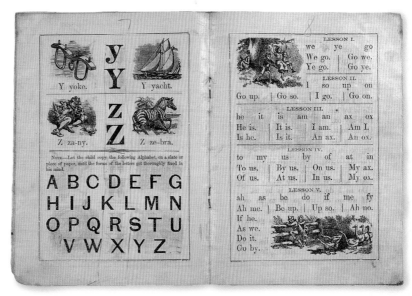

GIRLS AND BOYS NAME ABC

Published by McLoughlin Brothers,
New York

Copyright 1889

The Old and New Testament, historical figures, flowers, trees, and other elements of the natural world were frequent sources of children's names when this book was published. Young readers could find their own names, along with those of friends and family members, on its pages, accompanied by pictures of children playing, doing chores, and learning about the world around them.

LITTLE ABC BOOK

Published by McLoughlin Brothers,
New York

ca. 1880s

In addition to teaching the alphabet with pictures or rhymes, some books contained lists of words starting with each letter and short sentences using words learned in earlier lessons.

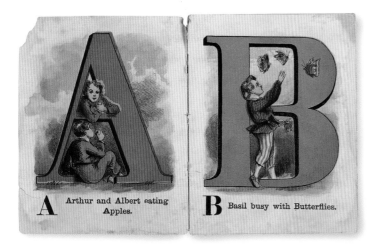

A Arthur and Albert eating Apples.

B Basil busy with Butterflies.

GREAT BIG ABC

Illustrated by J. H. Howard

Published by McLoughlin Brothers, 71 & 73 Duane St., New York

ca. 1870–80s

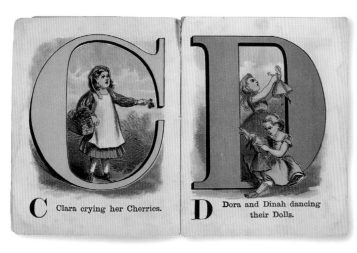

C Clara crying her Cherries.

D Dora and Dinah dancing their Dolls.

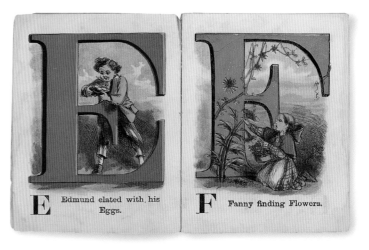

E Edmund elated with his Eggs.

F Fanny finding Flowers.

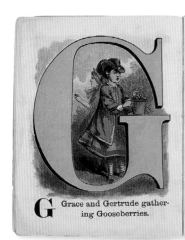

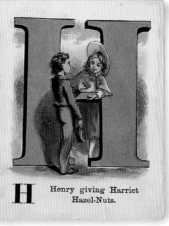

G Grace and Gertrude gathering Gooseberries.

H Henry giving Harriet Hazel-Nuts.

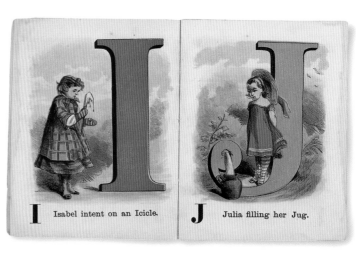

I Isabel intent on an Icicle.

J Julia filling her Jug.

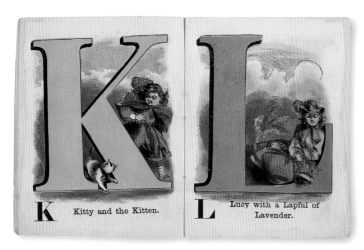

K Kitty and the Kitten.

L Lucy with a Lapful of Lavender.

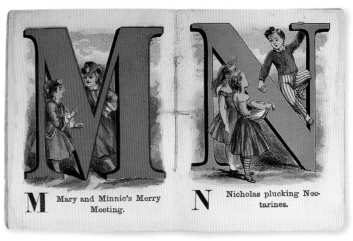

M Mary and Minnie's Merry Meeting.

N Nicholas plucking Nectarines.

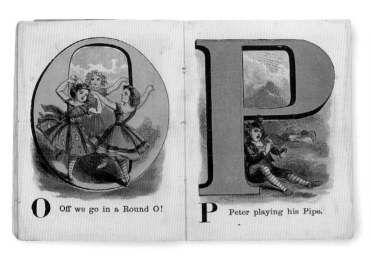

O — Off we go in a Round O!

P — Peter playing his Pipe.

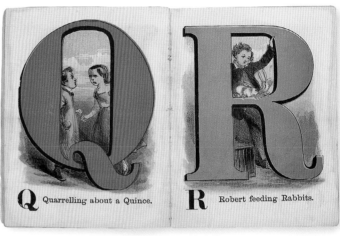

Q — Quarrelling about a Quince.

R — Robert feeding Rabbits.

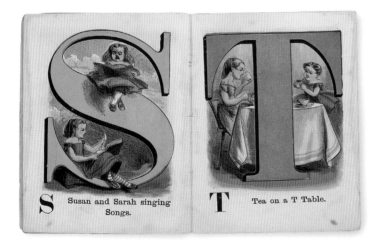

S — Susan and Sarah singing Songs.

T — Tea on a T Table.

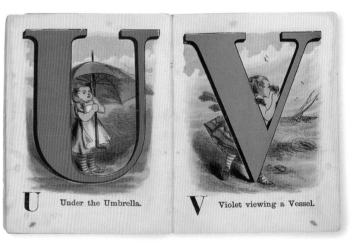

U — Under the Umbrella.

V — Violet viewing a Vessel.

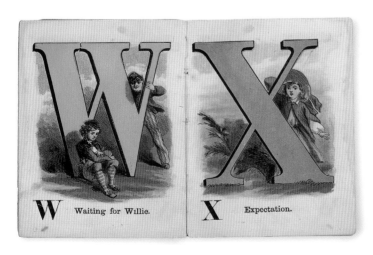

W — Waiting for Willie.

X — Expectation.

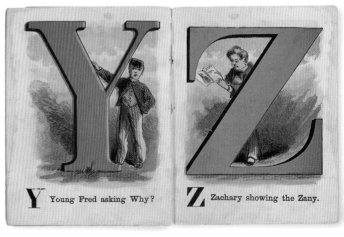

Y — Young Fred asking Why?

Z — Zachary showing the Zany.

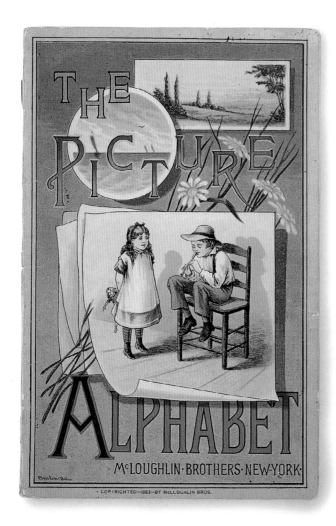

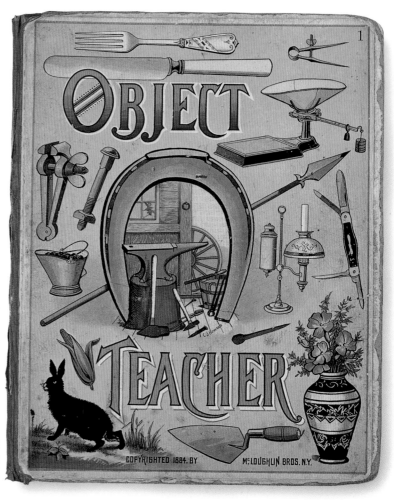

THE PICTURE ALPHABET

Published by McLoughlin Brothers, New York
Copyright 1883

OBJECT TEACHER

Illustrated by C. J. Howard
Published by McLoughlin Brothers, New York
Copyright 1884

The publisher of this "novel, instructive and in the highest degree amusing" book promised not only "constant occupation and pleasure" to its readers but also the development of "habits of observation and criticism." Flowers, animals, furniture, and objects familiar to us today are arranged randomly on each page alongside those now less familiar—a quill pen and bottle of ink, blacksmithing tools, and the boot lacer (shown here above the dog's head).

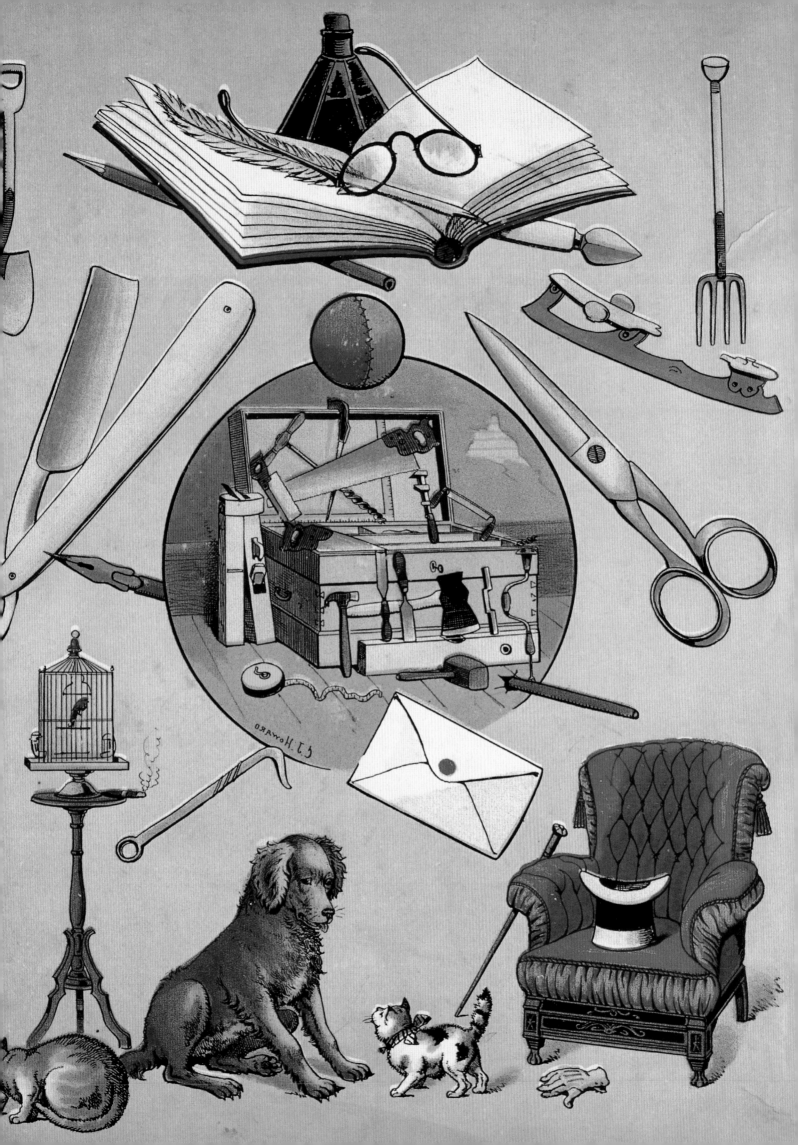

MERRY ALPHABET
Alphabet Series
Published by McLoughlin Brothers, New York
Copyright 1890

STARRY FLAG ABC BOOK

Published by McLoughlin Brothers, New York
Copyright 1899

As accurately as newspaper headlines, illustrations in children's books reveal the ardent patriotism aroused by the outbreak of the Spanish American War in 1898. Adults and children read daily accounts of the progress of Teddy Roosevelt's Rough Riders and closely followed the war at sea waged by Admiral Dewey and other Naval heroes from Guantánamo Bay, Cuba to the distant Philippine Islands. Their widely-heralded victories stirred patriotic sentiments and revived the fashion (begun by Queen Victoria in the 1840s) for American children to wear sailor suits such as that sported by the boy on the cover of this book. Carrying the patriotic theme further, the American flag appears throughout the volume's pages, with stars and stripes incorporated into the letters of the alphabet.

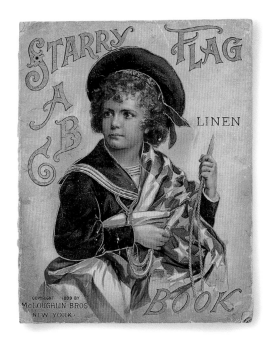

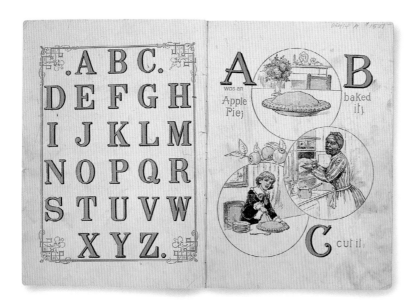

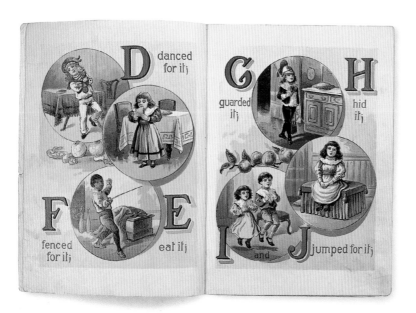

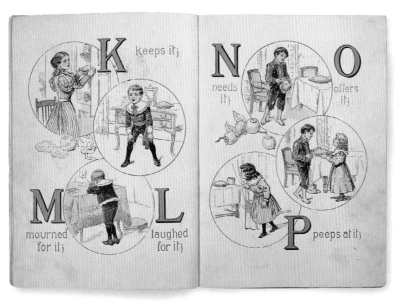

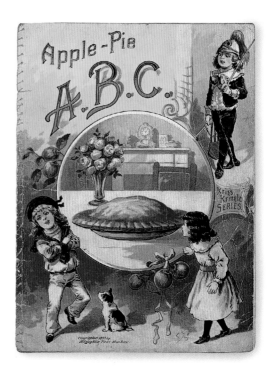

APPLE-PIE ABC
Kris Kringle Series
Published by McLoughlin Brothers,
New York
Copyright 1897

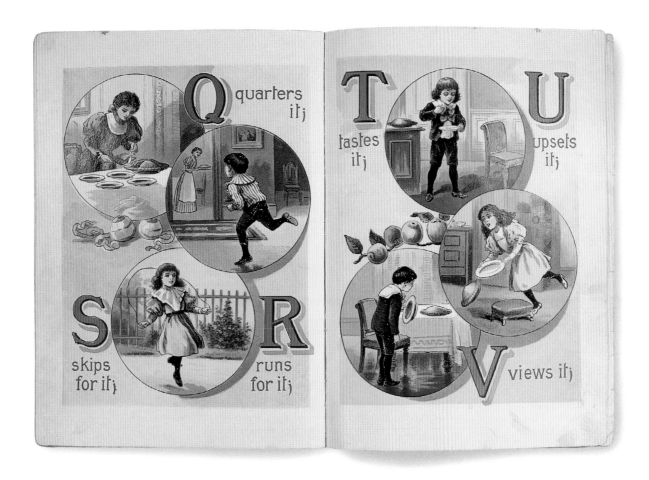

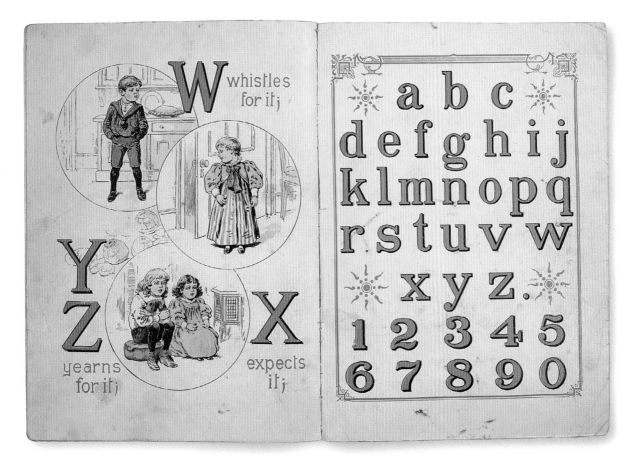

TOM THUMB ALPHABET

Published by McLoughlin Brothers, New York

ca. 1880s

Professions from the mundane butcher, farmer, and hunter to the more dubious "quack" and robber, form the thematic basis around which this humorous alphabet was created.

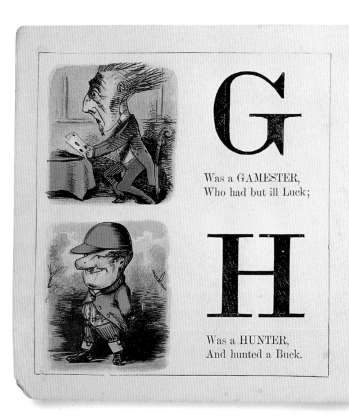

G

Was a GAMESTER,
Who had but ill Luck;

H

Was a HUNTER,
And hunted a Buck.

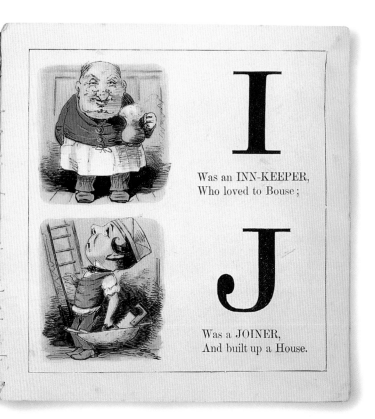

I

Was an INN-KEEPER,
Who loved to Bouse;

J

Was a JOINER,
And built up a House.

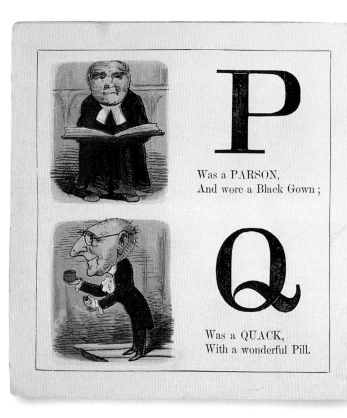

P

Was a PARSON,
And wore a Black Gown;

Q

Was a QUACK,
With a wonderful Pill.

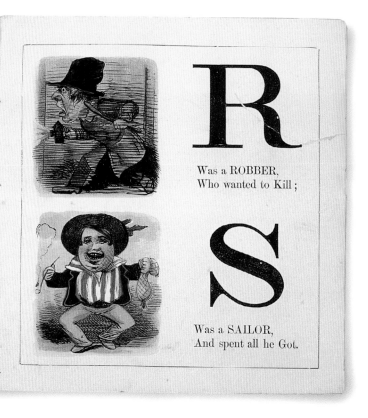

R

Was a ROBBER,
Who wanted to Kill;

S

Was a SAILOR,
And spent all he Got.

ONE, TWO,—
Buckle my Shoe;

That, good Sir, I'll readily do.
Do it; but mind, don't hurt my toe,
Or I shall scold you well, I trow.
I've done it, Sir, and very neat
With shoe and buckle look both
feet.

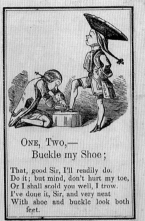

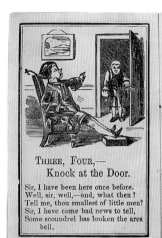

THREE, FOUR,—
Knock at the Door.

Sir, I have been here once before.
Well, sir, well,—and, what then ?
Tell me, thou smallest of little men?
Sir, I have come bad news to tell,
Some scoundrel has broken the area
bell.

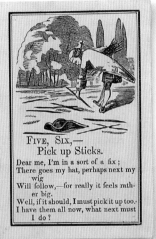

FIVE, SIX,—
Pick up Sticks.

Dear me, I'm in a sort of a fix ;
There goes my hat, perhaps next my
wig
Will follow,—for really it feels rath-
er big.
Well, if it should, I must pick it up too.
I have them all now, what next must
I do ?

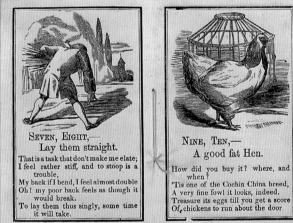

SEVEN, EIGHT,—
Lay them straight.

That is a task that don't make me elate;
I feel rather stiff, and to stoop is a
trouble,
My back if I bend, I feel almost double
Oh ! my poor back feels as though it
would break.
To lay them thus singly, some time
it will take.

NINE, TEN,—
A good fat Hen.

How did you buy it? where, and
when ?
'Tis one of the Cochin China breed,
A very fine fowl it looks, indeed.
Treasure its eggs till you get a score
Of chickens to run about the door

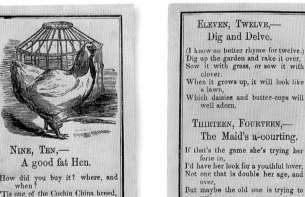

ELEVEN, TWELVE,—
Dig and Delve.

(I know no better rhyme for twelve.)
Dig up the garden and rake it over,
Sow it with grass, or sow it with
clover.
When it grows up, it will look like
a lawn,
Which daisies and butter-cups will
well adorn.

THIRTEEN, FOURTEEN,—
The Maid's a-courting.

If that's the game she's trying her
forte in,
I'd have her look for a youthful lover,
Not one that is double her age, and
over,
But maybe the old one is trying to
gain
Her smiles, and if so, he will labor
in vain.

FIFTEEN, SIXTEEN,—
The Maid's in the Kitchen.

And here she looks far more be-
witching.
In her right place, to her duties at-
tending,
She pleases and runs little chance
of offending ;
If thus she will act, and will study
to please,
She may then wear a smile and her
mind be at ease.

SEVENTEEN, EIGHTEEN,—
The Dinner is waiting.

This is the time when folks get de-
bating,
Talking, and grumbling of this and
of that,
And know not what next to be after
or at.
Cook, bring in the dishes as soon as
you're able,
Bring them up quickly and put them
on table.

OPPOSITE

TOM THUMB ALPHABET

Published by McLoughlin Brothers,

New York

ca. 1880s

RIGHT

ONE, TWO, BUCKLE MY SHOE

Aunt Mary's Series

Published by McLoughlin Brothers,

30 Beekman Street, New York

ca. 1860s

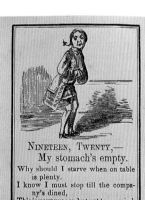

NINETEEN, TWENTY,—
My stomach's empty.

Why should I starve when on table
is plenty.
I know I must stop till the compa-
ny's dined,
This is very proper, but not to my mind.
When my turn comes, won't I take
a good fill,
Of what may be left !—to be shure
that I will.

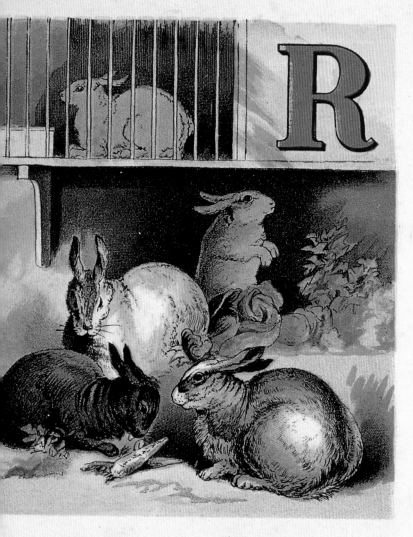

R

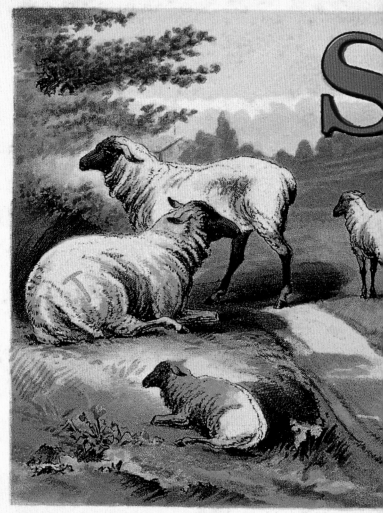

S

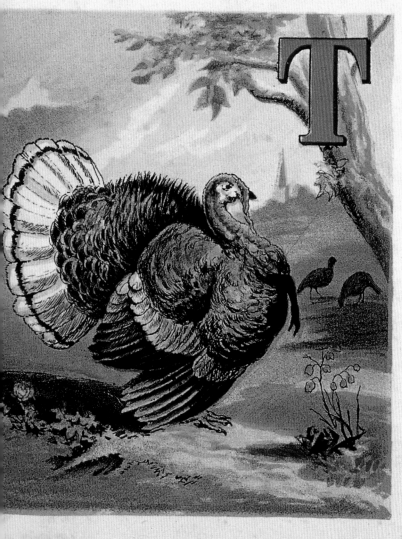

T

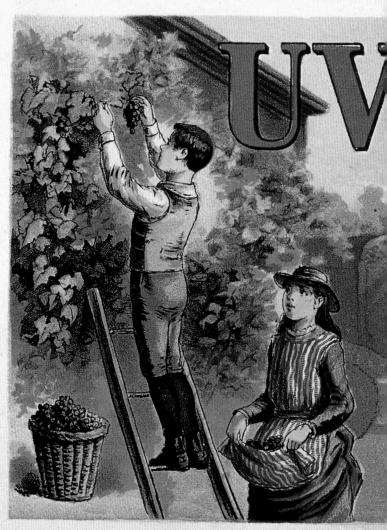

UV

R for the Rabbits, white, spotted, and gray;
Just see how that little one nibbles away.

S for the Sheep, with their coats of soft wool;
They stand in the meadows so pleasant and cool.

T for the Turkey, who stately doth sail,
With long sweeping wings and a wide-spreading tail.

U stands for Ursula, and V for the Vine
That yields her fine clusters in harvesting time. V

ALPHABET OF COUNTRY SCENES

Illustrated by Bruton
Published by McLoughlin Brothers, New York
ca. 1880s

As the nation grew less agrarian and increasingly industrialized, many American families moved to cities in pursuit of work. Urbanization fostered a nostalgia for country life, which some children experienced only through romanticized depictions in books such as this.

BELOW

OUR PETS ABC BOOK

Designed and printed by Koerner & Hayes, Buffalo
Published by W. B. Perkins & Co., New York and Buffalo
Copyright 1895, Koerner & Hayes

Nineteenth-century childrearing experts advocated allowing children to care for animals. In *The Mother's Book*, author Lydia Maria Child maintained, "It is a benefit to children to have the care of feeding animals, such as lambs, chickens, & c. It answers two good purposes—it excites kindness, and a love of usefulness."

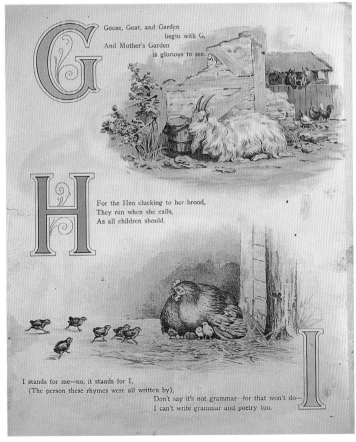

Goose, Goat, and Garden begin with G,
And Mother's Garden is glorious to see.

For the Hen clucking to her brood,
They run when she calls,
As all children should.

I stands for me—no, it stands for I,
(The person these rhymes were all written by),
Don't say it's not grammar—for that won't do—
I can't write grammar and poetry too.

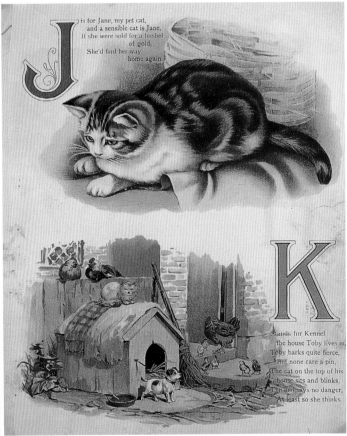

J is for Jane, my pet cat,
and a sensible cat is Jane,
If she were sold for a bushel of gold,
She'd find her way home again.

K stands for Kennel
the house Toby lives in,
Toby barks quite fierce,
But none care a pin,
The cat on the top of his
house sits and blinks,
The hen says no danger,
At least so she thinks.

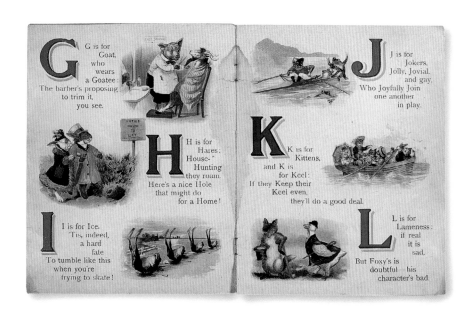

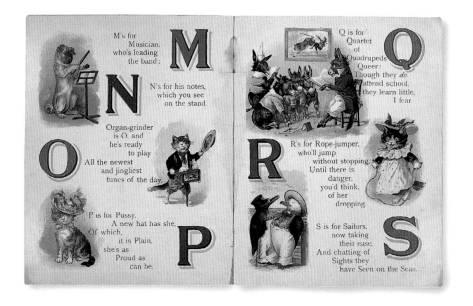

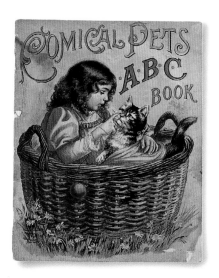

COMICAL PETS ABC BOOK
Published by McLoughlin Brothers,
890 Broadway, New York
Copyright 1899

The practice of keeping animals as companions blossomed in America in the nineteenth century, as reformers sought to prevent cruelty to animals and as urbanization distanced people from the animals they had once encountered in the wilderness or on the farm. The gaily dressed creatures illustrated in this book engage in all sorts of childhood activities from playing to going to school.

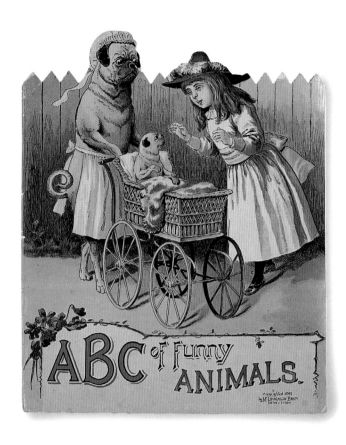

ABC OF FUNNY ANIMALS

Published by McLoughlin Brothers, New York

Copyright 1892

Once the prized pet of the wealthy, the pug dog on the cover of this book plays nursemaid as she pushes a baby in a wicker pram, the latest innovation in period childcare. Exotic animals take on human characteristics and engage in human activities, from reading and writing to dancing, throughout this humorous alphabet book. Anthropomorphizing animals was a common practice in the nineteenth century, with complex emotions characterizing not only the animals pictured in children's books but also those in natural histories published for adult readers.

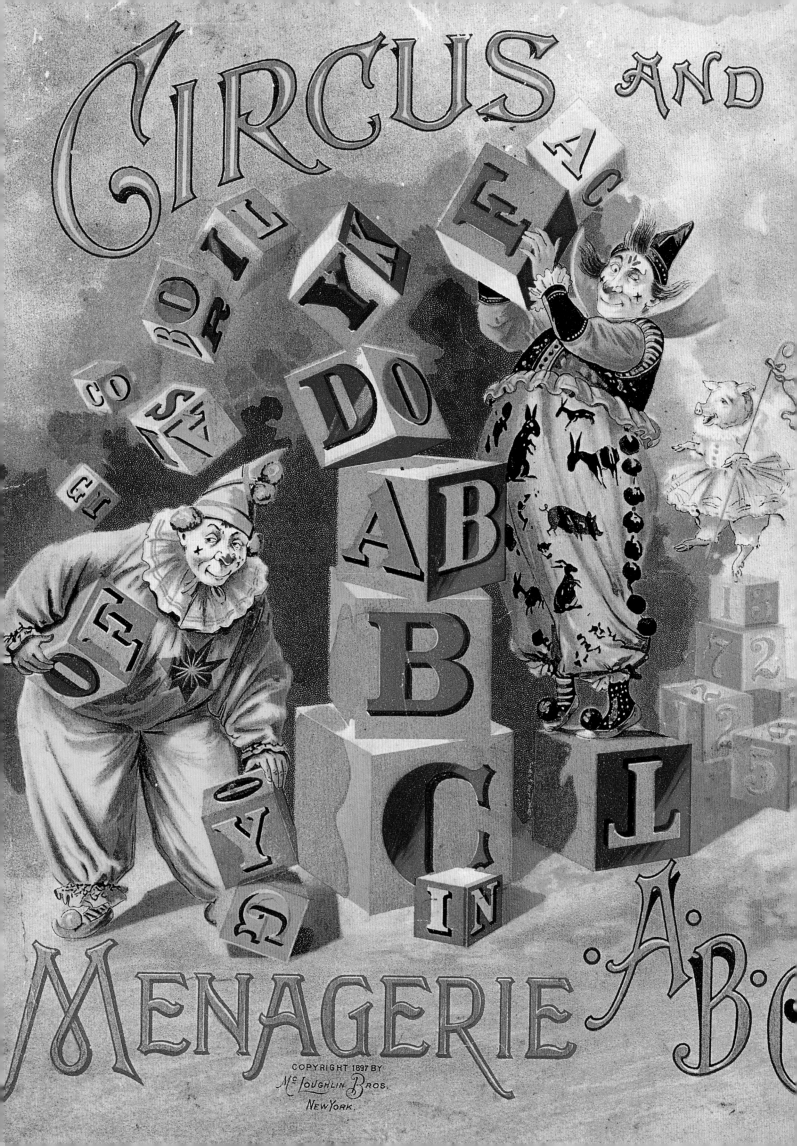

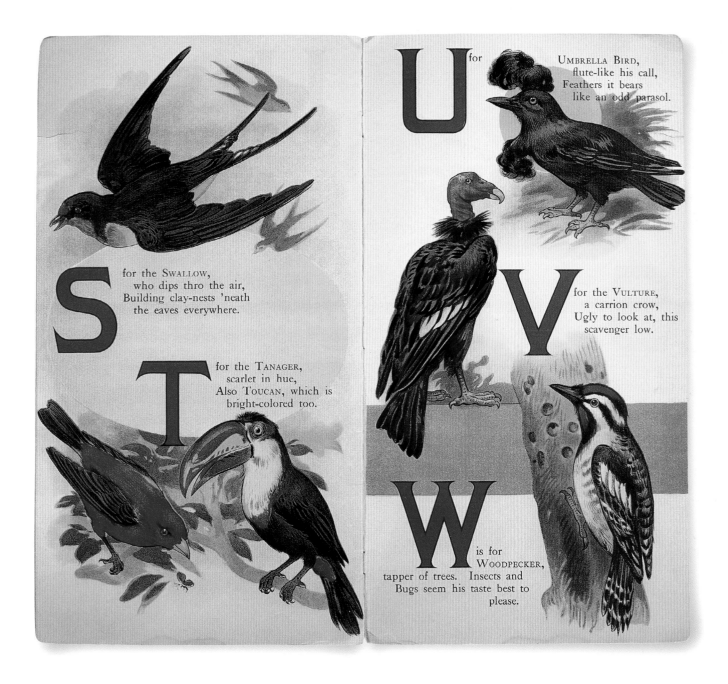

S for the SWALLOW,
who dips thro the air,
Building clay-nests 'neath
the eaves everywhere.

T for the TANAGER,
scarlet in hue,
Also TOUCAN, which is
bright-colored too.

U for UMBRELLA BIRD,
flute-like his call,
Feathers it bears
like an odd parasol.

V for the VULTURE,
a carrion crow,
Ugly to look at, this
scavenger low.

W is for
WOODPECKER,
tapper of trees. Insects and
Bugs seem his taste best to
please.

CIRCUS AND MENAGERIE ABC

Published by McLoughlin Brothers, New York

Copyright 1897

Circuses featuring clowns, acrobats, and performing animals toured the United States from the early part of the nineteenth century on. Traveling menageries and decorated circus wagons housing exotic animals drew crowds as the circus traveled from town to town, becoming attractions on their own. On the vibrant cover of this book, clowns assist potential readers with their ABCs.

ABC BOOK OF BIRDS

Written by Carolyn S. Hodgman

Illustrated by Will F. Stecher

Published by Stecher Litho. Co., Rochester

Copyright 1916

Ordinary, exotic, and extinct birds, including the albatross, bird of paradise, and dodo, to name just a few, populate the pages of this early twentieth-century alphabet book, one of several created by this writer/illustrator team.

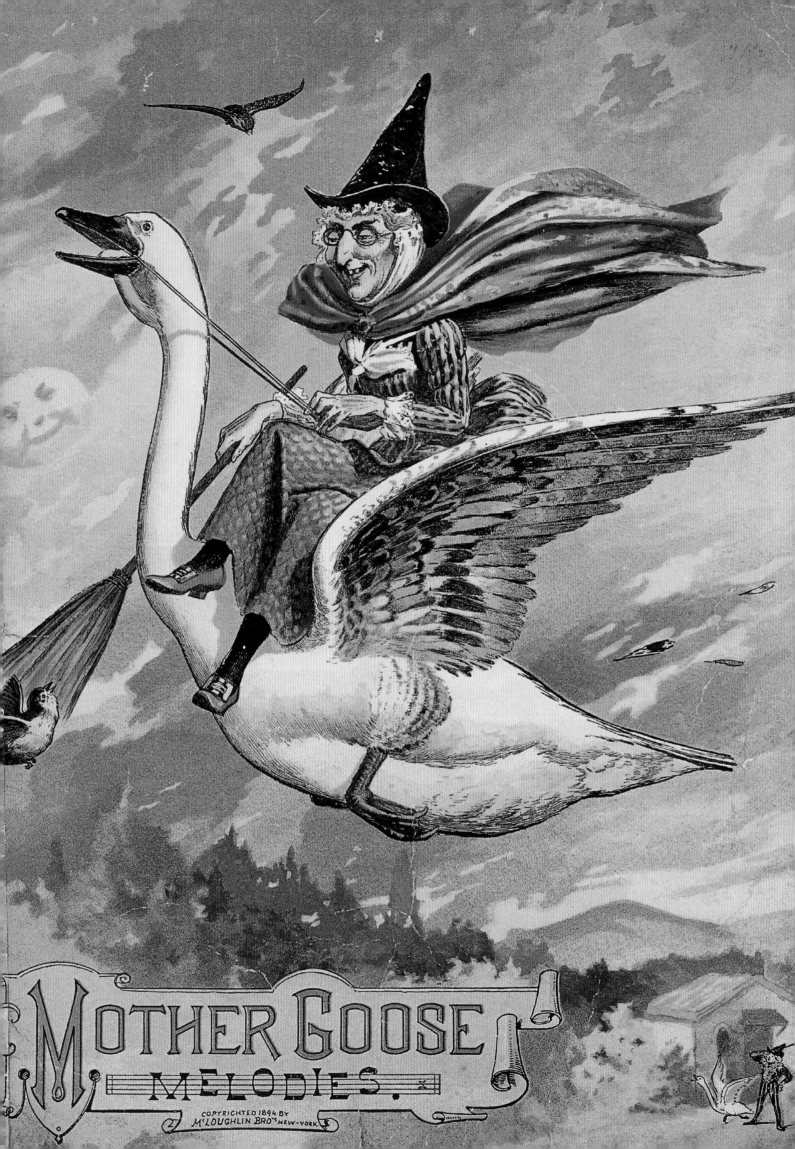

MOTHER GOOSE MELODIES.

COPYRIGHTED 1894 BY
Mc LOUGHLIN BRO'S NEW-YORK

THROUGH THE AIR ON A VERY FINE GANDER

GEMS FROM MOTHER GOOSE

Bringing joy to the ear and delight to the soul, the rhymes of Mother Goose have been amusing children of all ages for countless generations. Heard first in infancy, they remain forever in memory. The origins of some lie in antiquity; the origins of others, in the first stanzas of folk ballads. Lighthearted and silly on the surface, the rhymes nonetheless have been the subject of much study, from scholars who delve into their roots in global storytelling and lullaby traditions to those who seek the identity of the "real" Mother Goose, convinced that she can be located in history. In jest and with all due seriousness of purpose, many have sought to find a female figure with a name approximating "goose," pointing to such historically disparate figures as the medieval Bertrada, Queen Goosefoot, the mother of Charlemagne, and Elisabeth Vergoose, whose son-in-law Thomas Fleet, a colonial-era Boston printer, was long erroneously credited as the first to publish Mother Goose. Finding proof of such speculations about the authorship of these delightful rhymes had the same probability of success as all the king's horses and all the king's men putting Humpty Dumpty together again, and so the "author" of most of these traditional verses will likely remain anonymous.

Historians have, however, traced Mother Goose's earliest appearances on the printed page; two individuals who figure broadly in the history of children's literature are credited with giving life to Mother Goose there. Charles Perrault, the seventeenth-century French writer who first put fairytales into print, included a frontispiece in his first edition that depicted three people gathered in front of an elderly woman seated

39

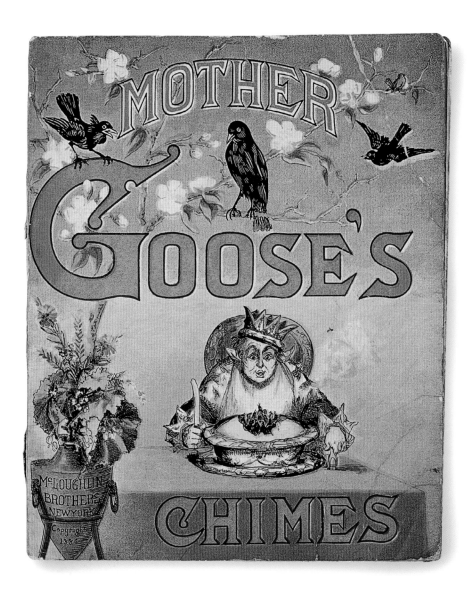

LEFT

MOTHER GOOSE'S CHIMES

Published by McLoughlin Brothers,
New York
Copyright 1886

PAGE 38

MOTHER GOOSE MELODIES

Published by McLoughlin Brothers,
New York
Copyright 1894

before a fire, apparently listening to her weave a story. The illustration was inscribed "La mère oye," which, when translated for a 1729 English edition became "Mother Goose's Tales." Early books with nursery rhymes by John Newbery also carried the name of Mother Goose. In 1780, the son-in-law and successor of this pioneering children's literature publisher sought copyright protection for *Mother Goose's Melody; or Sonnets for the Cradle*, based on a 1760s Newbery book.

But it was in the United States during the nineteenth century that the name and likeness of Mother Goose became synonymous with early childhood. Her nursery rhymes have remained steadily in print and a perennial favorite with children from their first American publication in 1786. Various publishers offered editions of Mother Goose in the early

It is unclear when American publishers adopted the practice of adding a goose to images of Mother Goose, but it became a steady feature. "Old Mother Goose, When she wanted to wander, Would ride through the air, On a very fine gander," served as the first verse of an early nineteenth-century chapbook about a goose that laid golden eggs. Mother Goose herself has been depicted in a variety of ways: as a warm, grandmotherly figure, as an old crone carrying a broom, and as a hag in a pointed witch's cap.

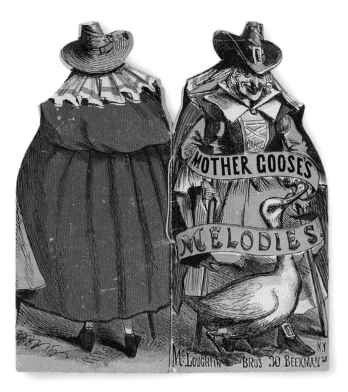

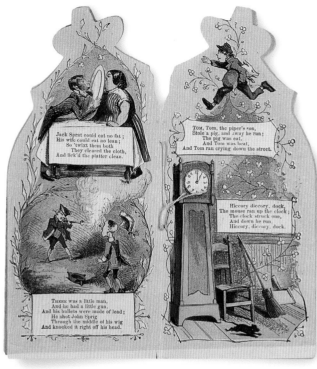

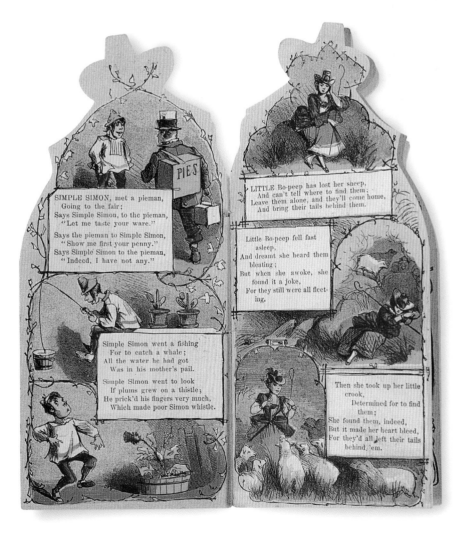

MOTHER GOOSE'S MELODIES

Published by McLoughlin Brothers,
30 Beekman Street, New York
ca. 1860s

Between the shaped covers of this
book are traditional nursery rhymes
associated with Mother Goose, includ-
ing "Jack Sprat," "Little Bo-Peep,"
"Tom the Piper's Son," "Hiccory
Diccory," and "John Sprig," who is
shot through the middle of his wig.
On the cover, a grimace lends a scary
aura to the face of the traditionally
benevolent storyteller.

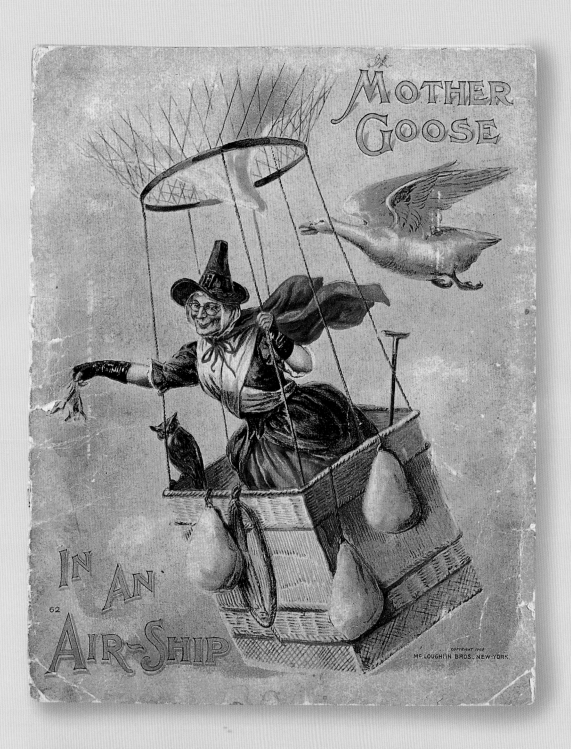

MOTHER GOOSE IN AN AIR-SHIP

Published by McLoughlin Brothers, New York
Copyright 1909

Air travel captivated the imagination of many at the turn of the twentieth century, including Mother Goose. The introduction to this collection of nursery rhymes, copyrighted after the invention of the zeppelin in 1900 and the Wright Brothers' historic flight near Kitty Hawk in 1903, explains the new mode of travel adopted by Mother Goose:

Mother Goose, when of old she would mount to the sky,
Relied on her gander to bear her on high,
But modern inventions are quite to her mind,
And to sailing in air-craft she's greatly inclined;
A balloon or an aeroplane now serves her need,
And she travels through cloudland at wonderful speed.

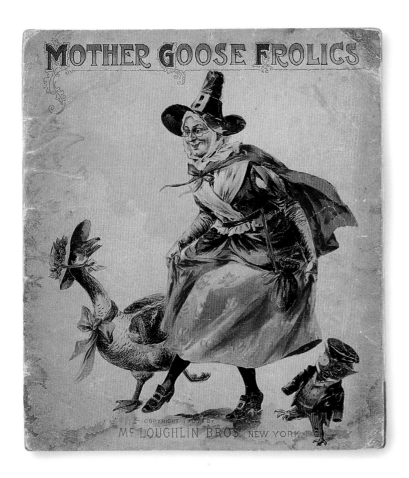

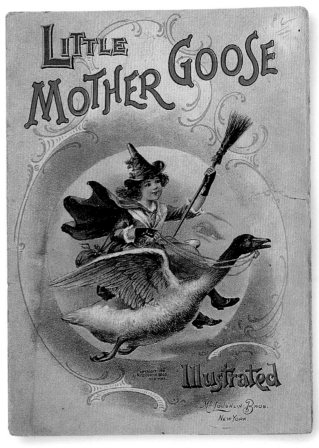

MOTHER GOOSE FROLICS

Published by McLoughlin Brothers,
New York
Copyright 1907

Mother Goose smiles and kicks up
her heels, dancing with her signature
feathered companion, as she gaily
invites young readers to open the
cover of this collection of rhymes.

**LITTLE MOTHER GOOSE
ILLUSTRATED**

Published by McLoughlin Brothers,
New York
Copyright 1901

part of the nineteenth century, but illustrated children's book publishing
powerhouse McLoughlin Brothers dominated the genre in the decades
after mid-century, shaping the figure's image and iconography. Although
the verses may be appreciated entirely through sound, when accompa-
nied by brightly colored, humorous illustrations, they gain a new sensory
dimension.

Just as some scholars have pursued the literary identity of Mother
Goose, others have analyzed her lyrics in search of historical signifi-
cance. The nonsense verses of "Ring around the Rosie," for example, have
been associated with the plague. Particularly in Britain, theories abound
about the royal identity of nursery rhyme characters: Mary Queen of
Scots has been "unmasked" as Little Bo-Peep, and Queen Elizabeth I
identified as the fine lady who rode a white horse to Banbury cross. More
rigorous scholarship has disputed most of those speculations, yet popular
interest persists. Of course, much of this effort is lost on children, who
seem content to accept the rhymes at face-value, reveling in the pure joy
of sound and imagery they present.

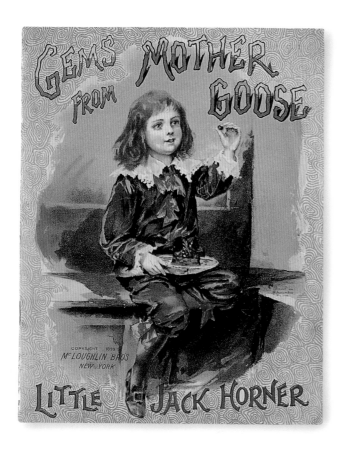

THIS PAGE

GEMS FROM MOTHER GOOSE

Published by McLoughlin Brothers, New York

Copyright 1899

With his hair in long golden curls, Little Jack Horner wears a lace-collared velvet suit of the kind worn by Little Lord Fauntleroy, the title character of Frances Hodgson Burnett's enormously popular 1886 book. Although written for children, the greatest fans of Burnett's book were mothers, who dressed their sons in similar finery.

OPPOSITE AND OVERLEAF

NURSERY RHYMES

Grandmother Goose's Series

Published by McLoughlin Brothers, New York

ca. 1870s–80s

Nursery rhymes were also known in the United States during the nineteenth century as "nursery jingles" and "nursery songs," phrases commonly used in Britain until very recently.

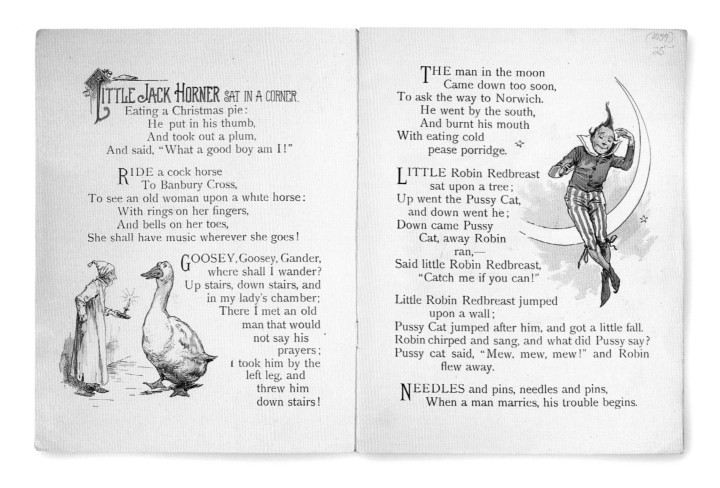

LITTLE JACK HORNER SAT IN A CORNER.
Eating a Christmas pie:
He put in his thumb,
And took out a plum,
And said, "What a good boy am I!"

RIDE a cock horse
To Banbury Cross,
To see an old woman upon a white horse:
With rings on her fingers,
And bells on her toes,
She shall have music wherever she goes!

GOOSEY, Goosey, Gander,
where shall I wander?
Up stairs, down stairs, and
in my lady's chamber;
There I met an old
man that would
not say his
prayers;
I took him by the
left leg, and
threw him
down stairs!

THE man in the moon
Came down too soon,
To ask the way to Norwich.
He went by the south,
And burnt his mouth
With eating cold
pease porridge.

LITTLE Robin Redbreast
sat upon a tree;
Up went the Pussy Cat,
and down went he;
Down came Pussy
Cat, away Robin
ran,—
Said little Robin Redbreast,
"Catch me if you can!"

Little Robin Redbreast jumped
upon a wall;
Pussy Cat jumped after him, and got a little fall.
Robin chirped and sang, and what did Pussy say?
Pussy cat said, "Mew. mew, mew!" and Robin
flew away.

NEEDLES and pins, needles and pins,
When a man marries, his trouble begins.

NURSERY JINGLES.

PUSSY Cat, Pussy Cat, where have you been?
I've been to London, to see the Queen.
Pussy Cat, Pussy Cat, what did you there?
I frightened a little mouse under a chair.

RIDE-A-COCK-HORSE to Banbury Cross,
To see an old Lady upon a white horse:
Rings on her fingers, and bells on her toes,
And so she makes music wherever she goes.

MARY, Mary, quite contrary,
How does your garden grow?
Silver bells and cockle-shells,
And pretty maids all of a row.

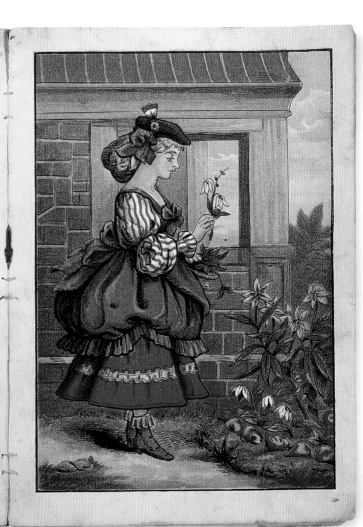

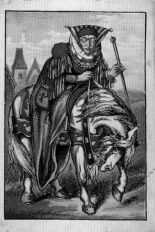

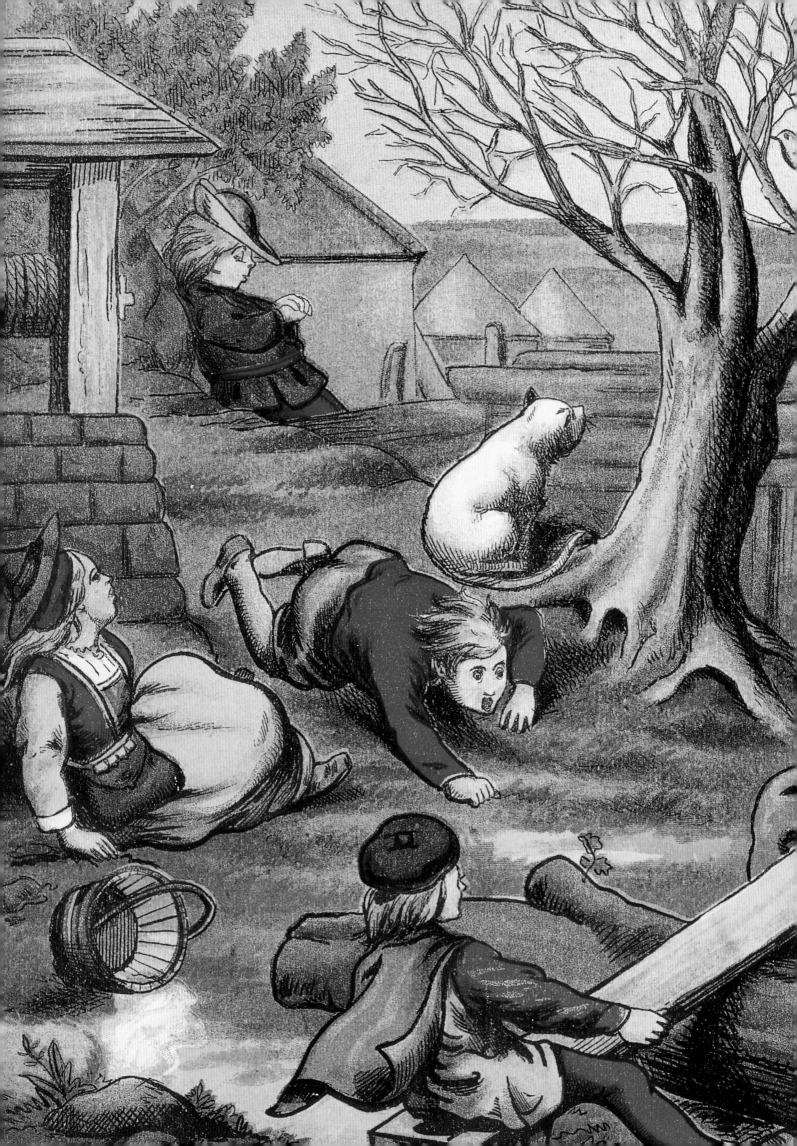

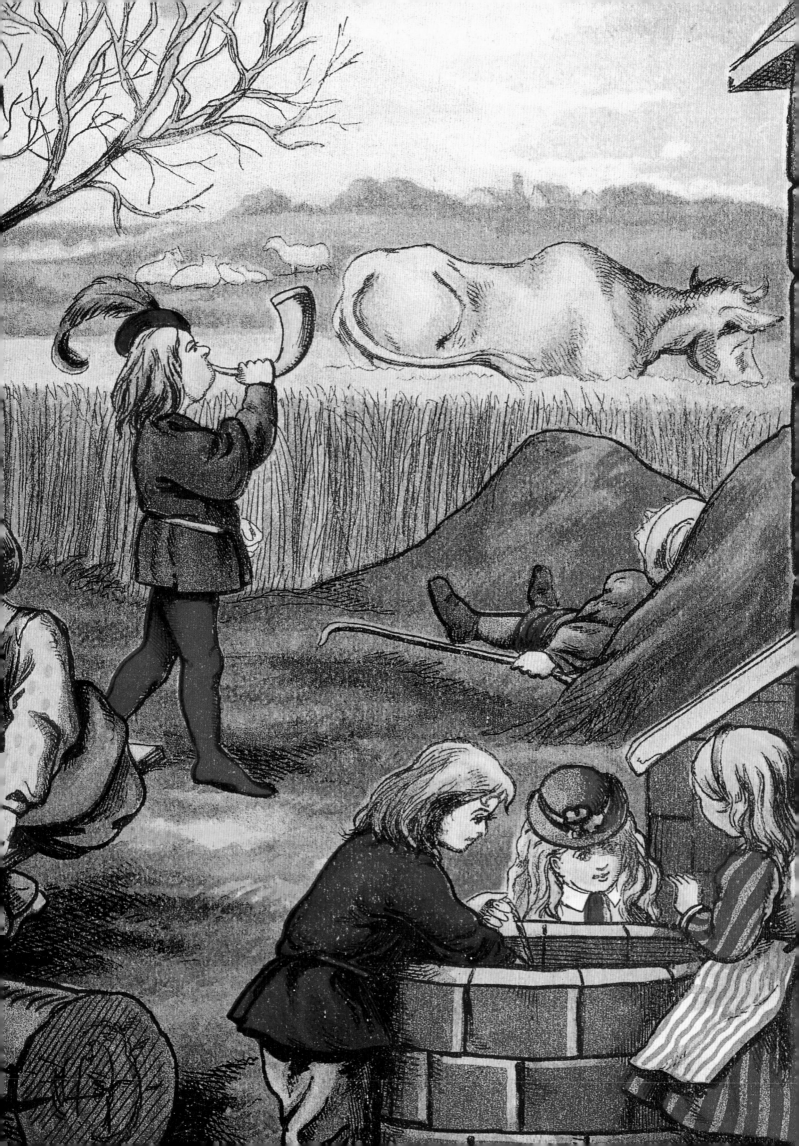

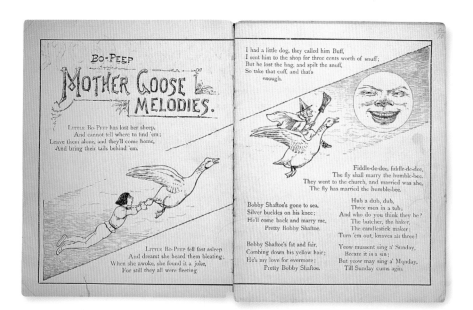

LEFT, TOP AND BOTTOM
BO-PEEP MOTHER GOOSE MELODIES
Published by McLoughlin Brothers, New York
Copyright 1887

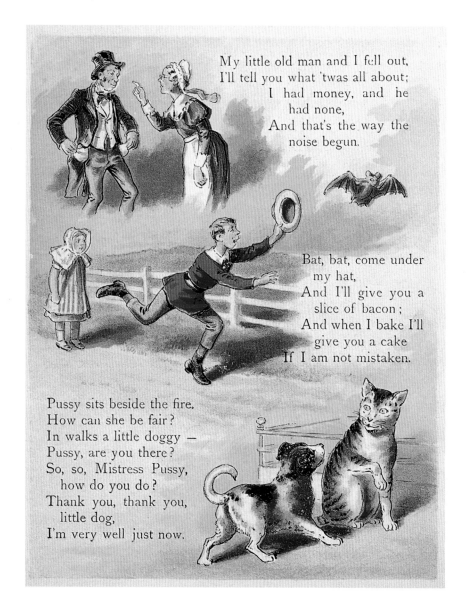

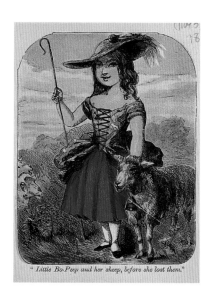

"*Little Bo-Peep and her sheep, before she lost them.*"

LITTLE BO-PEEP
Published by McLoughlin Brothers, 24 Beekman Street, New York
ca. 1850s–60s

Although many versions of *Little Bo-Peep* end with the sheep coming home, wagging their tails behind them, this book features additional verses little known today. Little Bo-Peep eventually finds her sheep, and their tails, and tries her best to re-attach them to the little lambs' bodies.

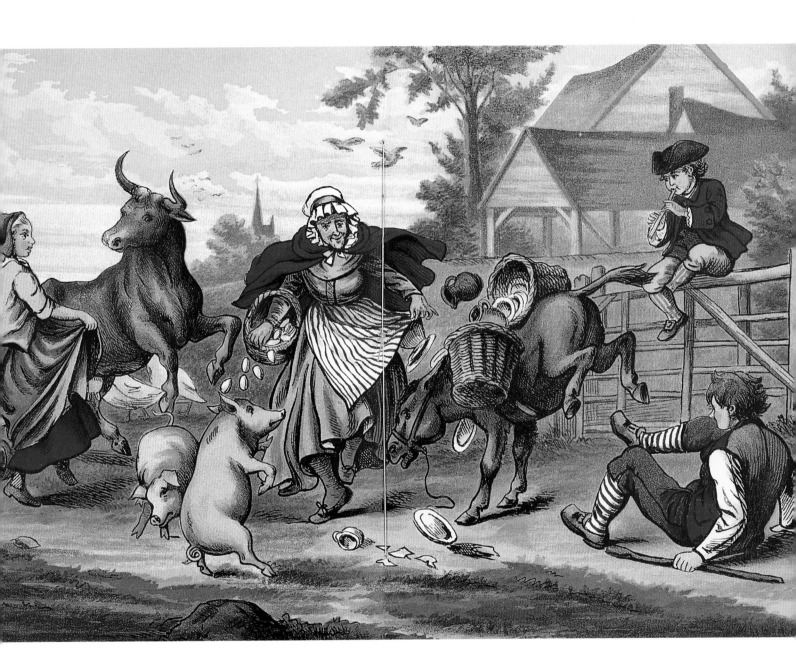

NURSERY SONGS

Grandmother Goose's Series

Published by McLoughlin Brothers, New York

ca. 1870s–80s

The lively and enchanting double-page illustration at the center of this book depicts Tom, Dolly, and Old Dame Trot—all characters in "Tom, the Piper's Son"—merrily dancing in a fantastic conflation of all six stanzas of the rhyme. The only tune that Tom could play was "Over the hills and far away"; he played so well that he entranced even pigs to prance on their hind legs.

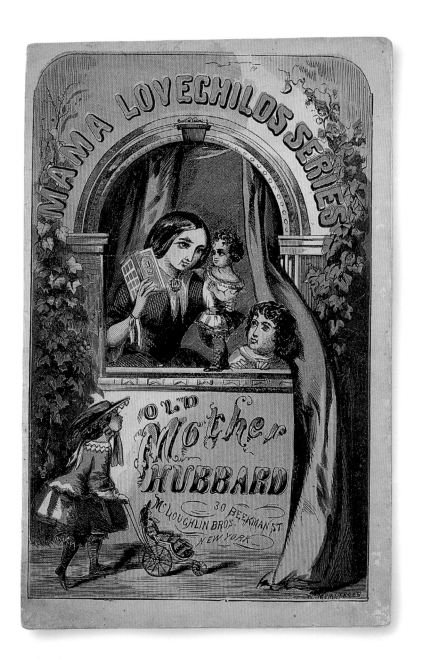

ABOVE

OLD MOTHER HUBBARD

Illustrated by William Momberger

Mama Lovechild's Series

Published by McLoughlin Brothers, 30 Beekman Street, New York

ca. 1860s

The initial publication of *The Comic Adventures of Old Mother Hubbard and Her Dog* became an overnight bestseller when first published in 1805, contrasting sharply with the moral tales dominating the children's market. "Mama Lovechild" is a permutation on "Nurse Lovechild," one of the many fictional storytellers to whom publishers in Britain and the United States attributed collections of verse.

OPPOSITE

OLD MOTHER HUBBARD AND HER DOG

Santa Claus Series

Published by McLoughlin Brothers, New York

Copyright 1889

Persons interested in finding historical references in nursery rhymes have linked the dog's antics in this verse to King Henry VIII's machinations to obtain a divorce (the bone) from the church (Old Mother Hubbard). Even if accurate, such arcane allusions would have been lost on nineteenth-century American children, who would have been drawn instead to the auditory pleasure of the rhyme and the visual delight of the old woman's dog who, dressed in finery, feeds a cat and plays a flute.

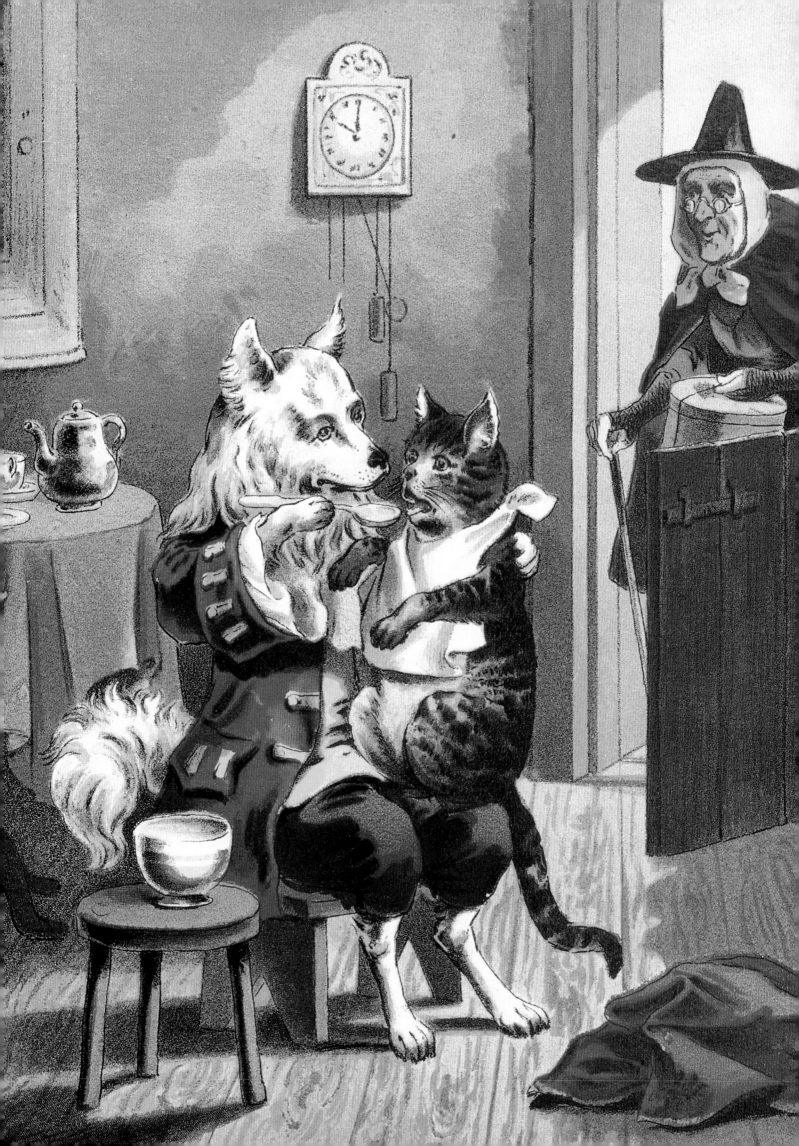

**ANCIENT ILLUMINATED
RHYMES: OLD MOTHER
HUBBARD AND HER DOG**
*Published by McLoughlin Brothers,
New York*
ca. 1880s–90s

The back cover of this vibrant book
yields a clue to its odd title. There it is
described as, "gorgeously illuminated
after the Mediaeval manner, in Colors
and Gold." The intense coloration
and metallic gold highlights are
marvelously suited to the images of
stained glass on Mother Hubbard's
cottage windows, an unlikely yet
striking decorative setting for her
bare cupboard.

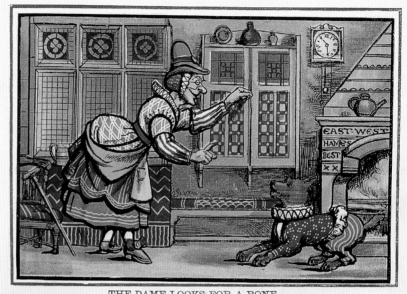

THE DAME LOOKS FOR A BONE.

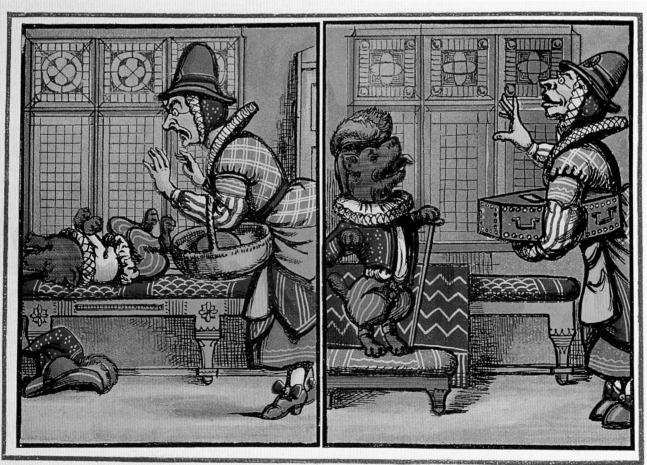

DOGGIE IS DEAD.　　　　THE DAME BRINGS HIS COFFIN.

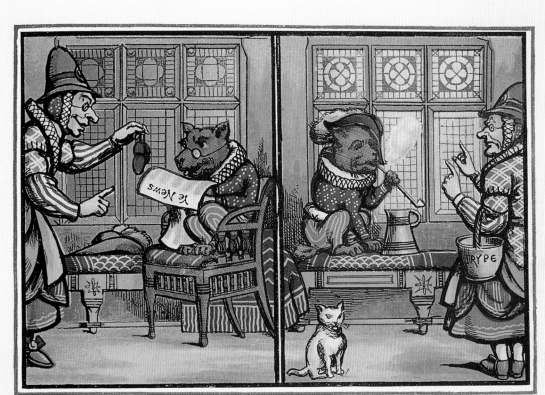

DOGGIE READING THE NEWS. DOGGIE SMOKING A PIPE.

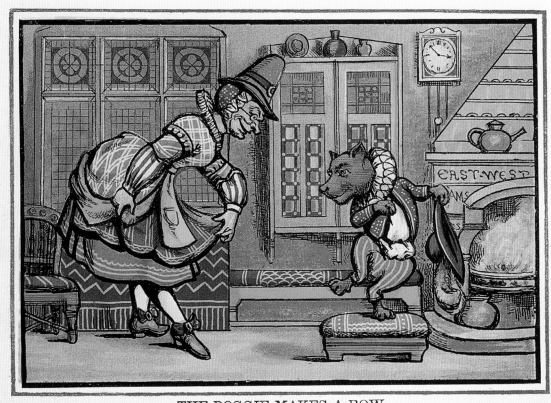

THE DOGGIE MAKES A BOW.

LITTLE DAME CRUMP
AND THE WHITE PIG
(THE HISTORY OF LITTLE
DAME CRUMP AND HER
LITTLE WHITE PIG)
Published by McLoughlin Brothers,
30 Beekman Street, New York
ca. 1860s

Finding a silver coin while sweeping
the floor, Dame Crump walks to market
and buys a pig. Her amusing struggles
to get her stubborn purchase home
comprise the story, told here in verse.

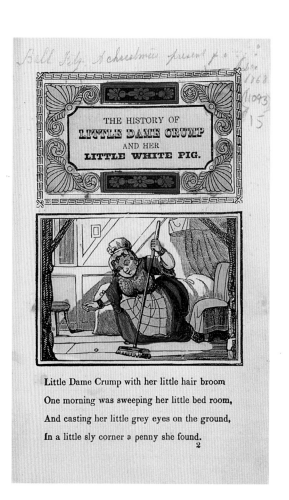

Little Dame Crump with her little hair broom
One morning was sweeping her little bed room,
And casting her little grey eyes on the ground,
In a little sly corner a penny she found.
2

Now she went to the Mill,
 Where she borrowed a sack,
Which she popped the pig in,
 And took on her back ,
Piggy cried to get out,
 But the little Dame said,
If you wont go by fair means,
 You then must be made

She soon to the end
 Of her journey was come,
And was mightly pleased
 When she got piggy home;
So she carried the pig
 To his nice little sty,
And made him a bed
 Of clean straw, snug and dry.
14

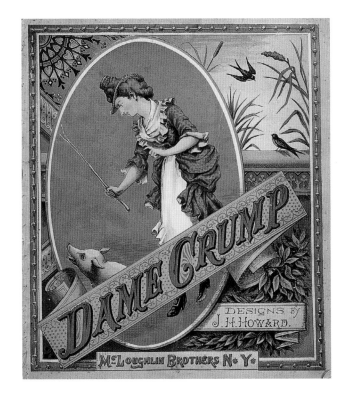

DAME CRUMP

Illustrated by J. H. Howard

Published by McLoughlin Brothers, New York

ca. 1880s–90s

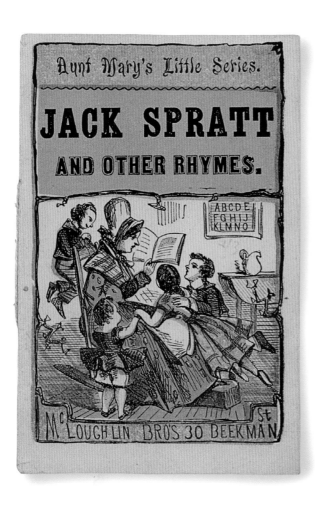

LEFT

JACK SPRATT AND OTHER RHYMES

Aunt Mary's Little Series
Published by McLoughlin Brothers, 30 Beekman Street, New York
ca. 1860s

Surrounded by children, Aunt Mary sits in a rocking chair and reads aloud in this adaptation of the earliest known depictions of Mother Goose. McLoughlin Brothers used this illustration in other books it published in the same period.

BELOW

STORY OF SIMPLE SIMON

Susie Sunshine's Series
Published by McLoughlin Brothers, 30 Beekman Street, New York
ca. 1860s

The escapades of the "simple" boy, whose lack of common sense leads to mayhem, date to the seventeenth century. This story concludes when, "He went for water in a sieve, But soon it all run through, And now poor Simple Simon Bids you all adieu."

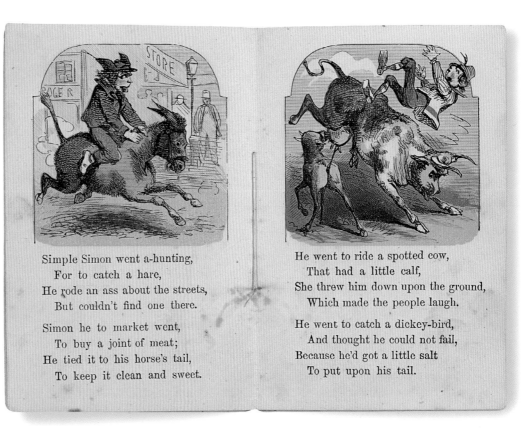

Simple Simon went a-hunting,
 For to catch a hare,
He rode an ass about the streets,
 But couldn't find one there.

Simon he to market went,
 To buy a joint of meat;
He tied it to his horse's tail,
 To keep it clean and sweet.

He went to ride a spotted cow,
 That had a little calf,
She threw him down upon the ground,
 Which made the people laugh.

He went to catch a dickey-bird,
 And thought he could not fail,
Because he'd got a little salt
 To put upon his tail.

MOTHER GOOSE'S MAGIC TRANSFORMATIONS

Published by McLoughlin Brothers, New York

ca. 1870s

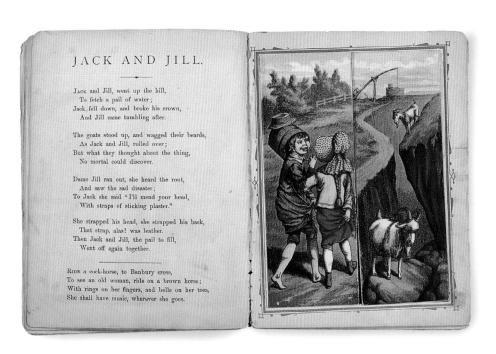

JACK AND JILL.

Jack and Jill, went up the hill,
To fetch a pail of water;
Jack fell down, and broke his crown,
And Jill came tumbling after.

The goats stood up, and wagged their beards,
As Jack and Jill, rolled over;
But what they thought about the thing,
No mortal could discover.

Dame Jill ran out, she heard the rout,
And saw the sad disaster;
To Jack she said "I'll mend your head,
With straps of sticking plaster."

She strapped his head, she strapped his back,
That strap, alas! was leather.
Then Jack and Jill, the pail to fill,
Went off again together.

Ride a cock-horse, to Banbury cross,
To see an old woman, ride on a brown horse;
With rings on her fingers, and bells on her toes,
She shall have music, wherever she goes.

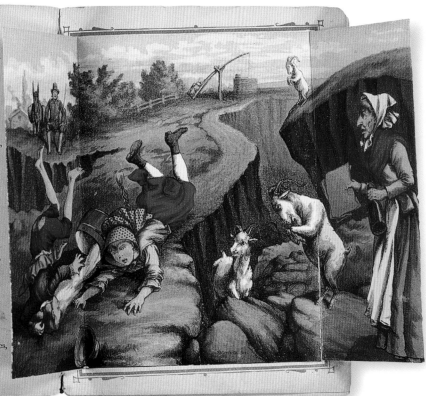

JACK AND JILL.

Jack and Jill, went up the hill,
To fetch a pail of water;
Jack fell down, and broke his crown,
And Jill came tumbling after.

The goats stood up, and wagged their beards,
As Jack and Jill, rolled over;
But what they thought about the thing,
No mortal could discover.

Dame Jill ran out, she heard the rout,
And saw the sad disaster;
To Jack she said "I'll mend your head,
With straps of sticking plaster."

She strapped his head, she strapped his back,
That strap, alas! was leather.
Then Jack and Jill, the pail to fill,
Went off again together.

Ride a cock-horse, to Banbury cross,
To see an old woman, ride on a brown horse;
With rings on her fingers, and bells on her toes,
She shall have music, wherever she goes.

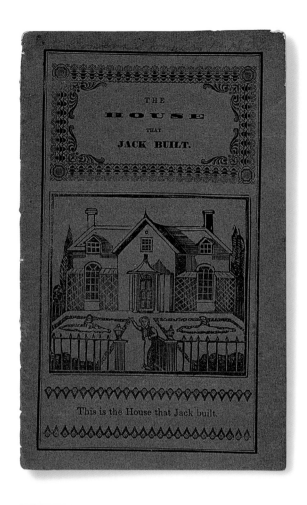

LEFT AND BELOW

THE HOUSE THAT JACK BUILT

[no publisher given]

ca. 1860s

OPPOSITE

THIS IS THE HOUSE THAT JACK BUILT

Cinderella Series

Published by McLoughlin Brothers, New York

Copyright 1890

An anonymous writer exploring the origins of *The House that Jack Built* on the pages of *The New York Times* on February 9, 1901 observed, "As the occupations and pleasures of childhood produce a powerful impression on the memory, it is probable that almost every reader who has passed his infantile days in an English nursery recollects the delight with which he repeated that puerile jingling legend, *The House that Jack Built*."

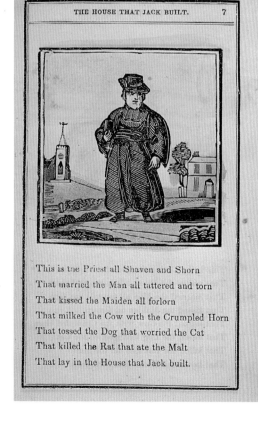

THE HOUSE THAT JACK BUILT. 7

This is the Priest all Shaven and Shorn
That married the Man all tattered and torn
That kissed the Maiden all forlorn
That milked the Cow with the Crumpled Horn
That tossed the Dog that worried the Cat
That killed the Rat that ate the Malt
That lay in the House that Jack built.

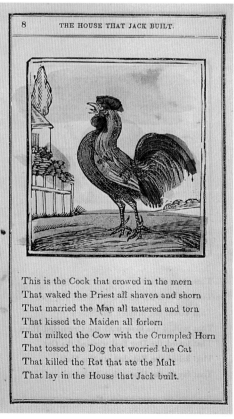

8 THE HOUSE THAT JACK BUILT.

This is the Cock that crowed in the morn
That waked the Priest all shaven and shorn
That married the Man all tattered and torn
That kissed the Maiden all forlorn
That milked the Cow with the Crumpled Horn
That tossed the Dog that worried the Cat
That killed the Rat that ate the Malt
That lay in the House that Jack built.

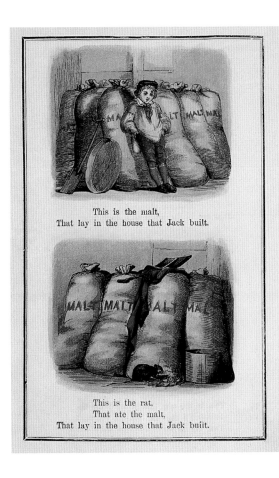

This is the malt,
That lay in the house that Jack built.

This is the rat,
That ate the malt,
That lay in the house that Jack built.

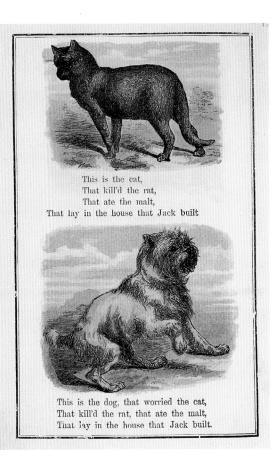

This is the cat,
That kill'd the rat,
That ate the malt,
That lay in the house that Jack built

This is the dog, that worried the cat,
That kill'd the rat, that ate the malt,
That lay in the house that Jack built.

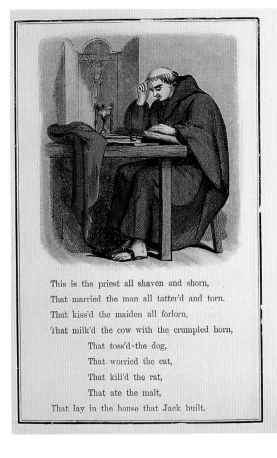

This is the priest all shaven and shorn,
That married the man all tatter'd and torn.
That kiss'd the maiden all forlorn,
That milk'd the cow with the crumpled horn,
 That toss'd the dog,
 That worried the cat,
 That kill'd the rat,
 That ate the malt,
That lay in the house that Jack built.

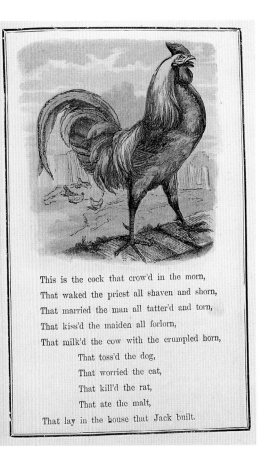

This is the cock that crow'd in the morn,
That waked the priest all shaven and shorn,
That married the man all tatter'd and torn,
That kiss'd the maiden all forlorn,
That milk'd the cow with the crumpled horn,
 That toss'd the dog,
 That worried the cat,
 That kill'd the rat,
 That ate the malt,
That lay in the house that Jack built.

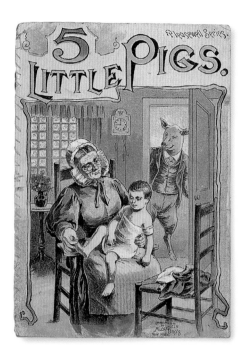

FIVE LITTLE PIGS

Pleasewell Series

Published by McLoughlin Brothers, New York

Copyright 1890

In this narrative version of the traditional "tickle game" played on the fingers and toes of toddlers, the richly colored illustrations provide visual clues to the action. The well-dressed and well-mannered pigs belie the disdain in which the animals were held in the early part of the century, when pigs were a common sight on city streets, creating a public nuisance while they rooted for food.

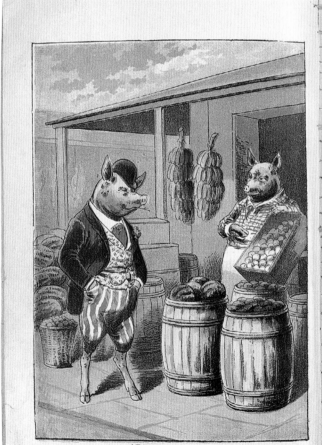

AT THE MARKET.

THE HOME PIG.

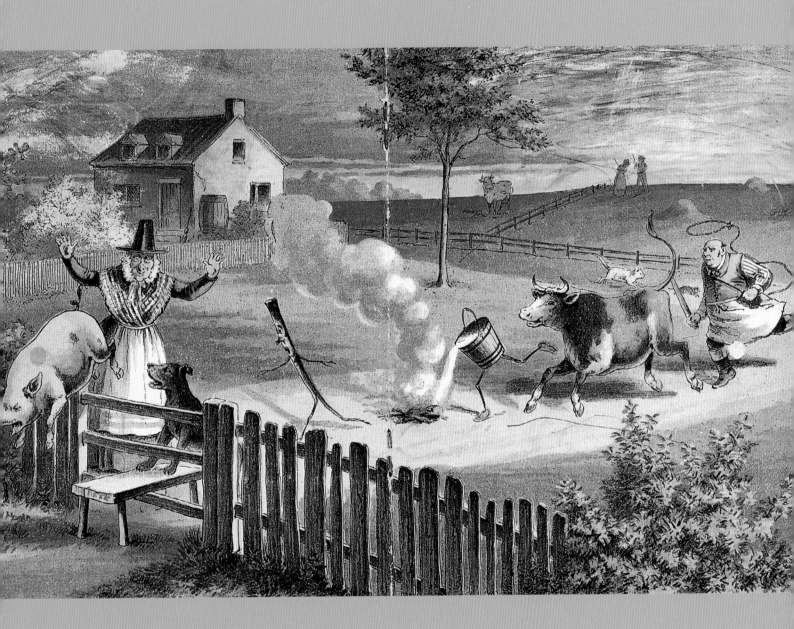

THE OLD WOMAN AND HER PIG

Pleasewell Series
Published by McLoughlin Brothers, New York
Copyright 1890

An accumulative poem, like *The House that Jack Built*, each verse
in this tale is built upon the one that precedes it and all are
repeated. The story begins when the pig refuses to jump over the
fence and the old woman is forced to call upon an array of crea-
tures and objects (all illustrated here) to encourage him home.

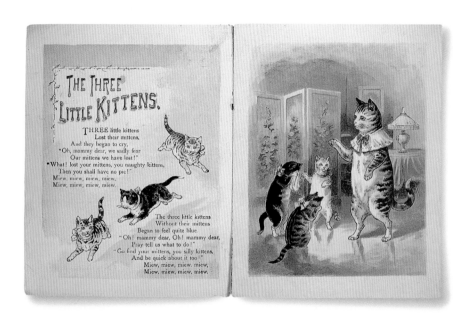

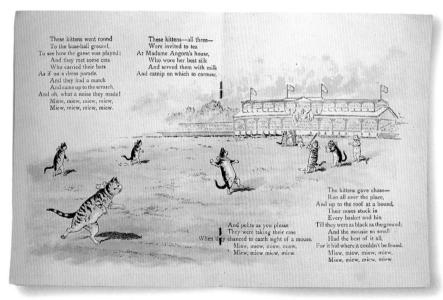

**THE STORY OF THE
THREE LITTLE KITTENS**
Little Kitten Series
Published by McLoughlin Brothers,
New York
Copyright 1892

The nursery rhyme about three little
kittens who lost their mittens was
probably first published under the
authorship of Eliza Follen in the 1840s
and became popular in the ensuing
decades. This extended version of the
familiar tale follows the frolicking
felines throughout their lives, as they
dance, marry, and raise their own little
kittens. Grounding the saga in a world
familiar to children at century's end,
the poem nods to the growing
popularity of the new American sport
of baseball: "These kittens went round
to the base-ball ground, to see how the
game was played."

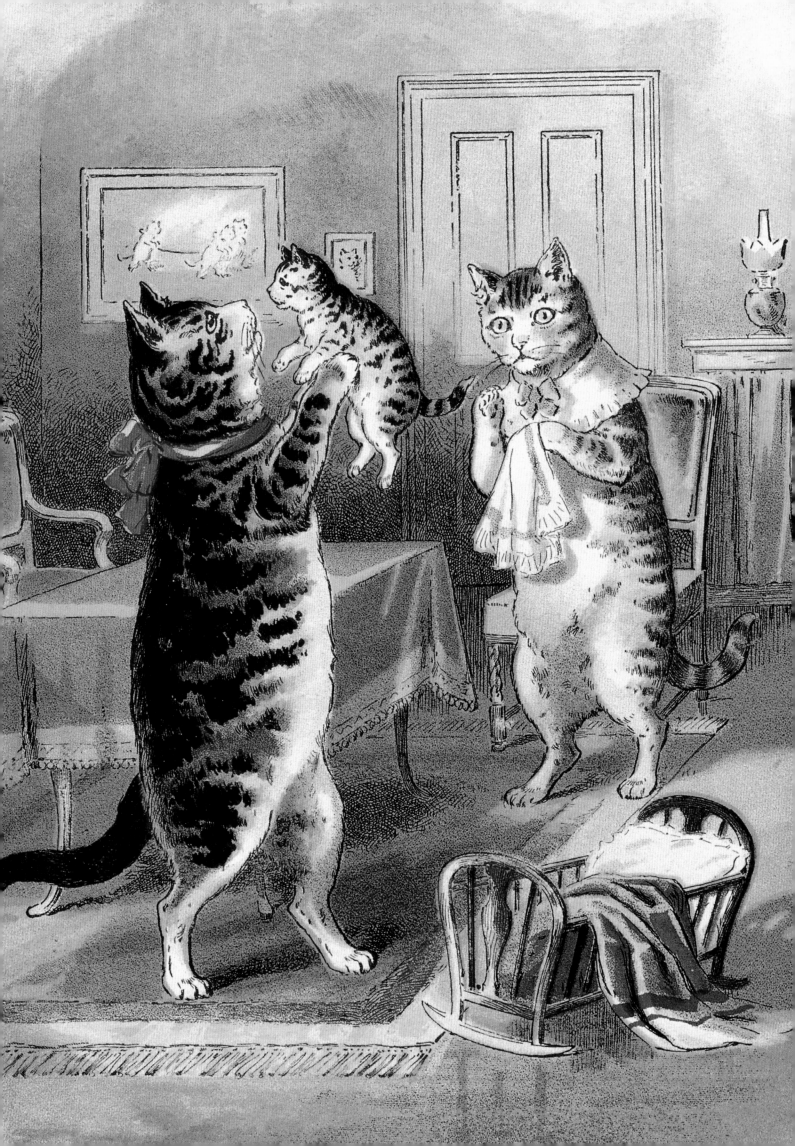

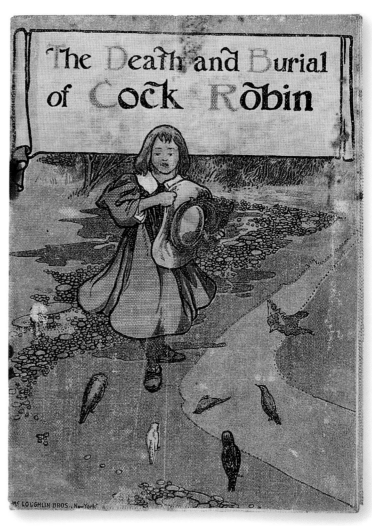

SAD FATE OF POOR ROBIN

Illustrated by Edward P. Cogger

Aunt Mary's Series

Published by McLoughlin Brothers, 24 Beekman Street, New York

ca. 1850s–60s

THE DEATH AND BURIAL OF COCK ROBIN

Published by McLoughlin Brothers, New York

ca. 1900s

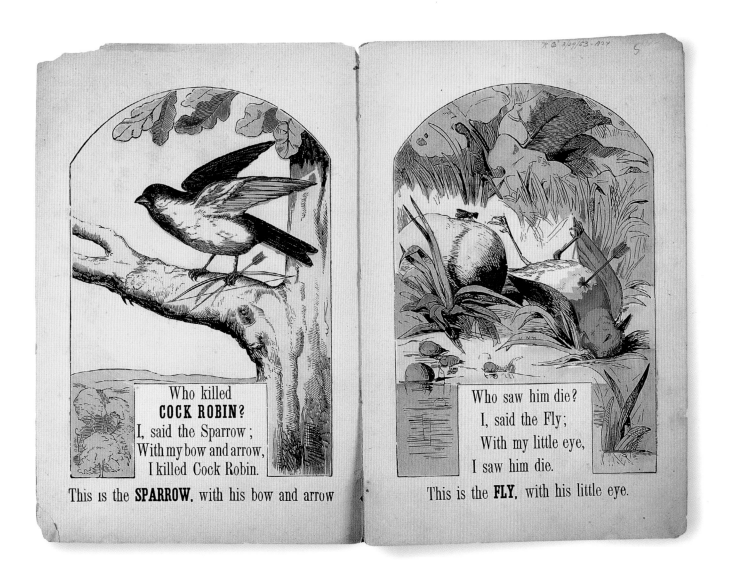

Who killed
COCK ROBIN?
I, said the Sparrow;
With my bow and arrow,
I killed Cock Robin.

This is the **SPARROW**, with his bow and arrow

Who saw him die?
I, said the Fly;
With my little eye,
I saw him die.

This is the **FLY**, with his little eye.

THE DEATH AND BURIAL OF POOR COCK ROBIN

Illustrated by William Momberger

Mama Lovechild's Series

Published by McLoughlin Brothers, New York

ca. 1860–70s

In an era that witnessed high rates of infant and maternal mortality, American children were not shielded from the reality of death. Death and mourning were inserted into children's poetry and literature throughout the nineteenth century. Published under many variations on the title, *The Death and*

Burial of Poor Cock Robin features birds playing all the parts. Questions, such as "Who killed Cock Robin?" "Who'll dig his grave?" and "Who'll be the parson?" are answered in verse. At the conclusion of the tale, all sob when they hear the bell toll for Cock Robin.

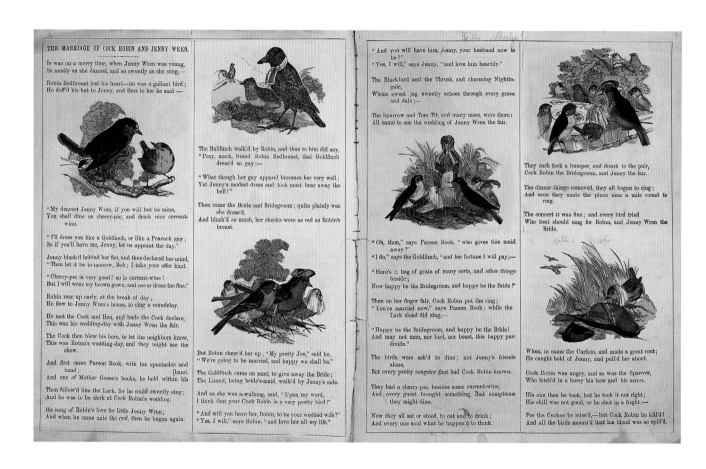

ABOVE

FUNNY RHYMES FOR LITTLE PEOPLE

Aunt Kitty's Nursery Series

Illustrated by Howard Del

Published by McLoughlin Brothers, 30 Beekman Street, New York

ca. 1860s

American publishers offered "prequels" to *The Death and Burial of Poor Cock Robin*, in much the same way that they created new stories featuring favorite characters to satisfy readers' cravings for new books. Among the most popular was a tale about the courtship and marriage of Cock Robin and Jenny Wren.

OPPOSITE

COCK ROBIN

Published by McLoughlin Brothers, New York

ca. 1890s

I, said the KITE.

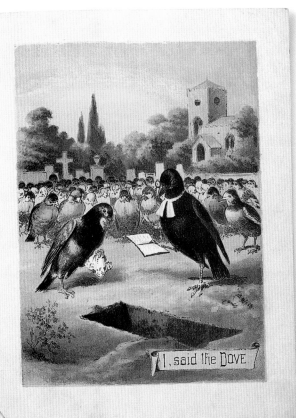

I, said the DOVE

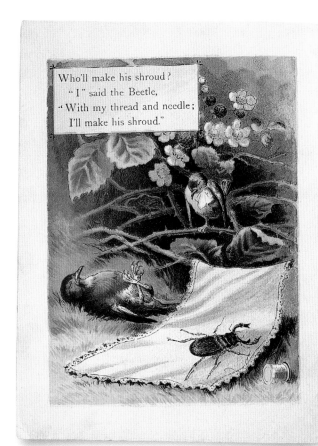

Who'll make his shroud?
 "I" said the Beetle,
"With my thread and needle;
 I'll make his shroud."

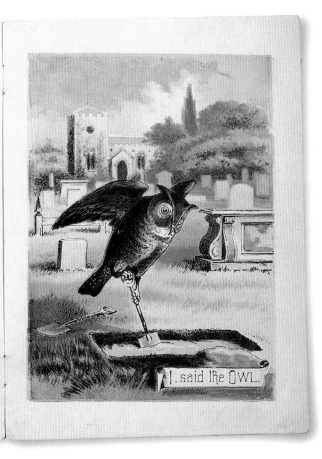

I, said the OWL.

ONCE UPON A TIME
FAIRYTALES AND FABLES

In many different languages, storytellers around the world have uttered the words "once upon a time," transporting listeners of all ages to magical lands, home to giants, witches, talking animals, and enchanted objects. The fairytales read by nineteenth-century American children are those we know today and are indebted to efforts to amuse the French aristocracy. In 1697, Charles Perrault (1628-1703) published *Histoires ou Contes du temps passé. Avec des Moralités*, a collection of eight captivating tales: *Sleeping Beauty*, *Little Red Riding Hood*, *Blue Beard*, *Puss in Boots*, *Diamonds and Toads*, *Cinderella*, and *Hop o' My Thumb*, along with one other that has not survived the test of time. Gaining immediate popularity among children and adults, the stories were translated into English in 1729 and soon were known in America.

The popularity of fairytales, as well as a battle over their fitness for juvenile consumption, waxed and waned throughout the eighteenth century. Interest was rekindled in the nineteenth century, through the efforts of Jacob Grimm (1785-1863) and Wilhelm Grimm (1786-1859). The brothers recorded folk tales told by ordinary people in their native Germany and published their work in 1812 as *Kinder-und Hausmärchen*. Translated into English in 1823, the Grimms's fairytales eventually numbered approximately two hundred, including many of those recorded earlier by Perrault, along with *Snow White*, *Hansel and Gretel*, and other now-classics. Culling from these sources, and from Danish storyteller Hans Christian Anderson (1805-1875), American publishers printed copious fairytales in the nineteenth century, occasionally taking

liberties with their plots and adding new twists that reflected the American social landscape.

Sir Walter Scott (1771–1832) was a strong advocate of fairytales and their ability to stir childhood imagination, boldly stating his preference for the genre over the moralizing "good-boy stories" that dominated the American juvenile fiction of his time. In 1898, *The New York Times* reprinted his impassioned championing of fairytales: "Truth is I would not give one tear shed over *Little Red Riding Hood* for all the benefit to be derived from a hundred histories of Tommy Goodchild."

Not everyone embraced the genre, however. Some American authorities objected to their purely imaginary content as foolish and immoral. In the September 1850 issue of *Woodworth's Youth Cabinet*, publisher Francis C. Woodworth railed against the tales told in *The Arabian Nights* as being "too strange and marvelous" and lacking in good moral influence although he admitted reading them with pleasure in his younger days. A more pragmatic view was recommended by Lydia Maria Child, in her widely read book of childrearing advice *The Mother's Book*: "A strong reason why we should indulge children in reading some of the best fairy-stories and fables . . . is, that we cannot possibly help their getting hold of some books of this description; and it is never wise to forbid what we cannot prevent."

Fables, like fairytales, are ancient stories. Narrated by talking animals, they emphasize common sense, rather than magic. Most are attributed to Aesop, who is thought by some to have been a seventh-century storyteller. *Aesop's Fables* were among the first books printed following the invention of the printing press, an English-language edition illustrated with woodcuts appearing in 1484. Like fairytales, fables made their way to America with the country's first settlers, and have been educating and entertaining children ever since.

PAGE 68
LITTLE RED RIDING HOOD
Aunt Friendly's Colored Picture Books
Published by McLoughlin Brothers, New York
ca. 1880s

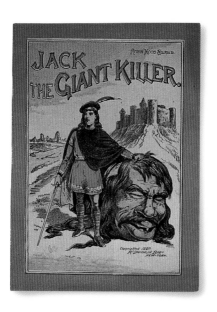

ABOVE
JACK THE GIANT KILLER
Robin Hood Series
Published by McLoughlin Brothers,
New York
ca. 1870s–80s

Jack the Giant Killer opens "in the days when King Arthur ruled in Britain," when "there were many giants in the land—huge, fierce monsters, who kept folks in constant terror." Like the superheroes of today, the ten-year-old Jack uses his wits, along with a sharp sword, a magical coat of darkness, and "shoes of swiftness," to rid the land of giants.

OPPOSITE
JACK AND THE BEANSTALK
May Bells Series
Published by McLoughlin Brothers,
New York
ca. 1870s

In this age-old tale, a boy who makes a seemingly foolish bargain by trading a cow—his poor mother's last asset—for magical beans is ultimately revealed as a brave young man who recovers his family's fortune and stature from the giant who lives at the top of the beanstalk.

JACK AND THE BEANSTALK

McLOUGHLIN BRO'S
NEW-YORK

MAY BELLS SERIES

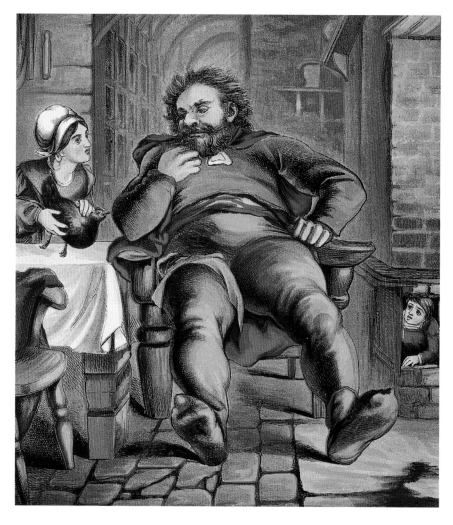

JACK AND THE BEAN-STALK

Aunt Louisa's Big Picture Series
Published by McLoughlin Brothers,
71 and 73 Duane Street, New York
ca. 1870s–80s

Despairing at her son's lack of common
sense, Jack's mother tosses away the
handful of pretty beans he accepted in
trade for her cow and they go to bed
hungry. The next morning, Jack finds
that a wondrous vine, growing into the
clouds, has sprouted from the beans and
sets off for the top. He meets a beautiful
fairy, who explains that he can avenge
his father's death and mother's poverty
by outsmarting the evil giant who
caused their misfortune. Hiding in the
giant's house at the summit of the stalk,
Jack does just that, retrieving a magic
hen, bags of money and an enchanted
harp, and escaping down the beanstalk
just ahead of the giant.

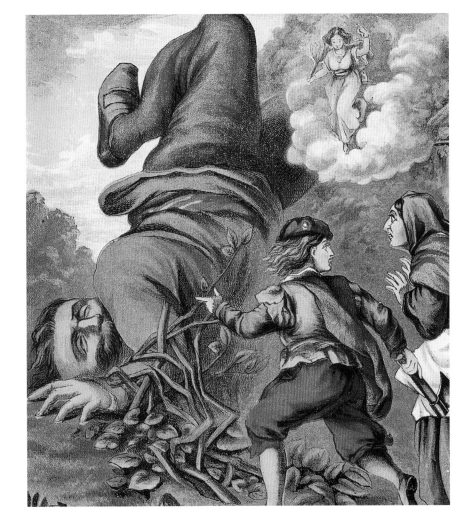

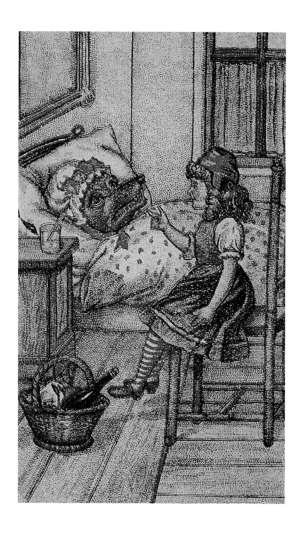

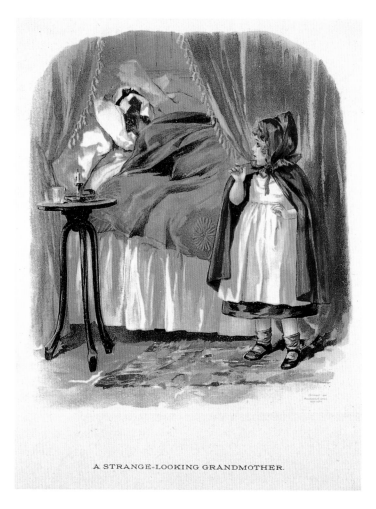

A STRANGE-LOOKING GRANDMOTHER.

ABOVE LEFT

ROTTKÄPPCHEN. LITTLE RED RIDING HOOD

German, for the American market

ca. 1880s

Most versions of *Little Red Riding Hood* feature an ailing grand-
mother, her granddaughter (dressed in a red cape), and a sly
and hungry wolf who tries to pass himself off as granny. The
endings vary, however. In Charles Perrault's late-seventeenth-
century telling, the wolf is the victor, consuming Little Red
Riding Hood and her grandmother, dramatically underscoring
the story's moral that young ladies should not talk to strangers.
This version of the fairytale adopts an ending like that recorded
by the Grimm brothers. At first, the wolf appears to triumph,
eating grandmother and Little Red Riding Hood, and taking a
nap after his big meal. A passing hunter hears his loud snores
and surmises what has taken place. He cuts open the wolf's
belly and frees the old woman and child. In their place, he sub-
stitutes heavy stones. Waking up thirsty, the wolf goes to the
well, where he promptly falls in and drowns.

ABOVE RIGHT

LITTLE RED RIDING HOOD

Red Rose Series

Published by McLoughlin Brothers, New York

Copyright 1889 and 1901

OPPOSITE

LITTLE RED RIDING HOOD

Illustrated by R. André

Little Folks Series

Published by McLoughlin Brothers, New York

Copyright 1888

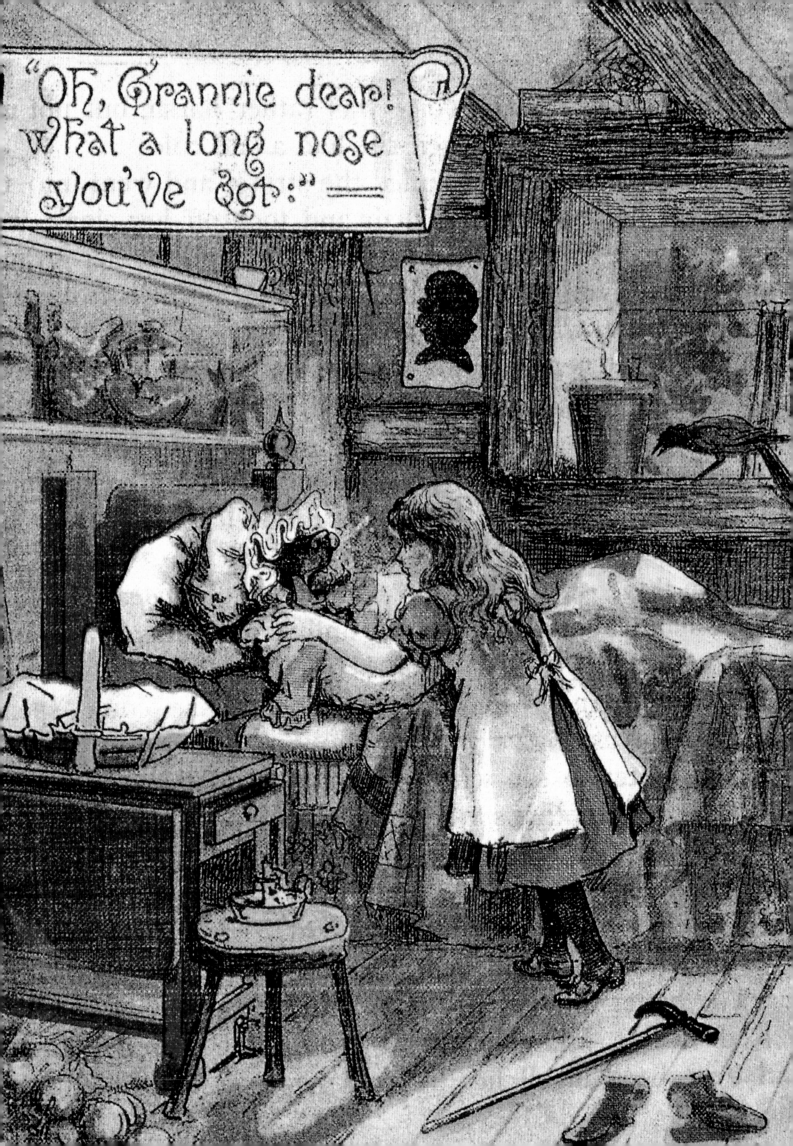

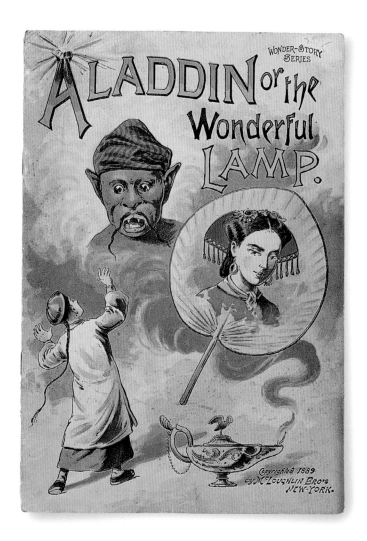

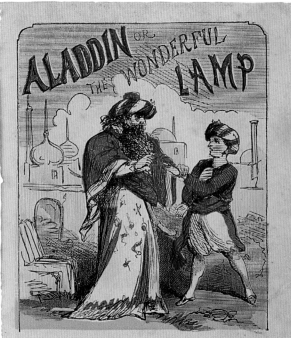

ALADDIN was the son of a poor tailor in an Eastern
city. He was a spoilt boy, and loved play better than
work : so that, when Mustapha, his father, died, he was
not able to earn his living, and his poor mother had to spin
cotton all day long to procure food for their support. But
she dearly loved her son, knowing that he had a good heart,
and she believed that as he grew older he would do better,
and become at last a worthy and prosperous man. One
day, when Aladdin was walking outside the town, an old
man came up to him, and looking very hard in his face,

ABOVE LEFT

ALADDIN OR THE WONDERFUL LAMP

Wonder-Story Series

Published by McLoughlin Brothers, New York

Copyright 1889

The story of Aladdin and his wonderful lamp is one of many
found in *The Arabian Nights*, the legendary epic of a beautiful
young woman who saves her life by telling a murderous sultan
a different story every night for a thousand and one nights.
Originating in Persian, Indian, and Arabic folklore, the tales
have been known in Asia and the Middle East at least since
A.D. 850. The cover image of this edition conflates the origins
of the tale, adding pseudo-Chinese motifs to heighten its exoti-
cism. *Aladdin*, *Sinbad the Sailor*, and *Scheherazade* became best
known of the tales in the western world after all were translated
in the eighteenth century.

ABOVE RIGHT

ALADDIN, OR THE WONDERFUL LAMP

Fairy Moonbeam Series

Published by McLoughlin Brothers, 30 Beekman Street, New York

ca. 1860s

OPPOSITE AND OVERLEAF

ALADDIN PANTOMIME TOY BOOK

Published by McLoughlin Brothers, New York

ca. 1890s

Aladdin is a careless, idle boy—a description that also applies to
Jack the Giant Killer, a hero of western fairytales. Aladdin's tri-
umph over wicked magicians who seek to steal his magic lamp
and jewels parallels Jack's mastery over evil-doing giants.
Reminding readers of their own real-world obligations, both
heroes use their new-found riches to provide for their mothers.

ALADDIN OR THE WONDERFUL LAMP

PANTOMIME TOY BOOKS

McLOUGHLIN BRO'S, N.Y.

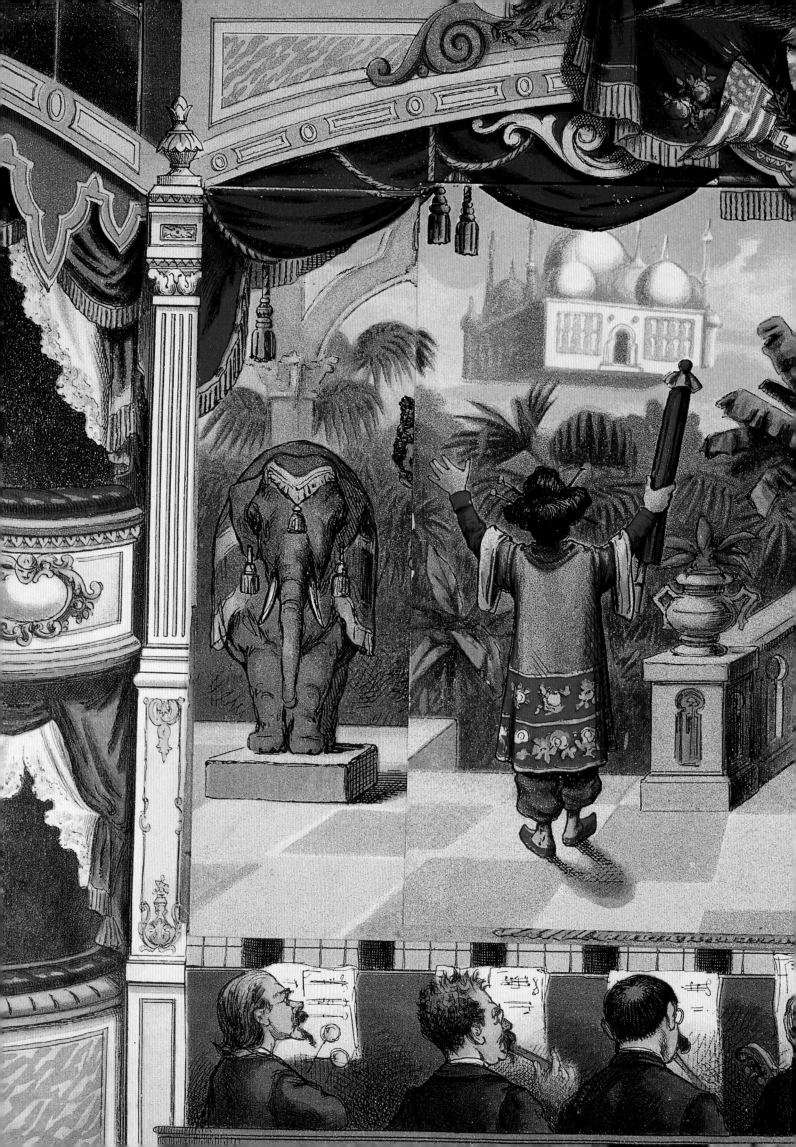

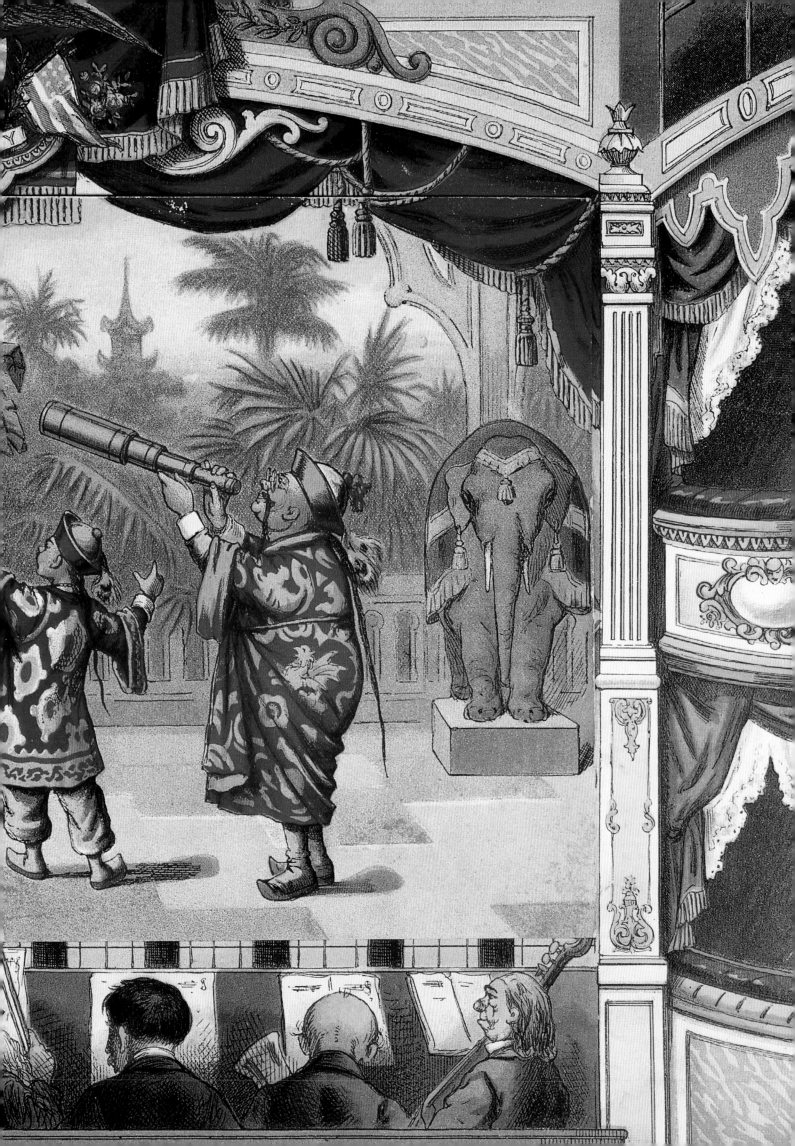

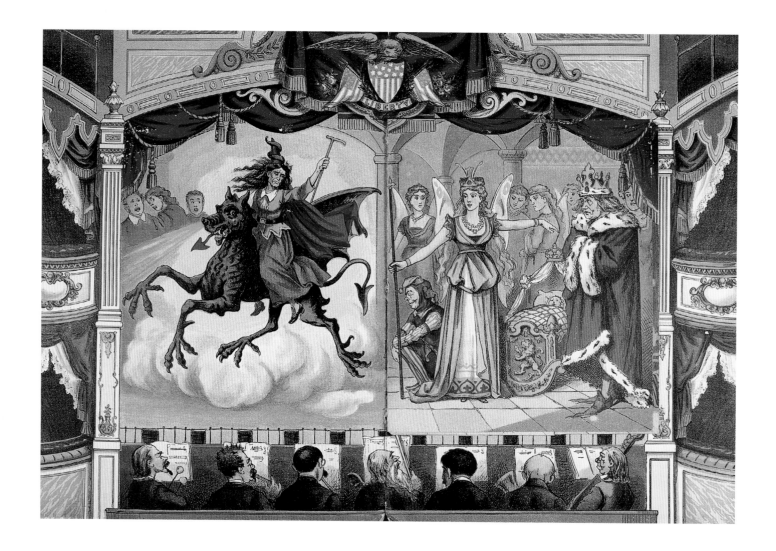

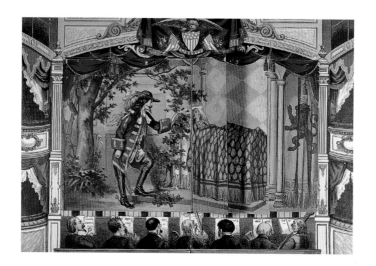

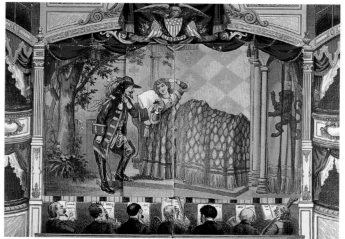

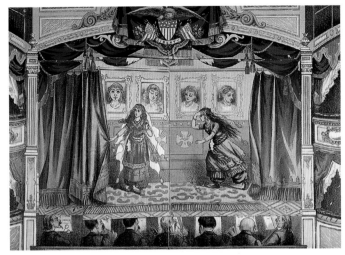

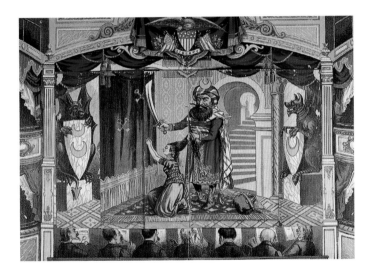

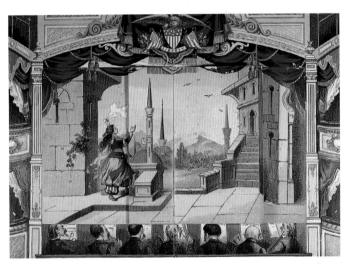

OPPOSITE

SLEEPING BEAUTY PANTOMIME TOY BOOK
Published by McLoughlin Brothers, New York
ca. 1890s

Sleeping Beauty is known in many cultures, with variations on
how the curse that causes the princess to sleep for one hundred
years is inflicted. In this version of the tale, the ugly witch
Cassandra rides to the castle on a horrible beast, bringing the
darling baby Rosebud a thorn, symbolizing the curse that she
will one day prick her finger and die. As always, a good witch
arrives to minimize the harm: when the inevitable accident
occurs, Rosebud falls into a deep slumber. A handsome prince
awakens the sleeping beauty, and they live happily ever after.

ABOVE

BLUE BEARD PANTOMIME TOY BOOK
Published by McLoughlin Brothers, New York
ca. 1890s

In this tale of trust and temptation, Blue Beard hands his new
young wife the keys to his castle, enabling her to unlock treas-
ure boxes and rooms full of luxuries. He warns her, however,
never to open the door to one small chamber. When Blue Beard
leaves the castle in a test of her obedience, his bride cannot
resist the urgings of her friends to unlock the forbidden door.
She yields to temptation and finds the murdered bodies of Blue
Beard's many previous wives. A bloodstain that magically
appears on the key immediately reveals her transgression to
Blue Beard, who has returned "early" from his journey. At the
end of the tale, the disobedient wife is rescued from her murder-
ous husband, escaping the fate of her unlucky predecessors.

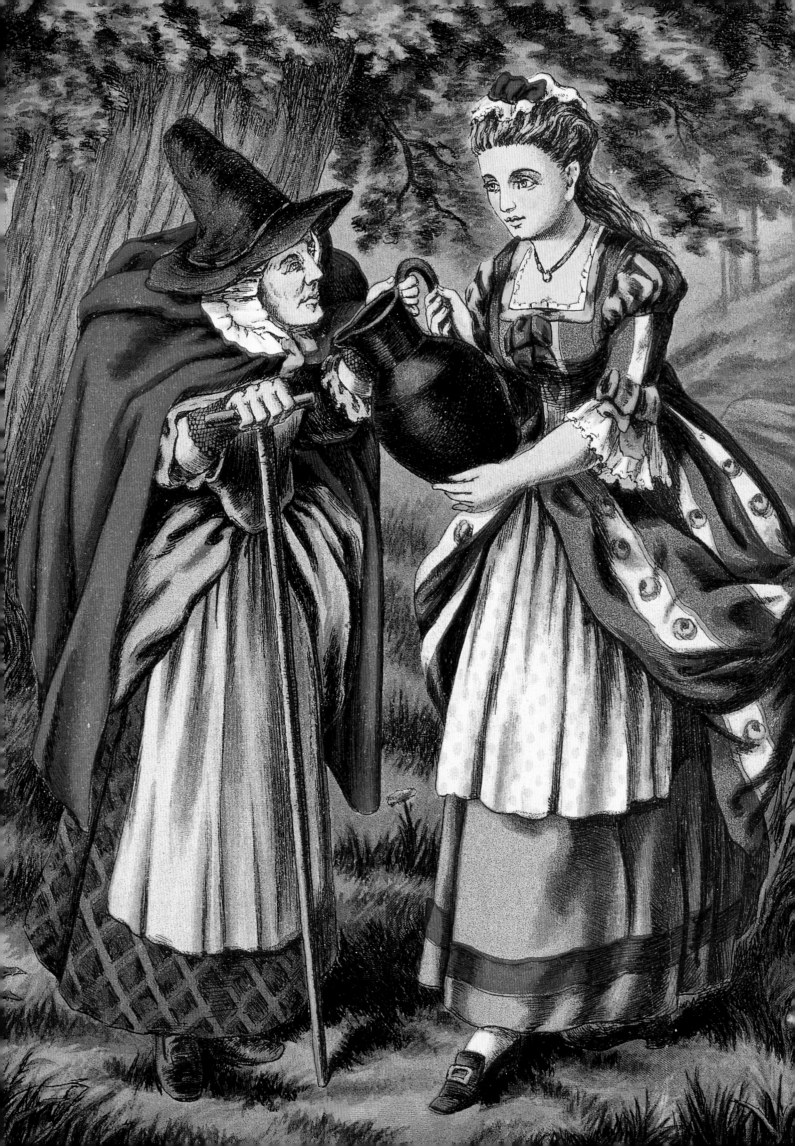

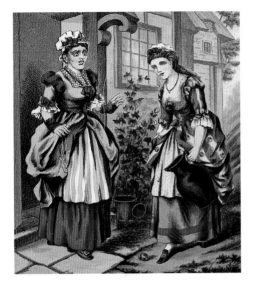

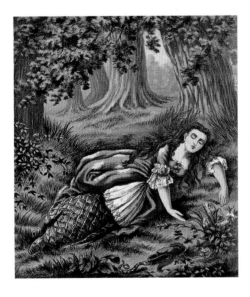

DIAMONDS AND TOADS

Published by McLoughlin Brothers, New York

ca. 1880s–1900s

In this tale, a pretty young girl ill-treated by her mother and spoiled sister is forced to fetch water from a distant fountain. One day, she graciously gives some of the water in her humble jug to an old woman—a fairy in disguise. In exchange for this kindness, the fairy bestows a special gift: roses, pearls, and diamonds fall from the girl's lips whenever she speaks. Witnessing this good fortune, her mother sends her haughty daughter to the well with a silver pitcher, in search of the same bounty. But the girl's begrudging offer of only a sip of water triggers the fairy's curse: her words are turned into toads. The generous daughter thrives, while her sister withers and dies, revealing the thinly veiled moral of this story: be kind to everyone you encounter in life.

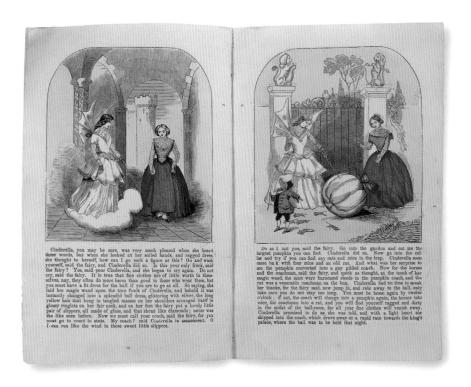

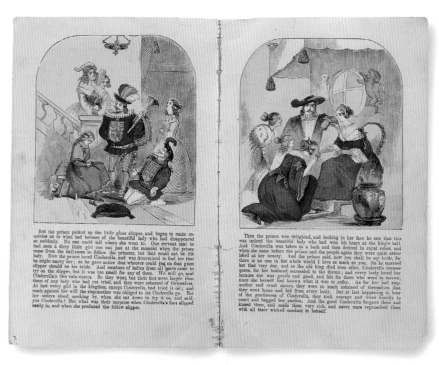

OPPOSITE

CINDERELLA

*Published by McLoughlin Brothers,
New York
Copyright 1891*

LEFT

CINDERELLA,
OR THE GLASS SLIPPER

*Cinderella Series
Published by McLoughlin Brothers,
30 Beekman Street, New York
ca. 1860s*

The story of a sweet young girl rescued
from a life of servitude and drudgery
by a handsome prince has become so
entrenched in American popular cul-
ture that the phrase "Cinderella story"
is now a part of everyday speech. In
this retelling, tenets of nineteenth-
century American morality find their
way into the text of this classic fairy-
tale. Cinderella's godmother maintains,
"fine clothes are of little worth in
themselves, nay, they often do more
harm than good to those who wear
them, but you must have a fit dress for
the ball."

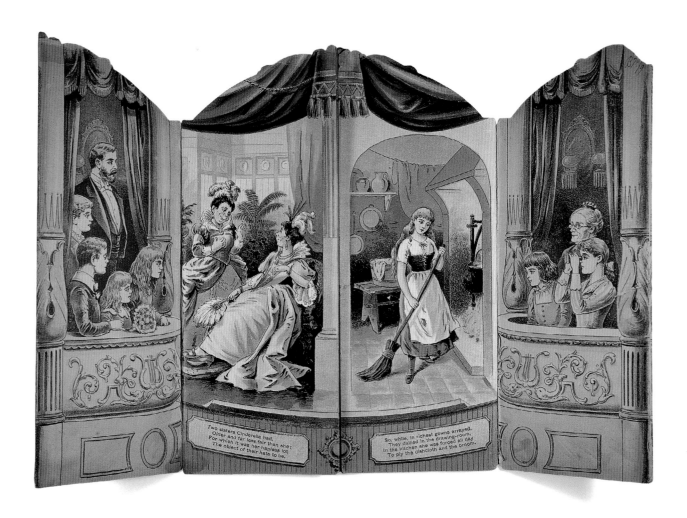

Two sisters Cinderella had,
Older and far less fair than she;
For which it was her hapless lot
The object of their hate to be.

So, while, in richest gowns arrayed,
They dallied in the drawing-room,
In the kitchen she was forced all day
To ply the dishcloth and the broom.

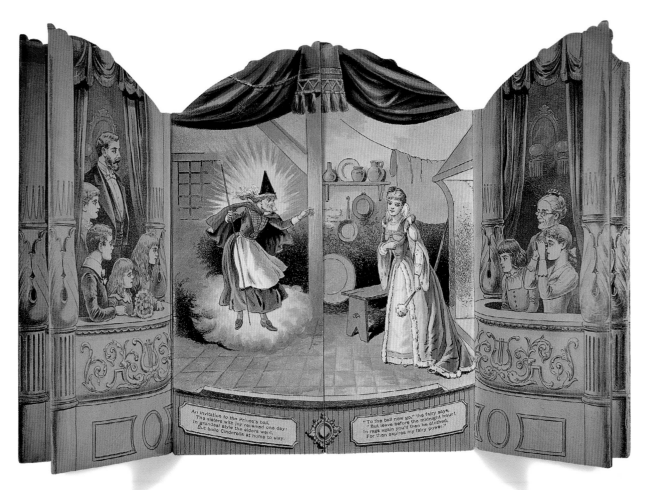

An invitation to the Prince's ball,
The sisters with joy received one day;
In grandest style the elders went,
But bade Cinderella at home to stay.

"To the ball now go," the fairy says,
"But leave before the midnight hour!
In rags again you'll then be clothed,
For then expires my fairy power."

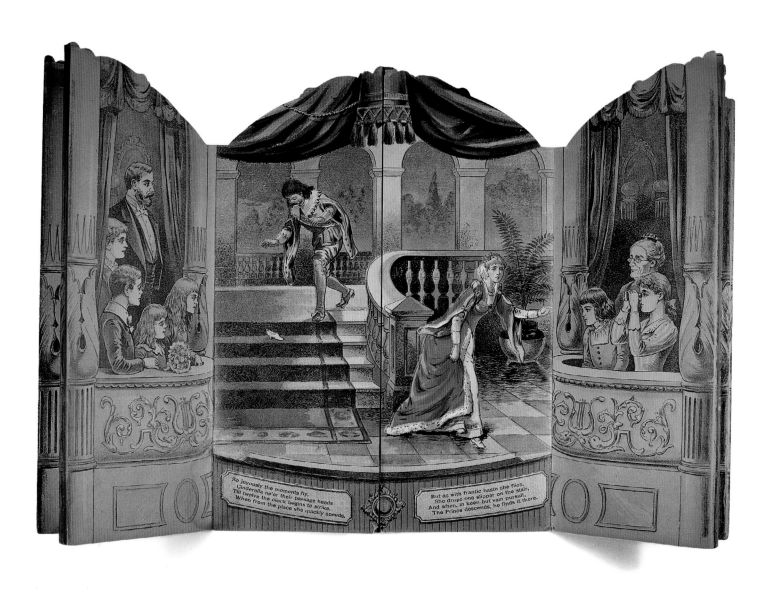

So joyously the moments fly,
Cinderella ne'er their passage heeds
Till twelve the clock begins to strike,
When from the place she quickly speeds.

But as with frantic haste she flies,
She drops one slipper on the stair,
And when, in keen but vain pursuit,
The Prince descends, he finds it there.

CINDERELLA
Published by McLoughlin Brothers,
New York
Copyright 1891

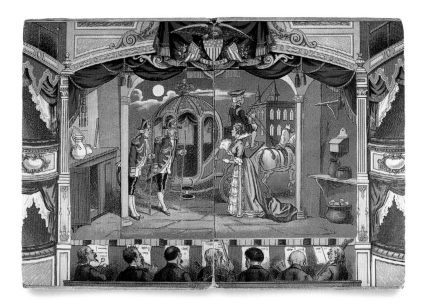

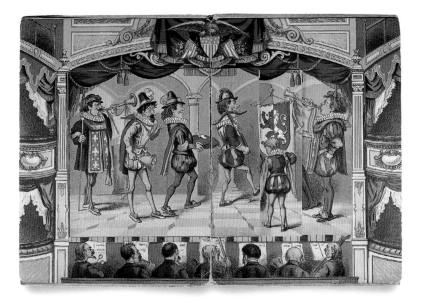

CINDERELLA, OR THE
LITTLE GLASS SLIPPER
PANTOMIME TOY BOOK
Published by McLoughlin Brothers,
New York
ca. 1890s

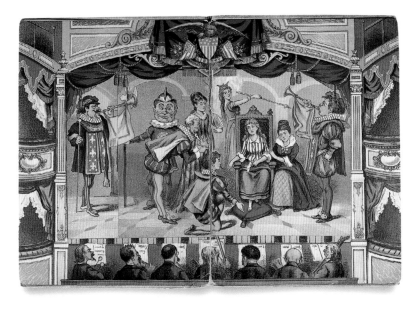

THE BABES IN THE WOOD

Illustrated by R. André

Jack and the Bean Stalk Series

Published by McLoughlin Brothers,
New York

ca. 1880s–90s

In this folktale, a brother and sister are left in the care of an uncle after their loving parents die, leaving a fortune that will be theirs when they are grown. Within a year, thoughts of the money that could be his cause the uncle to renege on his promise to raise the children. He leaves them in the woods to die at the hands of ruffians. Although the children meet a sad fate, "God's blessed will" prevents the villains from profiting from their bad deeds and brings them only "want and misery" instead.

THE CHILDREN IN THE WOOD

Aunt Kate's Series

Published by McLoughlin Brothers, New York

1884

The death of model children is found in many nineteenth-century American and English stories, meant to encourage children to comport themselves properly at all times. *The Children in the Wood* deals directly with the children's death: "They died in one another's arms, from hunger, fear and grief."

THE BABES COVERED WITH LEAVES BY BIRDS AND SQUIRRELS.

But when they heard the dreadful tale,
 And to the prison sped,
To bring the wicked uncle forth,
 He lay all stark and dead!

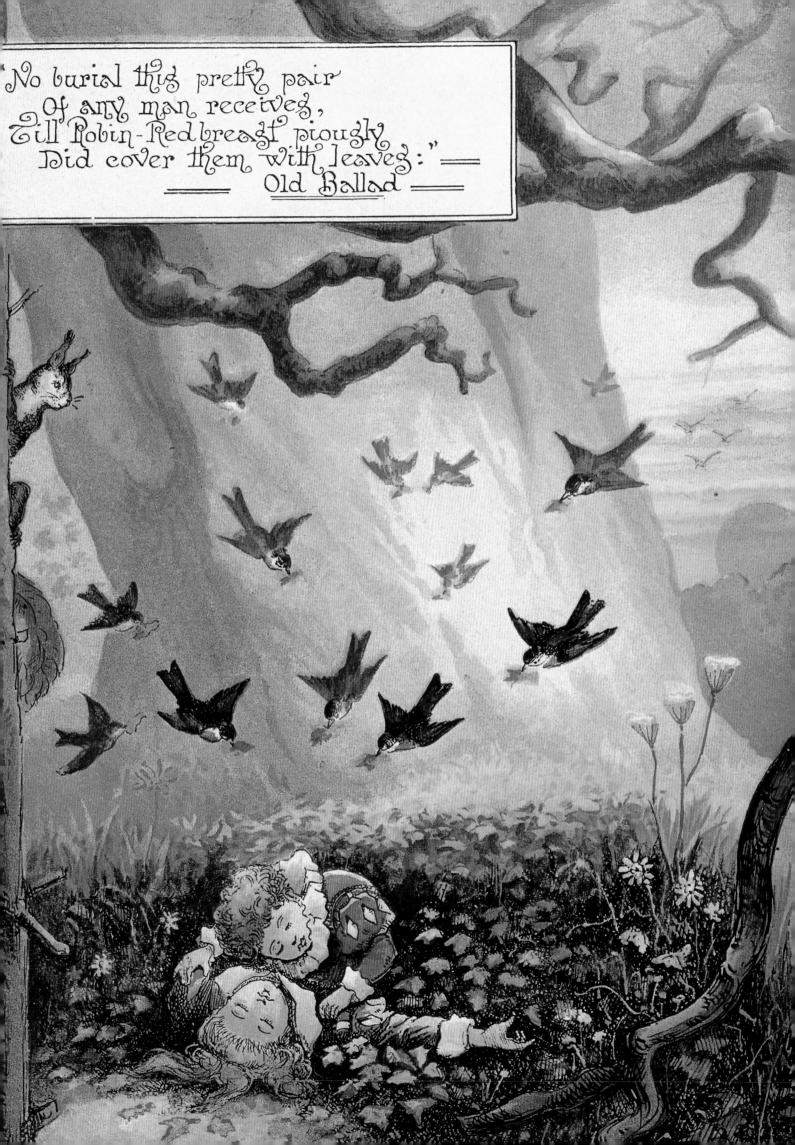

"No burial this pretty pair
Of any man receives,
Till Robin-Redbreast piously
Did cover them with leaves:" —
—— Old Ballad ——

After Tom had been at Court some time, the King sent him home to see his father and mother. His parents, who thought he was lost, were very glad to see him again, so they made much of him. After a short stay with them, he began to think of returning to Court; and as his mother could not make her appearance there, when she got near to the Palace she placed Tom on the back of her hand, and with a good puff blew him from a window into the royal garden.

Tom's return to Court gave much pleasure to all; and the King was so pleased, that he made him go a-hunting with him, and had him mounted on a very spirited mouse, with a handsome saddle and bridle, and gave the little hero a trusty sword to defend him from all enemies. Tom was now very happy, and so fond did the King become of him, for his droll ways and funny sayings, that he knighted him in the presence of all the Court, dubbing him SIR THOMAS THUMB THE GREAT

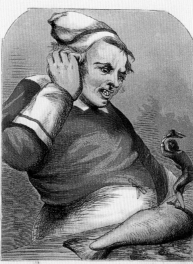

Tom's father had made him a whip of barley straw to drive the cattle with, and one day, when he was trotting along in a ploughed field, a raven picked him up, as if he were a grub, and flew away with him to the sea-side, where the astonished bird soon dropped him on the waves. A fish coming by, and thinking Tom would make him a nice meal, swallowed him in a minute. The fish was caught, and being a very fine one, was sent as a present to the Court.

The fish was taken to the royal kitchen, and the cross Cook was at his wit's end, when, on cutting it open, out popped Master Tom, glad enough to be released from his frightful prison. Tom thanked the Cook so politely, that when he recovered his temper, he had the little fellow presented at Court. King Arthur was quite charmed with Tom, and the courtiers were so diverted with his clever tricks, that he soon became a great favourite with all.

LEFT

TOM THUMB

Cinderella Series
Published by McLoughlin Brothers,
New York
ca. 1870s

First published in England early in the seventeenth century, the tales of a tiny child's strange and wonderful adventures reached the United States by 1686. They had become so familiar that in 1842 General Tom Thumb was adopted as the stage name of P. T. Barnum's famously petite performer. Tom's fantastical escapades, set in the mythical time of King Arthur, begin with his tumble into a bowl of pudding in his mother's kitchen. Subsequently swallowed by a fish, he narrowly escapes a gruesome fate when a cook discovers him while filleting the king's prospective dinner.

OPPOSITE

TOM THUMB

Little Folks Series
Published by McLoughlin Brothers,
New York
Copyright 1888

Tom's ultimate demise is prefigured on the cover of this edition of the tale: the tiny boy is bitten by a spider.

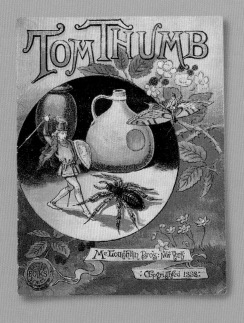

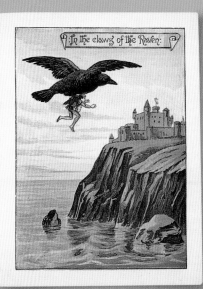

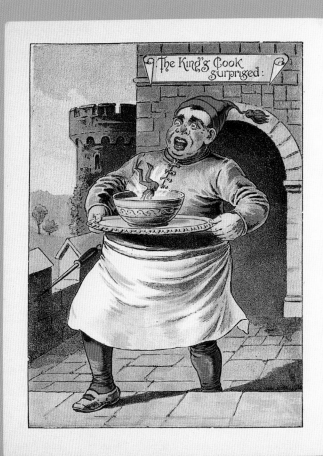

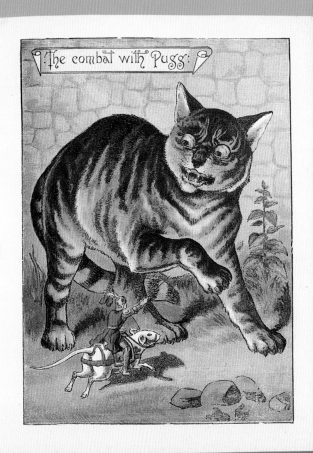

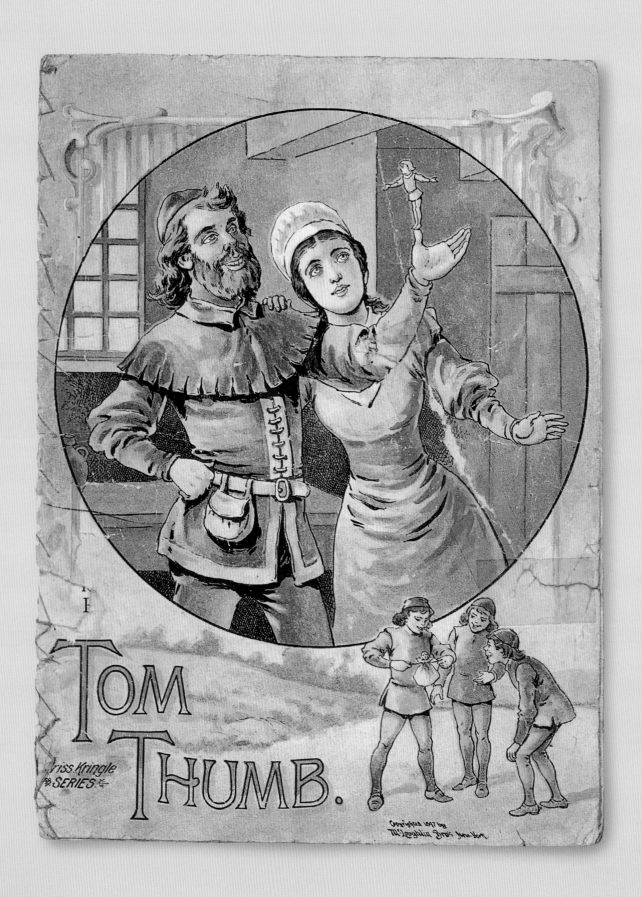

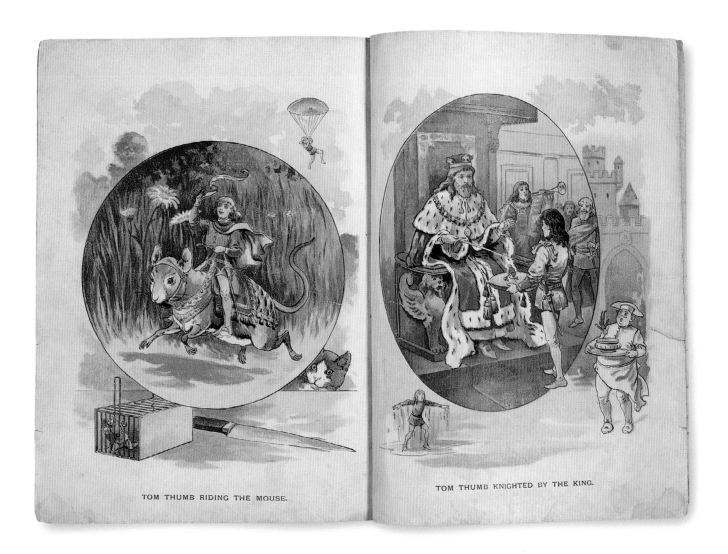

TOM THUMB RIDING THE MOUSE.

TOM THUMB KNIGHTED BY THE KING.

OPPOSITE AND ABOVE

TOM THUMB

Kriss Kringle Series

Published by McLoughlin Brothers, New York

Copyright 1897

Hans Thumbling

and Other Stories

McLoughlin Brothers · New-York

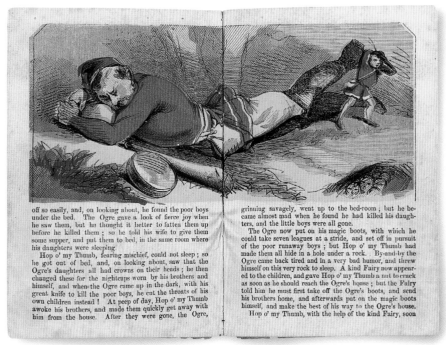

off so easily, and, on looking about, he found the poor boys under the bed. The Ogre gave a look of fierce joy when he saw them, but he thought it better to fatten them up before he killed them ; so he told his wife to give them some supper, and put them to bed, in the same room where his daughters were sleeping.

Hop o' my Thumb, fearing mischief, could not sleep ; so he got out of bed, and, on looking about, saw that the Ogre's daughters all had crowns on their heads ; he then changed these for the nightcaps worn by his brothers and himself, and when the Ogre came up in the dark, with his great knife to kill the poor boys, he cut the throats of his own children instead ! At peep of day, Hop o' my Thumb awoke his brothers, and made them quickly get away with him from the house. After they were gone, the Ogre,

grinning savagely, went up to the bed-room ; but he became almost mad when he found he had killed his daughters, and the little boys were all gone.

The Ogre now put on his magic boots, with which he could take seven leagues at a stride, and set off in pursuit of the poor runaway boys ; but Hop o' my Thumb had made them all hide in a hole under a rock. By-and-by the Ogre came back tired and in a very bad humor, and threw himself on this very rock to sleep. A kind Fairy now appeared to the children, and gave Hop o' my Thumb a nut to crack as soon as he should reach the Ogre's house ; but the Fairy told him he must first take off the Ogre's boots, and send his brothers home, and afterwards put on the magic boots himself, and make the best of his way to the Ogre's house.

Hop o' my Thumb, with the help of the kind Fairy, soon

ABOVE LEFT

HOP·O'·MY·THUMB

Hop-O'-My-Thumb Series

Published by McLoughlin Brothers, New York

ca. 1860s–70s

This story of a tiny boy who uses his wits to save himself and help his impoverished family was among those documented by Charles Perrault in France in the late-seventeenth century. It shares plot elements with *Tom Thumb* and with the Grimm brothers' *Hansel and Gretel*. Like the main characters in those stories, Hop O' My Thumb must fend for himself in the woods, outsmarting a wicked eater of children.

OPPOSITE

HANS THUMBLING AND OTHER STORIES

Published by McLoughlin Brothers, New York

ca. 1880s–90s

Thumbling and *The Travels of Thumbling,* stories about a boy born no larger than his father's thumb, were compiled by the Grimm brothers. The miniscule hero embarks upon a series of adventures in which he foils thieves, lands in a mouse hole, and is swallowed by animals. A model of self-sufficiency like Tom Thumb, Thumbling saves himself from desperate fates through the strength of his own wits.

ABOVE RIGHT

HOP O' MY THUMB

Fairy Moonbeam Series

Published by McLoughlin Brothers, New York

ca. 1860s–70s

Tom, the youngest and smallest of seven children, overhears his parents' desperate plan to leave their offspring in the woods when they can no longer afford to feed and care for them. Tom fills his pockets with small stones, and as they are led into the wilderness he marks a trail that he and his abandoned siblings use to find their way back home. Left in the forest a second time, Tom scatters a breadcrumb trail, which proves less useful. Undaunted, the brave little boy manages to outsmart an ogre who tries to kill the children. With the help of a fairy, he makes off with the ogre's fortune, enabling his family to live together again.

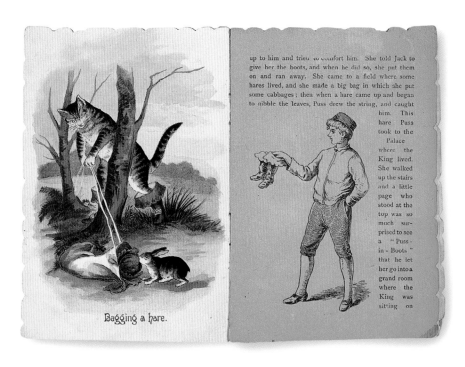

up to him and tried to comfort him. She told Jack to give her the boots, and when he did so, she put them on and ran away. She came to a field where some hares lived, and she made a big bag in which she put some cabbages; then when a hare came up and began to nibble the leaves, Puss drew the string, and caught him. This hare Puss took to the Palace where the King lived. She walked up the stairs and a little page who stood at the top was so much surprised to see a "Puss-in-Boots" that he let her go into a grand room where the King was sitting on

Bagging a hare.

PUSS IN BOOTS
Published by McLoughlin Brothers, New York
ca. 1870s–80s

The youngest son of a poor miller receives "only" a cat upon the death of his father and wonders how he will get on in life. Luckily for him, the cat is an enchanted and cunning creature, whose wits, aided by the magic boots he wears, lead to wealth and happiness for his master. This version of the fairytale concludes with the moral, "A handsome monument was erected containing a life-size statue of Puss in Boots, and on the base of it were these words: A Faithful Friend is a Man's Best Fortune."

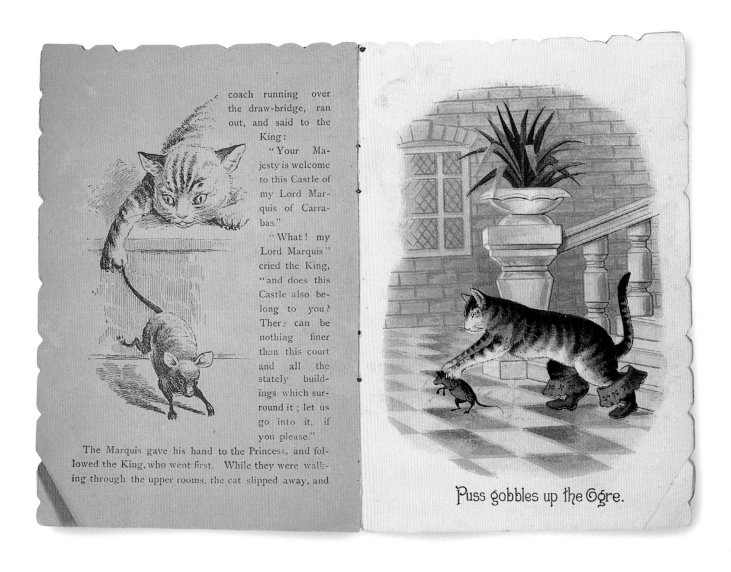

coach running over the draw-bridge, ran out, and said to the King:

"Your Majesty is welcome to this Castle of my Lord Marquis of Carrabas."

"What! my Lord Marquis" cried the King, "and does this Castle also belong to you? There can be nothing finer than this court and all the stately buildings which surround it; let us go into it, if you please."

The Marquis gave his hand to the Princess, and followed the King, who went first. While they were walking through the upper rooms, the cat slipped away, and

Puss gobbles up the Ogre.

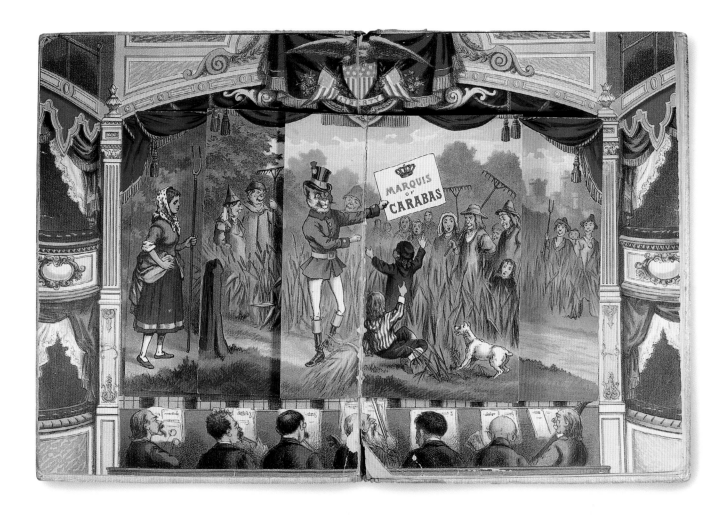

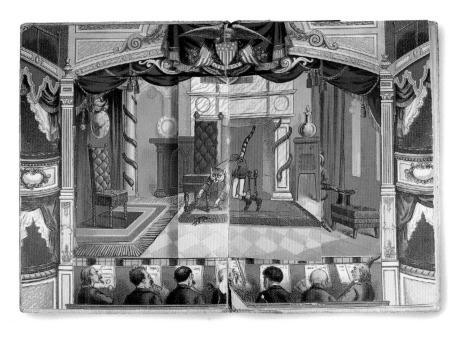

PUSS IN BOOTS

PANTOMIME TOY BOOK

Published by McLoughlin Brothers, New York

ca. 1890s

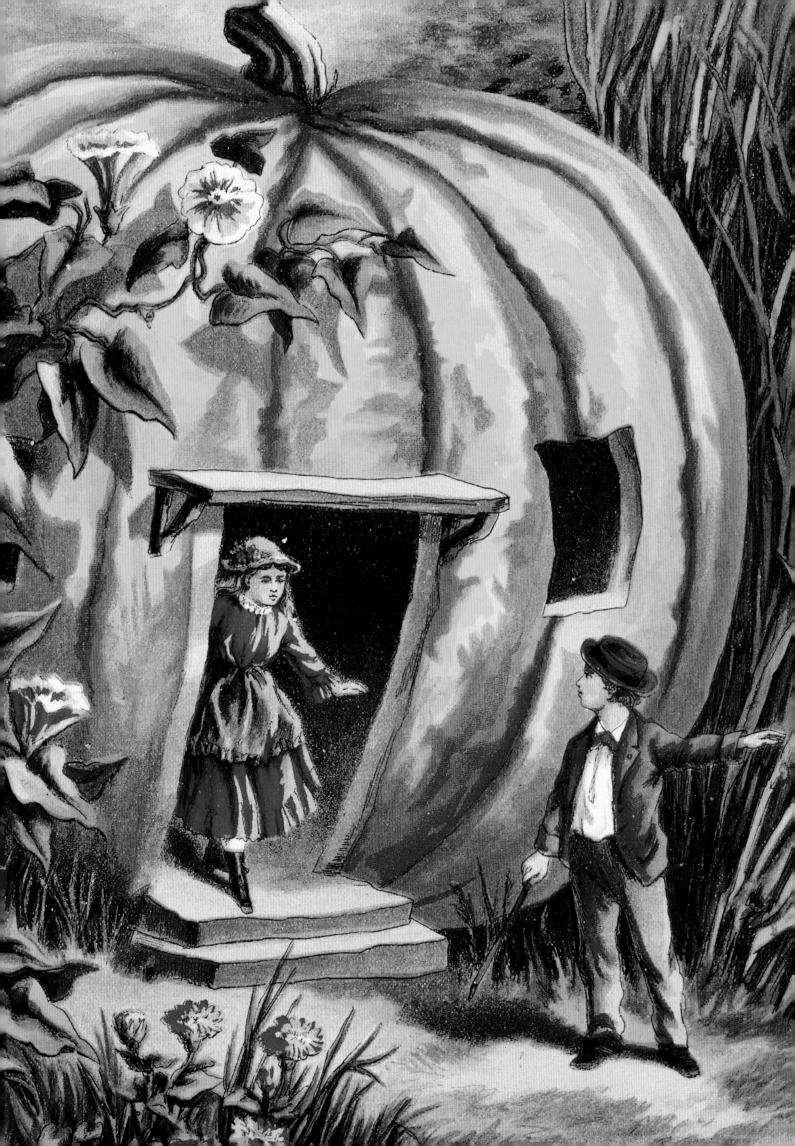

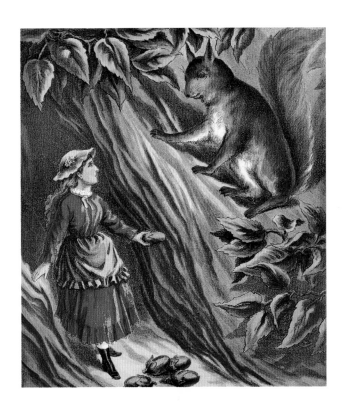

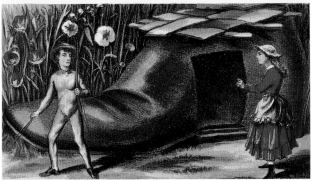

AUNT LOUISA'S CHARMS FOR CHILDREN,
COMPRISING PUMPKIN HOUSE, SLEEPING BEAUTY,
DIAMONDS & TOADS, BOB'S SCHOOL DAYS
Published by McLoughlin Brothers, New York
ca. 1890s–1900s

Richly colored illustrations accompany the fairytales in this hard-
cover volume, which would have made a lavish gift. In addition
to traditional fairytales, the compilation includes a story with
themes that would have resonated with Americans of the period.
The Pumpkin House, or the Adventures of Little Flora and Jack, tells
of a beautiful, idle, and vain girl and her friend, a poor, bright,
and willing boy, who are carried to a magical land of mammoth
scale. As the plot unfolds, the pair migrates steadily westward,
making resourceful use of materials at hand to feed and house
themselves. A friendly red squirrel poignantly describes the
prejudice she encountered after marrying a black squirrel. Jack
and Flora learn tolerance, respect, and self-reliance on their
journey and float safely home on a giant puff of thistle down.

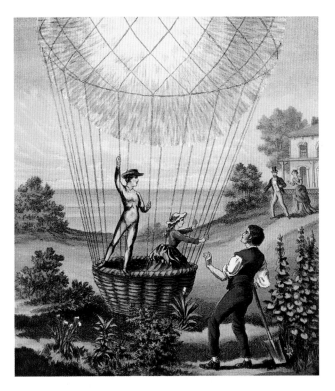

THE TOWN AND COUNTRY MOUSE.

ONCE on a time (so runs the fable)
A Country Mouse right hospitable
Received a Town Mouse at his board,
Just as a farmer might a lord.
A frugal Mouse upon the whole,
Yet loved his friend and had a soul.

He brought him bacon (nothing lean),
Pudding that might have pleased a dean,
Cheese such as men in Suffolk make,
But wished it Stilton for his sake;
Yet, to his guest though no way sparing,
He ate himself the rind and paring.
Our courtier scarce could touch a bit,
But showed his breeding and his wit:
He did his best to seem to eat,
And cried, "I vow, you're mighty neat;
But, la! my friend, this savage scene!
I pray you come and live with men.
Consider, mice, like men, must die,
Both small and great—both you and I
Then spend your life in joy and sport.
This doctrine, friend, I learned at Court."
The veriest hermit in the nation
May yield, Heaven knows! to strong
temptation.
Away they went through thick and thin,
To a tall house in Lincoln's Inn.

Now, let it in a word be said,
The moon was up, the men abed,
The napkins white, the carpet red;
The guests withdrawn, had left the treat,
And down the Mice sat *tête-à-tête*.
Our courtier walks from dish to dish,
Tastes for his friend of fowl and fish.
"That jelly's rich, this Malmsey's heal-
ing,
Pray dip your whiskers and your tail in."
Was ever such a happy swain?
He stuffs and swills, and stuffs again.
"I'm quite ashamed! 'tis mighty rude
To eat so much, but all's so good!
I have a thousand thanks to give.
My lord alone knows how to live."

No sooner said than from the hall
Rush chaplain, butler, dogs, and all.
"A rat! a rat! clap to the door!"
The cat comes bounding on the floor.
Oh for the heart of Homer's mice!
Or gods to save them in a trice!
"An't please your honor," quoth the
peasant,
"This same dessert is not so pleasant;
Give me again my hollow tree,
A crust of bread—and liberty!"
ANON.

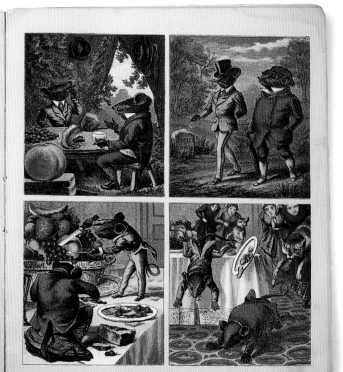

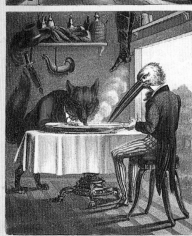

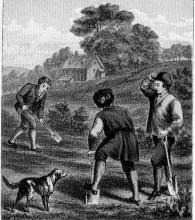

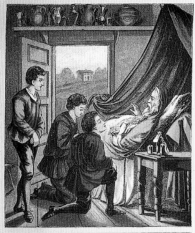

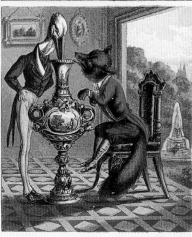

WORLD WIDE FABLES
Aunt Louisa's Series
Published by McLoughlin Brothers,
New York
ca. 1870s–80s

Like fairytales, the morals contained in
fables often change with successive
reprintings to reflect the times and
mores of their particular era. Here,
puritanical austerity and American love
of freedom are woven together in *The
Town and Country Mouse*, in which an
unpretentious rodent rejects the trap-
pings of the city, concluding, "Give me
again my hollow tree, a crust of bread—
and liberty," after huge dogs chase him
and his host from the remains of their
fancy dinner in town.

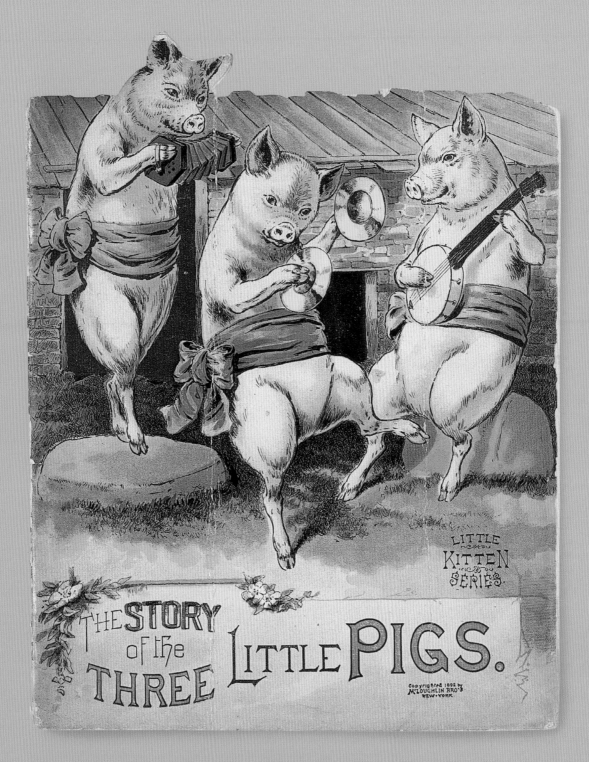

THE STORY OF THE THREE LITTLE PIGS

Little Kitten Series
Published by McLoughlin Brothers, New York
Copyright 1892

In this classic fable, poverty forces three little pigs to leave home and seek their fortunes. Although a villainous wolf outsmarts the pigs who build their homes of straw and wood, the third little pig triumphs over the wily enemy by using his wits and building in brick.

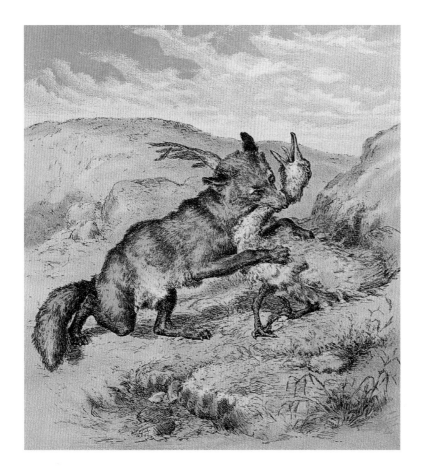

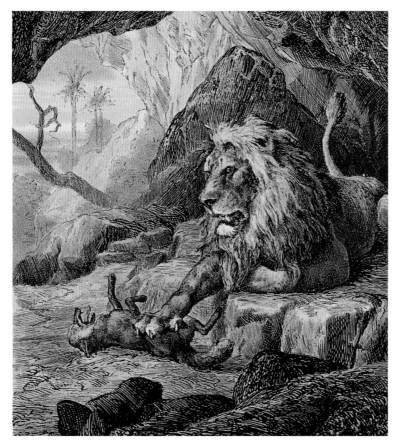

LADY FOX

Published by Peter G. Thomson, Cincinnati
Copyright 1887

Finely detailed, occasionally macabre
illustrations accompany this story of
the enduring bond between lion and
jackal, and the fox who sought to
destroy their friendship for her own
benefit. This complex story comes with
the extended moral: *Now little children,*
learn from this story of the sly fox how
wicked it is to try to deceive, and how
contemptible to try and get some other
person to do your own work. The fox was
strong and well, and plenty able to pro-
vide the food for her young, but did not
wish to ruffle her fur and brush by labor;
in fact she wished to be a Lady Fox, so she
thought to impose on the generous lion.
Such meanness may sometimes flourish
for a time, but it always in the end
receives the punishment it deserves.

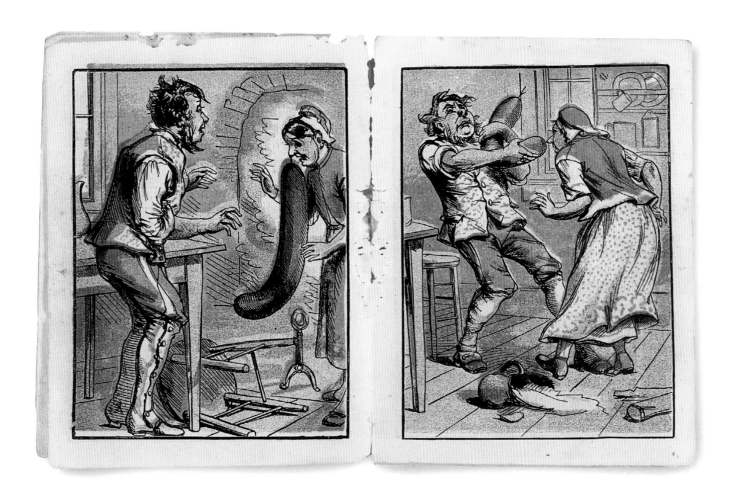

LITTLE DELIGHT'S THREE WISHES

Published by McLoughlin Brothers, New York

ca. 1860s

In this retelling of an ancient story in which a fairy grants three wishes, a wife's careless wish for a large string pudding (a common sausage-like concoction) precipitates her husband's rueful wish that the pudding would stick to her nose. They use their last wish to remove the pudding. All is not lost, however, for when the fairy vanished, she "left the pudding which they cooked for supper, and so [the couple] consoled themselves." The tale concludes with the admonishment, "by using a little common sense, they might have been comfortable for life, and they were justly punished for hankering after splendor and riches, which, in their station of life, would be ridiculous."

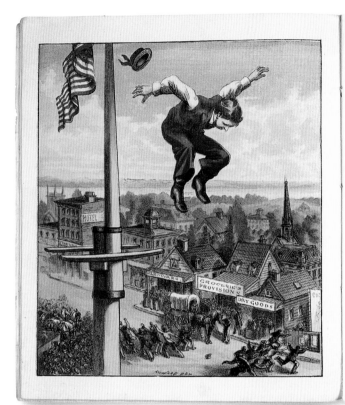

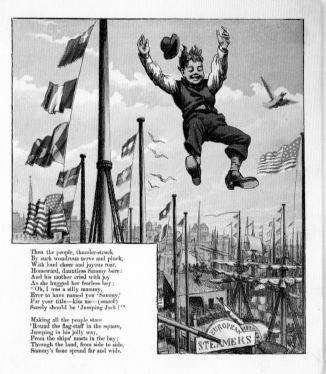

Then the people, thunder-struck
By such wondrous nerve and pluck,
With loud cheer and joyous roar,
Homeward, dauntless Sammy bore:
And his mother cried with joy
As she hugged her fearless boy;
"Oh, I was a silly mammy,
Ever to have named you 'Sammy,'
For your title—kiss me—(*smack*)
Surely should be 'Jumping Jack!'"

Making all the people stare
'Round the flag-staff in the square,
Jumping in his jolly way,
From the ships' masts in the bay;
Through the land, from side to side,
Sammy's fame spread far and wide.

THE WONDERFUL LEAPS OF SAM PATCH
Published by McLoughlin Brothers, New York
ca. 1870s

This illustrated children's volume presents the legendary exploits of Sam Patch (ca. 1807–1829), a factory worker who gained notoriety by executing daredevil leaps from ever-more dizzying heights. Patch began jumping off waterfalls with other boys for fun, transforming the practice into a public spectacle as a young man. Soon after becoming the first person to survive the 120-foot plunge at Niagra Falls, in October 1829, Patch died when he jumped the more modest Genesee Falls in Rochester. *The Wonderful Leaps of Sam Patch* embellishes Patch's life story with imaginary jumps from New York to Boston and across the Atlantic.

THE

FOX AND THE GEESE.

AN ANCIENT NURSERY TALE.

THERE was once a Goose at the point of death,
 So she called her three daughters near,
And desired them all, with her latest breath,
 Her last dying words to hear :

" There's a Mr. Fox," said she, " that I know,
 Who lives in a covert hard by,
To our race he has proved a deadly foe,
 So beware of his treachery.

" Build houses, ere long, of stone or of bricks,
 And get tiles for your roofs, I pray ;
For I know, of old, Mr. Reynard's tricks,
 And I fear he may come any day."

THE FOX AND THE GEESE:

AN ANCIENT NURSERY TALE

Pleasure Books

Published by McLoughlin Brothers, 30 Beekman Street, New York

ca. 1860s

Stories about foxes preying on geese and geese outsmarting
their wily predators may be found in Aesop's Fables, stories
recorded by the Grimm brothers, and other collections of folk-
tales. In this version, reminiscent of "The Three Little Pigs,"
three young geese are warned about the dangers posed by their
enemy. Their mother teaches them how to build safe houses, but
only one little goose heeds her advice; she lives to kill the fox.

FACT AND FICTION
NOVELS, HISTORY BOOKS, AND ANTHOLOGIES

Once the notion of writing and publishing books for children became firmly established in the nineteenth century, the field knew no bounds. Science, biography, history, and literature all proved fertile ground, as children's books reflected mainstream adult interests as well as childish pursuits. When addressing adult purchasers of books, publishers stressed their product's practical and instructional value, but they also made sure to include plenty of illustrations to enhance the visual appeal of their volumes to the children who would ultimately read them. They also included movable parts and eye-catching devices, such as shaped covers and fold-outs, to animate their pages.

In the realm of literature, novels written for adult readers have long been adopted by younger, less sophisticated audiences. Many versions of these novels were printed just for children, their plots condensed, their syntax simplified, and their words occasionally restricted to those of a single syllable. Even the works of Shakespeare appeared in editions edited and designed for children's pleasure.

Among the time-tested favorites were adventure stories such as Jonathan Swift's *Gulliver's Travels* of 1726 and Daniel Defoe's *Robinson Crusoe* of 1719. The shipwrecked Crusoe's struggles to survive on a remote island resonated so strongly with American children that industry giant McLoughlin Brothers alone printed more than eighty versions of the story. Parents who had been warned by nineteenth-century reformers about the dangerous trumpery of novels that imparted no useful information could rest assured that *Robinson Crusoe* would do their children no

harm: educational philosopher Jean-Jacques Rousseau had recommended the novel during the preceding century as one that would teach children to judge things by their usefulness—a practical skill for children at the dawn of the advertising age.

Also popular were richly illustrated volumes of natural history created especially for young readers. A field of sophisticated scientific inquiry during the eighteenth-century age of reason, natural history reached a non-scientific audience in the following century. Lectures by leading researchers instructed and entertained audiences of all ages in Europe and the United States. Rev. George Wood's "sketch lectures" did much to broaden the appeal of the discipline in the 1880s, and his many books published in England influenced children's offerings on both sides of the Atlantic. Reports on global explorations from the North Pole to the Galapagos Islands inspired children's interest in geography, while the great world's fairs of 1876 and 1892 brought many in direct contact with exotic cultures and wildlife. By the end of the nineteenth century, books on zoology, ornithology, botany, and marine life had entered the juvenile market. In addition, the centennial of the American Revolution and the four hundredth anniversary of Columbus's landing in the New World awakened and renewed Americans' interest in their own patrimony and inspired the publication of children's books on the history of the nation and its leaders from its earliest known times to the present.

Toward the end of the nineteenth century, American publishers began to offer collections of stories, verses, and images reflecting the daily life—albeit often idealized—of the children for whom they were intended. Some were meant to help children read and featured dashes between syllables as an aid to pronunciation. These anthologies incorporated diverse reading material, from vignettes of happy childhood days to short, informative essays on topics of a scientific or historic nature. Many encouraged charity, benevolence, and humane behavior toward animals—themes present in earlier moral tales. Here, however, the stories feature a more realistic portrait of children, who are neither entirely virtuous nor incorrigible. Influenced by the success of Robert Louis Stevenson's *A Child's Garden of Verses* of 1885, these collections begin to depict the world from a child's perspective.

PAGE 106

THE ADVENTURES OF
COMMODORE PAUL,
THE NAVAL HERO
Illustrated by Alfred Fredericks
Uncle Sam Series
Published by Peter G. Thomson, Cincinnati
Copyright 1884

This biography of John Paul Jones equates the Scottish-born American naval officer with other famed European heroes of the American Revolution, including the Marquis de Lafayette and General von Steuben. All are stirringly described as "brave men animated by a love for Liberty" who "moved by their Sympathy with an infant people in defense of their rights and liberties against the most powerful Nation of the World, crossed the ocean to fight their battles and contribute to their success."

LEFT

STORY OF ROBIN HOOD

Robin Hood Series

Published by McLoughlin Brothers, New York

Copyright 1889

Accounts of the legendary exploits of Robin Hood, aided by his merry band of followers in Sherwood Forest, date at least as far back as the Middle Ages. The story of a brave individualist who battled oppression, authoritarianism, and poverty, it is easy to understand the hero's appeal to children raised in a culture that sought to instill principles of liberty and justice. So popular was Robin Hood that McLoughlin Brothers adopted his name for one of the firm's series of books.

RIGHT

RIP VAN WINKLE

Written by George P. Webster

Robin Hood Series

Published by McLoughlin Brothers, New York

Copyright 1889

Rip Van Winkle is one of the most well known and beloved of Washington Irving's fictionalized tales of olden days in New Netherland. Originally published in 1819, this humorous story follows a genial man who drinks too much and fritters away his time in idle pursuits. Children immediately sympathize with Rip's plight when he awakes from his afternoon nap to find that time has moved ahead by many years while he slept.

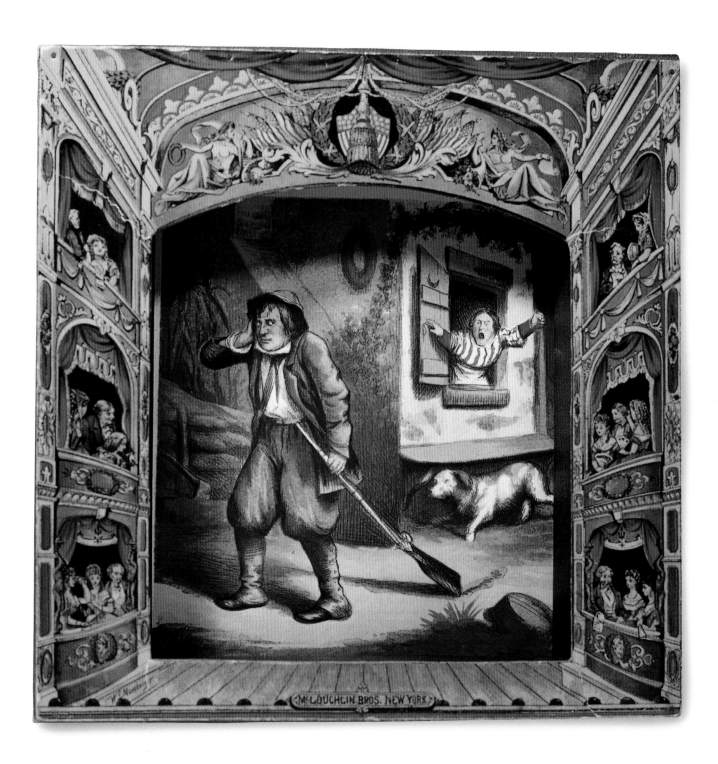

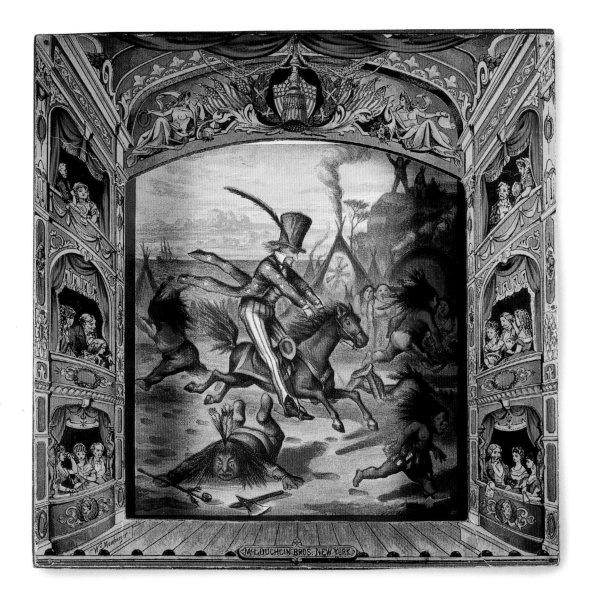

UNCLE SAM'S PANORAMA
OF RIP VAN WINKLE AND YANKEE DOODLE
Illustrated by William Momberger
Published by McLoughlin Brothers, New York
ca. 1870s–1890s

In this magnificent "moving picture" book, a scroll is rolled from one wooden dowel to another behind a miniature proscenium to reveal vignettes of two American classics: *Rip Van Winkle* and *Yankee Doodle*. William Momberger (1829-?), who studied painting and chromolithography first in his native Germany and again in the United States, where he emigrated in 1848, created the rich, dimensional illustrations; his signature appears on the covers of a variety of children's books published by McLoughlin Brothers.

Master J. Spraggles
his Version
of
ROBINSON CRUSOE
AS NARRATED & depicted TO HIS
SchoolFellows
At Dr Tickeltoby's Academy

J. S.

**ROBINSON CRUSOE (MASTER J. SPRAGGLES:
HIS VERSION OF ROBINSON CRUSOE AS
NARRATED & DEPICTED TO HIS SCHOOL
FELLOWS AT DR. TICKLETOBY'S ACADEMY)**

Published by McLoughlin Brothers, New York
ca. 1870s

This wry version of *Robinson Crusoe* is told from the perspective
of a young schoolboy, Master J. Spraggles, who recalls the essen-
tials of this beloved story from memory, using "his own words."
He illustrates key scenes—the shipwreck, building a hut,
Crusoe's meeting Friday, and Friday's education—in drawings
scrawled on a slate.

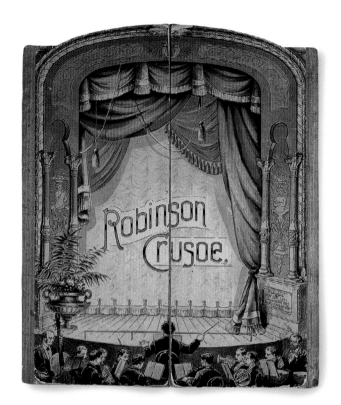

ROBINSON CRUSOE
Published by McLoughlin Brothers,
New York
Copyright 1893

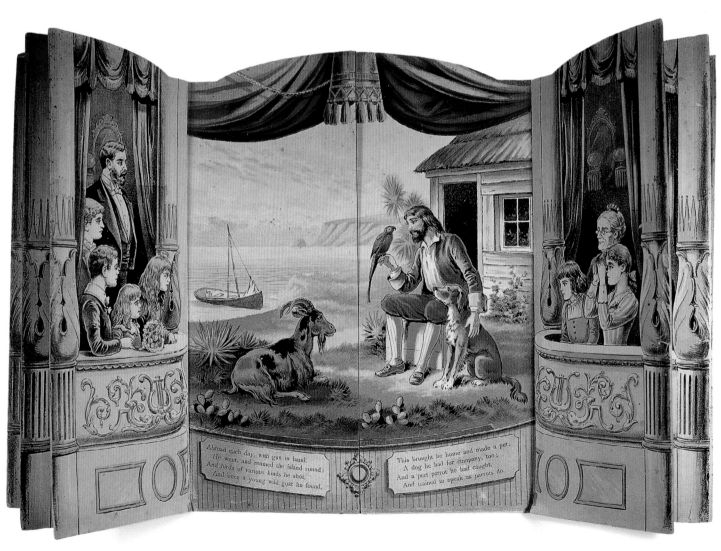

Crusoe taking a Load from the Ship to the Shore.

ROBINSON CRUSOE

IN WORDS OF

ONE SYLLABLE.

BY
MARY GODOLPHIN.

WITH COLORED ILLUSTRATIONS.

NEW YORK:
McLOUGHLIN BROTHERS, PUBLISHERS,
1882.

ABOVE

ROBINSON CRUSOE IN WORDS OF ONE SYLLABLE
Written by Mary Godolphin
Published by McLoughlin Brothers, New York
1882

Published in 1719 as *The Life and Strange and Surprising
Adventures of Robinson Crusoe*, Daniel Defoe's work is often
considered the first English novel. Crusoe's thrilling escapades
spawned a host of imitators that eventually bore the sobriquet
"Robinsonnades." Mary Godolphin adapted the popular book—
and many others in the McLoughlin Brothers line—"to the use
of the youngest readers" in the 1880s. In her preface, she notes
the novelty of her approach in bringing one-syllable construc-
tion out of the bland spelling book and into the realm of the
adventure novel.

RIGHT

ROBINSON CRUSOE
Published by McLoughlin Brothers, New York
Copyright 1897

The publisher of this radically condensed version of the popular
novel advises youngsters, "As soon as you can read yourself, you
should read the complete life of Robinson Crusoe."

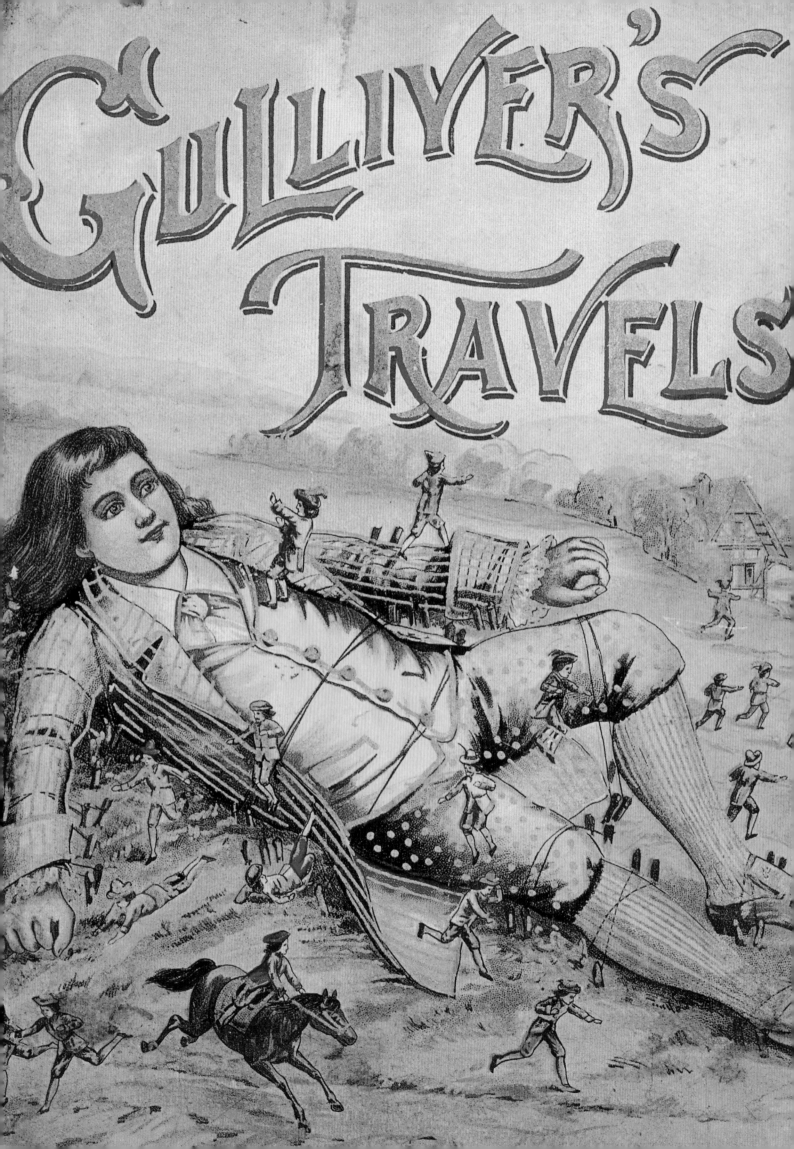

GULLIVER'S TRAVELS

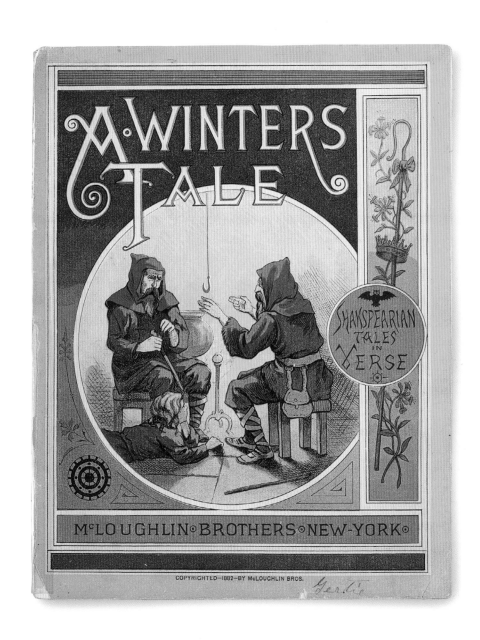

OPPOSITE

GULLIVER'S TRAVELS

Published by W. B. Conkey Company,
Chicago
ca. 1890s

Jonathan Swift's account of Lemuel
Gulliver's fantastic voyages to Lilliput,
Brobdingnag, and other imaginary
lands and the curious people he met
along the way resonated with children
in the United States, a melting pot of
immigrants from many lands who
transported their native costumes,
goods, and cultures from abroad.
Oblivious to Swift's satirical commen-
tary on eighteenth-century British
political and social life, children
delighted instead in the thrills of
Gulliver's adventures.

RIGHT

A WINTERS TALE:
SHAKESPEARIAN TALES
IN VERSE

Published by McLoughlin Brothers,
New York
Copyright 1892

Not even the great English bard
was safe from having his iambic
pentameter translated into mono-
syllables.

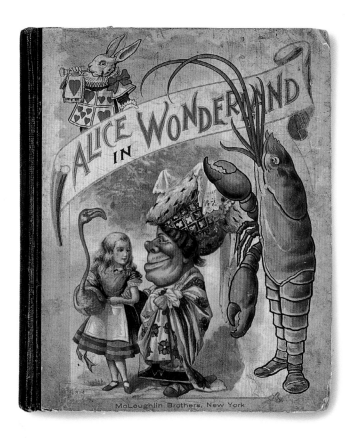

ALICE'S ADVENTURES IN WONDERLAND AND THROUGH THE LOOKING GLASS

Written by Lewis Carroll
Illustrations after John Tenniel
Published by McLoughlin Brothers, New York
ca. 1900s–10s

Many artists have portrayed the fantasyland and strange inhabitants of *Alice's Adventures in Wonderland*, including the author, Reverend Charles Lutwidge Dodgson (1832–1898), whose sketches animated his first handwritten manuscript of the extravagantly whimsical story. But it is the 1865 black and white wood-engraved images created by political cartoonist Sir John Tenniel (1820–1914) for the first publication of *Alice* that have become inextricably linked to the startling saga of her adventures in Wonderland. This undated American edition reproduces Tenniel's iconic images of Alice, the White Rabbit, the Mad Hatter and his tea party guests, and many others; it also reworks the images, adding color to many and adapting details to frame the text.

ABOVE, LEFT AND RIGHT

THE MOTOGRAPH MOVING PICTURE BOOK

Cover design by H. de Toulouse-Lautrec
Illustrated by F. J. Vernay, Yonick & Co.
Published by Bliss, Sands and Co., London
1898

Capitalizing on the excitement generated by "moving pictures," first seen by Americans in the 1890s, this exquisite volume of illustrations forms an interactive at-home family entertainment. The book makes use of a "transparency"—a small, rigid square of ribbed translucent material (a proto-plastic). When the square is placed as instructed (as shown on Toulose-Lautrec's cover), the underlying image appears to move just as the object would in real life. Water sprays gracefully from a fountain; the silken folds of a dress ripple; and cogs, wheels, and gears move with industrial precision. Here lava spews from the top of a volcano, off the page and into the reader's living room.

OPPOSITE, TOP

THE TABLE-BOOK

Dame Wonder's Picture Books
Published by McLoughlin Brothers, 30 Beekman Street, New York
ca. 1860s

In words and pictures, this book provides the terminology needed to measure all manner of things in a nineteenth-century child's universe. Especially practical at a time when clothes were made at home is the table of equivalencies for measuring lengths of cloth.

OPPOSITE, BOTTOM

BOY'S HUNTING BOOK

Published by McLoughlin Brothers
ca. 1900s

This book was likely published around 1900, when the big-game hunting exploits of Teddy Roosevelt and others coincided with a growing concern with wildlife conservation.

CLOTH MEASURE.

Two and a quarter inches makes one nail.

Four nails make one quarter of a yard.

Four quarters make one yard.

TIME MEASURE.

Sixty seconds make one minute.
Sixty minutes make one hour.
Twenty-four hours make one day.
Seven days make one week.
Four weeks make one month.
Twelve months make one year.
One hundred years make one century.

BOY'S HUNTING BOOK

SQUIRREL HUNTING.

Every one knows the harmless, playful little Squirrel, and every one knows how tame he becomes, in our parks and gardens, where we see him sitting upon his haunches, munching at nuts. Yet the Squirrel, in the woods, is a shy and wary little creature. When a hunter comes to try and shoot him, he shows great skill in keeping out of the way. As the hunter walks around the tree, Master Squirrel keeps turning with him, so that the hunter often does not get a sight of his little victim. They build nests, which at a distance resemble those of the crow, and here it is, on a windy tree top, that the little Squirrels spend their babyhood, till they are large enough for their parents to take out, and teach them how to climb, and where to find nuts.

A BUFFALO HUNT IN THE WILD WEST

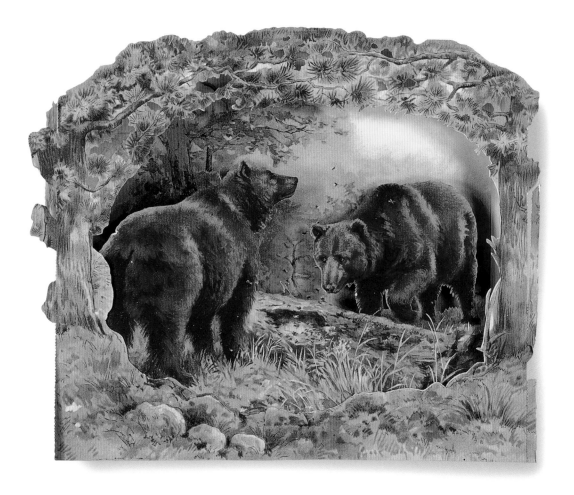

WILD ANIMAL STORIES
Introduction by G. Manville Fenn
Published by Ernest Nister, London, and
E. P. Dutton & Company, New York
ca. 1890s–1900s

Wild animals leap from the pages of this panorama picture book automatically, without requiring the child to lift a flap or pull a tab, as other moveable books of the period required for their animation.

WOOD'S ILLUSTRATED NATURAL HISTORY
Published by McLoughlin Brothers, New York
ca. 1880s–1900s

English naturalist Rev. George Wood broadened the appeal of natural history by writing a series of "best sellers" in the 1850s and 1860s, including volumes especially for children. Flora and fauna of the jungle and desert are delightfully conflated in this probably unauthorized version of one of these.

BIG ANIMAL PICTURE BOOK

Published by McLoughlin Brothers, New York

Copyright 1902

Pictures of animals on the farm, in the wild, and in the home are accompanied by short descriptions of their species in the *Big Animal Picture Book.* The more exotic the animal, the longer the text.

THE ELEPHANT.

THE Elephant is the largest of four-footed animals. Its most noticeable feature is its long snout, called its trunk. This it can bend in every direction. At the end is a finger-like contrivance, with which it can pick up even the smallest articles as easily as if it were a hand.

THE GIRAFFE.

THIS is the tallest of animals, reaching sometimes the height of eighteen feet. Its tongue, as well as its neck, is very long, and is adapted for tearing off the leaves of the trees upon which it feeds. It is a mild animal, but when attacked can make a vigorous defense with its heels.

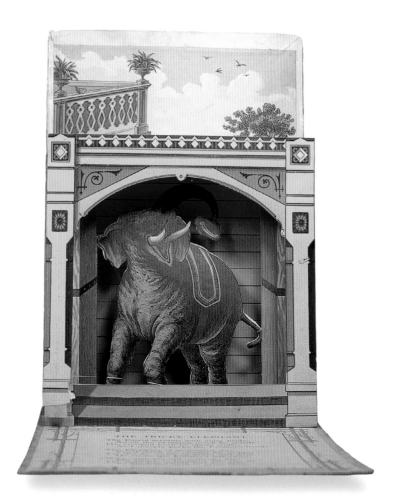

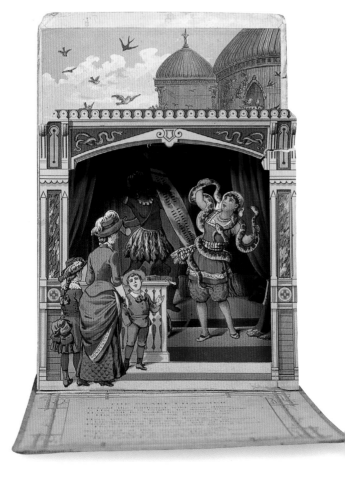

JUMBO AND THE COUNTRYMAN

Little Showman's Series

Published by McLoughlin Brothers, New York

ca. 1880s

Pop-up books in the Little Showman's Series presented a pictorial scene around which children could read the simple accompanying text and invent their own stories.

THE SNAKE CHARMER

Little Showman's Series

Published by McLoughlin Brothers, New York

ca. 1880s

In an era of colonial adventures on many continents, unfamiliar people were often seen as exotic, as were strange animals. Vibrant images enhance the thrill of the pop-up effect here.

MODES OF TRAVEL, OR BY LAND AND WATER
Published by McLoughlin Brothers, New York
Copyright 1902

Presumably reinforcing geography lessons learned at school, the illustrations in this book describe means of transportation throughout the world. Modes range from the ordinary horse-drawn farm wagon to the exotic bejeweled elephant and man-powered rickshaw. In a nod to changing times at home, the book pictures a modern American touring car—an "exotic" mode of travel of another sort, available only to the wealthy and adventurous.

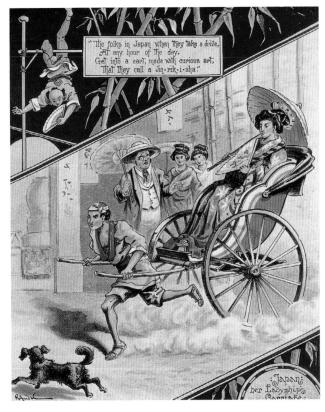

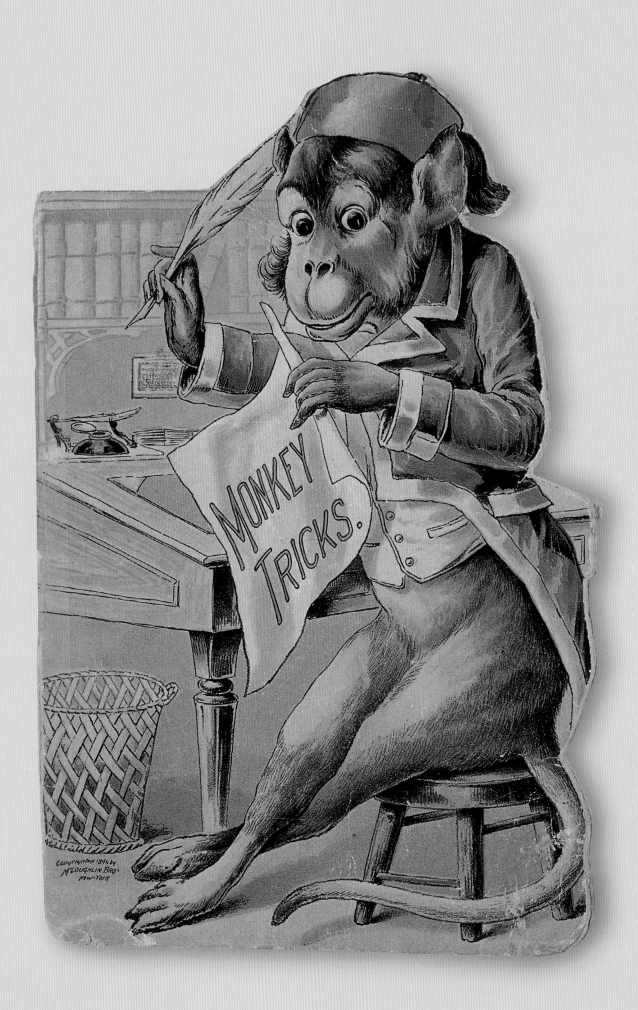

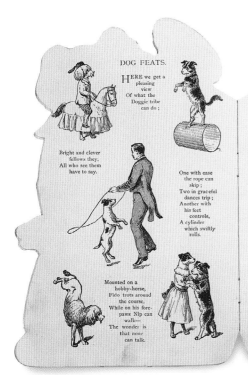

DOG FEATS.

HERE we get a
pleasing view
Of what the
Doggie tribe
can do ;

Bright and clever
fellows they,
All who see them
have to say.

One with ease
the rope can
skip ;
Two in graceful
dances trip ;
Another with
his feet
controls,
A cylinder
which swiftly
rolls.

Mounted on a
hobby-horse,
Fido trots around
the course,
While on his fore-
paws Nip can
walk—
The wonder is
that none
can talk.

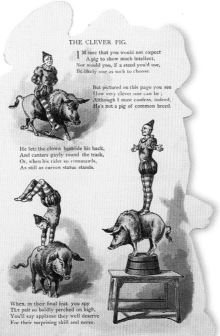

THE CLEVER PIG.

I'M sure that you would not expect
A pig to show much intellect,
Nor would you, if a steed you'd use,
Be likely one as such to choose.

But pictured on this page you see
How very clever one can be ;
Although I must confess, indeed,
He's not a pig of common breed.

He lets the clown bestride his back,
And canters gayly round the track,
Or, when his rider so commands,
As still as carven statue stands.

When, in their final feat, you spy
The pair so boldly perched on high,
You'll say applause they well deserve
For their surprising skill and nerve.

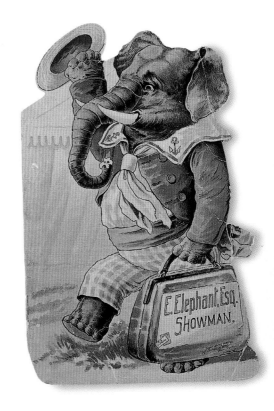

ABOVE

E. ELEPHANT, ESQ. SHOWMAN
Published by McLoughlin Brothers,
New York
Copyright 1894

OPPOSITE AND RIGHT

MONKEY TRICKS
Published by McLoughlin Brothers,
New York
Copyright 1894

The engaging monkeys in this shape
book go to school, do tricks, and
engage in antics to delight the young
reader.

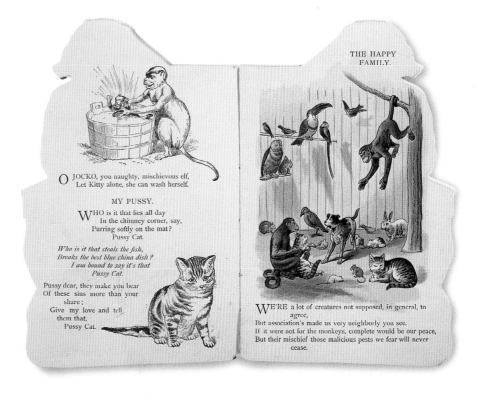

O JOCKO, you naughty, mischievous elf,
Let Kitty alone, she can wash herself.

MY PUSSY.

WHO is it that lies all day
In the chimney corner, say,
Purring softly on the mat?
Pussy Cat.

Who is it that steals the fish,
Breaks the best blue china dish ?
I am bound to say it's that
Pussy Cat.

Pussy dear, they make you bear
Of these sins more than your
share ;
Give my love and tell
them that,
Pussy Cat.

THE HAPPY
FAMILY.

WE'RE a lot of creatures not supposed, in general, to
agree,
But association's made us very neighborly you see.
If it were not for the monkeys, complete would be our peace,
But their mischief those malicious pests we fear will never
cease.

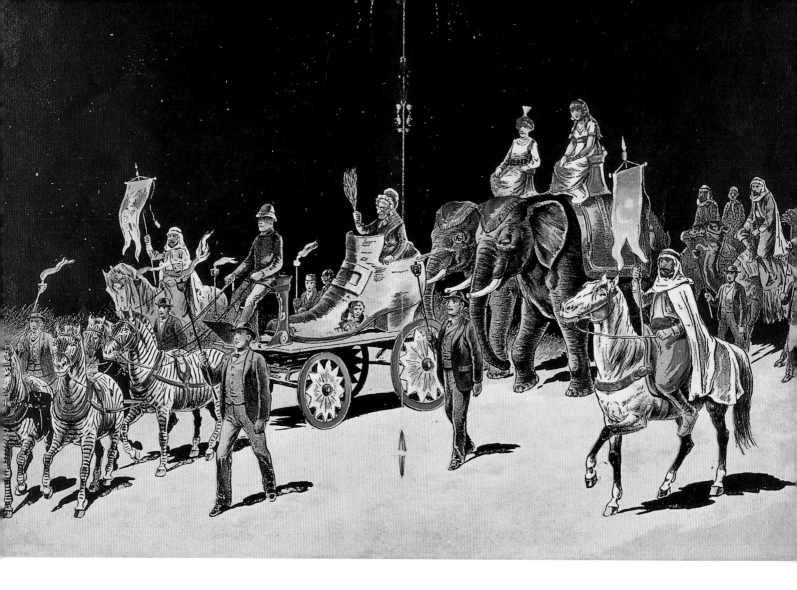

WONDERS OF THE CIRCUS

Published by McLoughlin Brothers,
New York
Copyright 1883

From the Roman Empire to the Victorian era, circuses featuring
costumed performers, prancing horses, and exotic animals have
provided centuries of entertainment, if not always for children.
The modern circus, in which acrobats, jugglers, and dancers per-
form in a ring, interrupted by the antics of trained animals and
colorfully costumed clowns, came to the United States from
England at the close of the eighteenth century. With the intro-
duction of three rings of constant amusement, the circus reached
its peak of popularity as family entertainment in the late nine-
teenth century, after evangelical fervor warning against its evil
effects on children had subsided.

CIRCUS TRICKS

Circus Series
Published by McLoughlin Brothers, New York
Copyright 1890

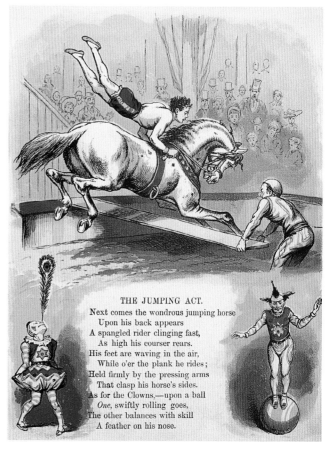

THE JUMPING ACT.
Next comes the wondrous jumping horse
Upon his back appears
A spangled rider clinging fast,
As high his courser rears.
His feet are waving in the air,
While o'er the plank he rides;
Held firmly by the pressing arms
That clasp his horse's sides.
As for the Clowns,—upon a ball
One, swiftly rolling goes,
The other balances with skill
A feather on his nose.

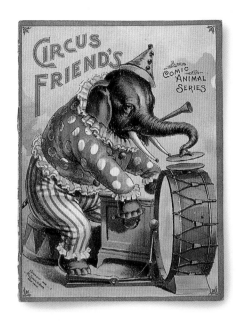

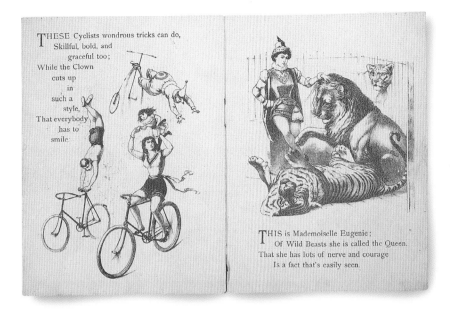

THESE Cyclists wondrous tricks can do,
 Skillful, bold, and
 graceful too;
While the Clown
 cuts up
 in
 such a
 style,
That everybody
 has to
 smile.

THIS is Mademoiselle Eugenie;
 Of Wild Beasts she is called the Queen.
That she has lots of nerve and courage
 Is a fact that's easily seen.

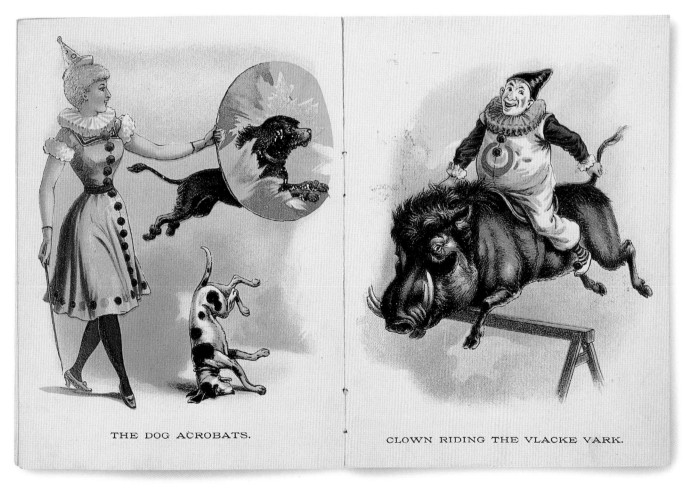

THE DOG ACROBATS.

CLOWN RIDING THE VLACKE VARK.

CIRCUS FRIENDS
Comic Animal Series
Published by McLoughlin Brothers, New York
Copyright 1898

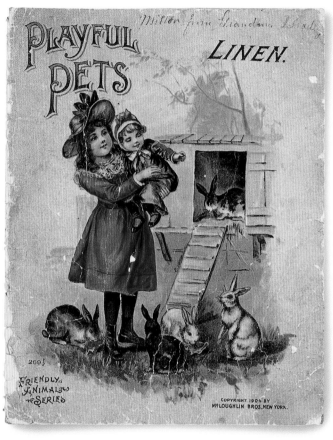

LEFT

OUTDOOR FRIENDS

Friendly Animal Series
Published by McLoughlin Brothers, New York
Copyright 1904

RIGHT

PLAYFUL PETS

Friendly Animal Series
Published by McLoughlin Brothers, New York
Copyright 1904

The practice of bringing animals into the home and caring for them as pets grew in popularity during the nineteenth century, as industrialization and urbanization distanced people and nature. The stories in this collection, which feature not only cats and dogs, but also monkeys and squirrels, chronicle the lively antics of man's furry friends, charming children and adults alike.

FRISKY THE SQUIRREL

Written by C. E. B. (probably Charlotte E. Bowen)
Snowflake Series
Published by McLoughlin Brothers, New York
Copyright 1889

This short adventure story reveals the bonds of affection
between a boy and his squirrel. During the colonial era and into
the nineteenth century, children tamed baby squirrels, teaching
them tricks and sometimes even keeping them indoors on leash
and collar. Here, Archie rescues an injured animal, which devel-
ops a fondness for sitting in the young boy's pocket. When
Archie falls while learning to ice skate, the frightened squirrel
runs off. Archie searches in vain for his lost pet. Frightened and
exhausted, he falls asleep in the cold, dark woods. Rescued by his
worried father, Archie is relieved to wake up at home but misses
his squirrel. To his great joy, he soon discovers that Frisky has
slipped back into the warmth and comfort of his pocket.

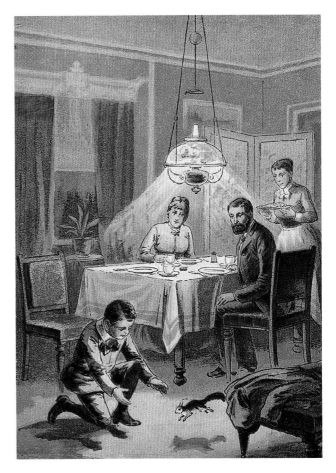

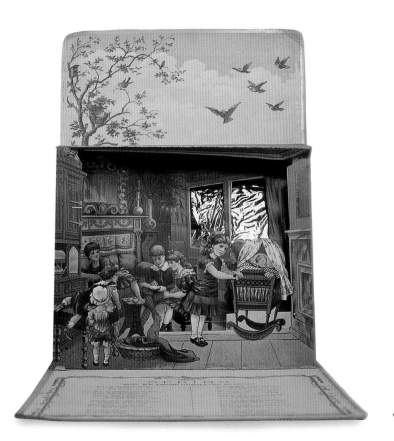

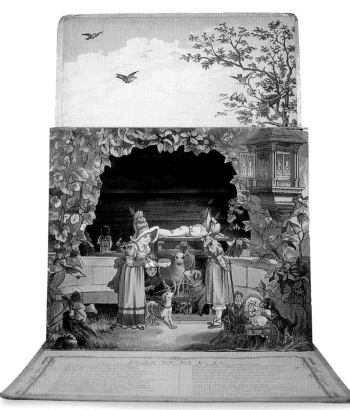

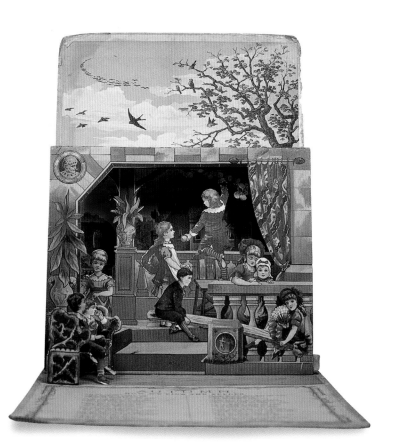

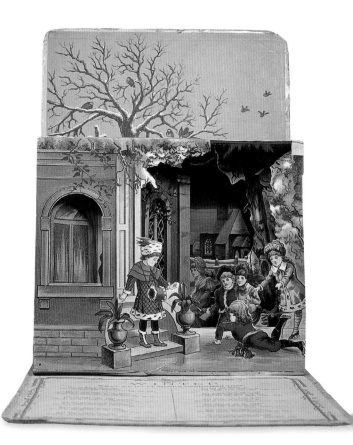

OPPOSITE, CLOCKWISE
FROM TOP LEFT
**SPRING; SUMMER;
WINTER; AUTUMN**
Little Showman's Series No. 2
Published by McLoughlin Brothers,
New York
Copyright 1884

Cutout images are arranged in layered
effects and attached to each other and
to the back cover of these pop-up
books. When the front cover is lifted,
the backdrop and cutout figures pop up
and rock back and forth on hinges. A
descriptive verse or narrative, but no
sequential plot, accompanies the image,
giving the child's imagination free rein
to present his own show—an early
example of an interactive plaything.

RIGHT
**THE HISTORY OF THE
UNITED STATES, TOLD IN
ONE SYLLABLE WORDS**
Published by McLoughlin Brothers,
New York
1884

This compressed history of the United
States takes young readers from the
voyages of Norse explorers a thousand
years ago through the significant events
of their own day. In typical McLoughlin
Brothers fashion, the identical text
appears behind two different covers
designed to entice the broadest possible
audience: this one portrays American
soldiers of the Revolution and Civil
War; the other features historical fig-
ures of different time periods—George
Washington, Christopher Columbus,
and Native Americans—all of perennial
interest to American children.

OVERLEAF
STORY OF THE FIREMEN
Published by McLoughlin Brothers New York
Copyright 1908 and 1911

In words and pictures, this book provides thrilling factual
descriptions of the hazardous and exciting work done by fire-
men in a big city. Illustrations depicting the newly introduced
automotive fire engines emphasize the growing presence of
cars in the American landscape at the start of the new century.

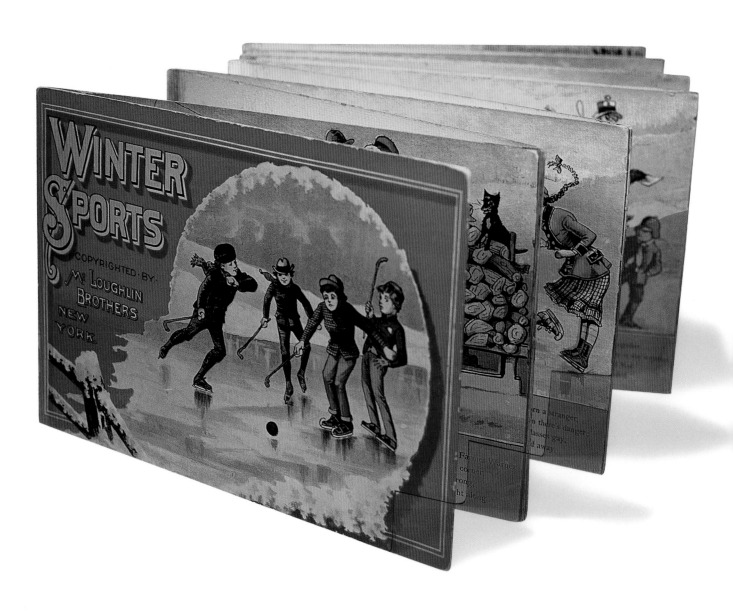

ABOVE

WINTER SPORTS

Published by McLoughlin Brothers, New York

Copyright [no date]

This twelve-foot accordion-folded book presents a plethora of
winter activities for boys and girls to enjoy, from ice skating to
sledding to playing hockey.

OPPOSITE, TOP

CHILD'S FIRST BOOK

Published by McLoughlin Brothers,
New York
Copyright 1886

OPPOSITE, BOTTOM

WEE BABY STORIES

Cassell & Company Limited,
London, Paris & New York
ca. 1890s–1900s

The verses, short stories, and engraved illustrations in this anthol-
ogy feature very young children (the age of the intended reader)
playing with their toys, doing chores, and learning to grow up.
They teach lessons of kindness, hard work, and generosity.

THE COW AND HER CALF.

HERE are three good friends. May is fond of the calf, and of-ten brings a nice bunch of greens in her hands for it to eat. While it eats, the old cow looks on as if pleased to have her lit-tle one made a pet of.

MAYBUD AND CARPIE.

THE DONKEY-RIDE.

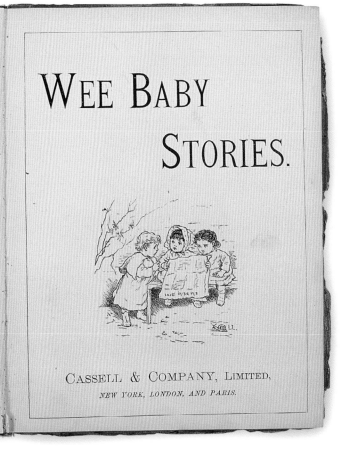

WEE BABY STORIES.

CASSELL & COMPANY, LIMITED,
NEW YORK, LONDON, AND PARIS.

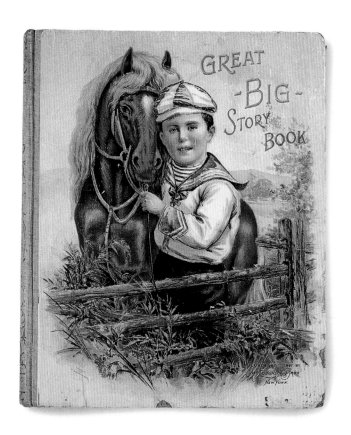

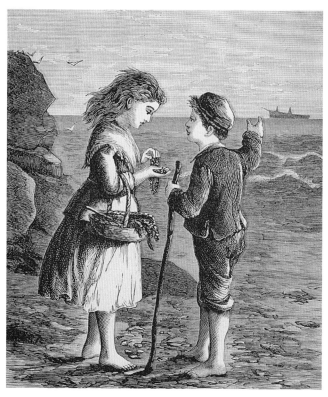

ABOVE LEFT
GREAT BIG STORY BOOK
Published by McLoughlin Brothers, New York
Copyright 1897

ABOVE RIGHT
OUR DARLING'S STORY BOOK
Published by McLoughlin Brothers, New York
ca. 1890s–1900s

OPPOSITE
BROWNIE YEAR BOOK
Written and illustrated by Palmer Cox
Published by McLoughlin Brothers, New York
Copyright 1895

The impish Brownies created by Palmer Cox (1840–1924) made
their first public appearance in the popular children's magazine *St.
Nicholas* and soon after romped through the pages of other books.
In the *Brownie Year Book*, the frolicsome fairies engage in antics
appropriate to each month of the year, twirling umbrellas in April;
swimming and boating the summer days away; and sledding, ice
skating, and building snowmen during the winter months.

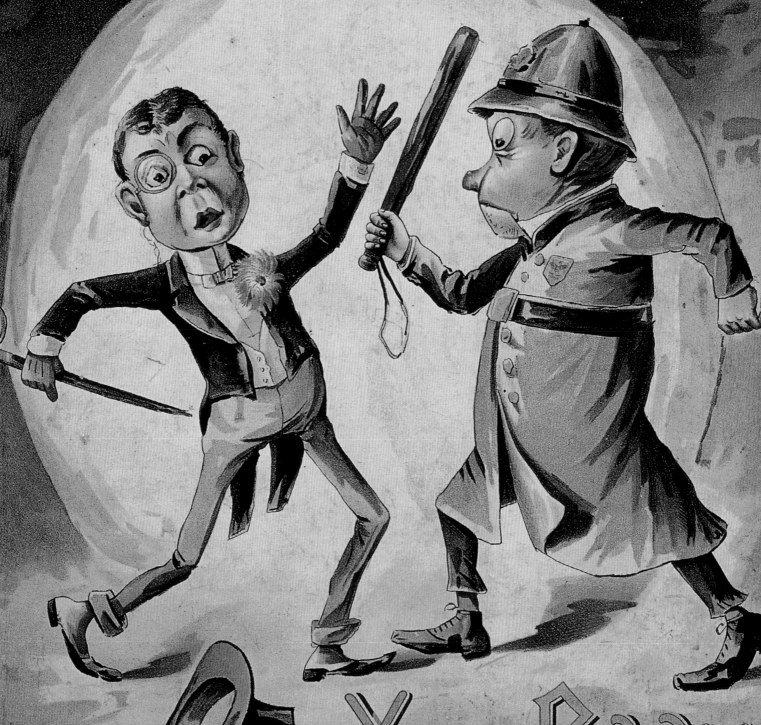

Brownie

Palmer Cox. Year Book.

COPYRIGHTED 1895 BY

McLoughlin Bros.
New York.

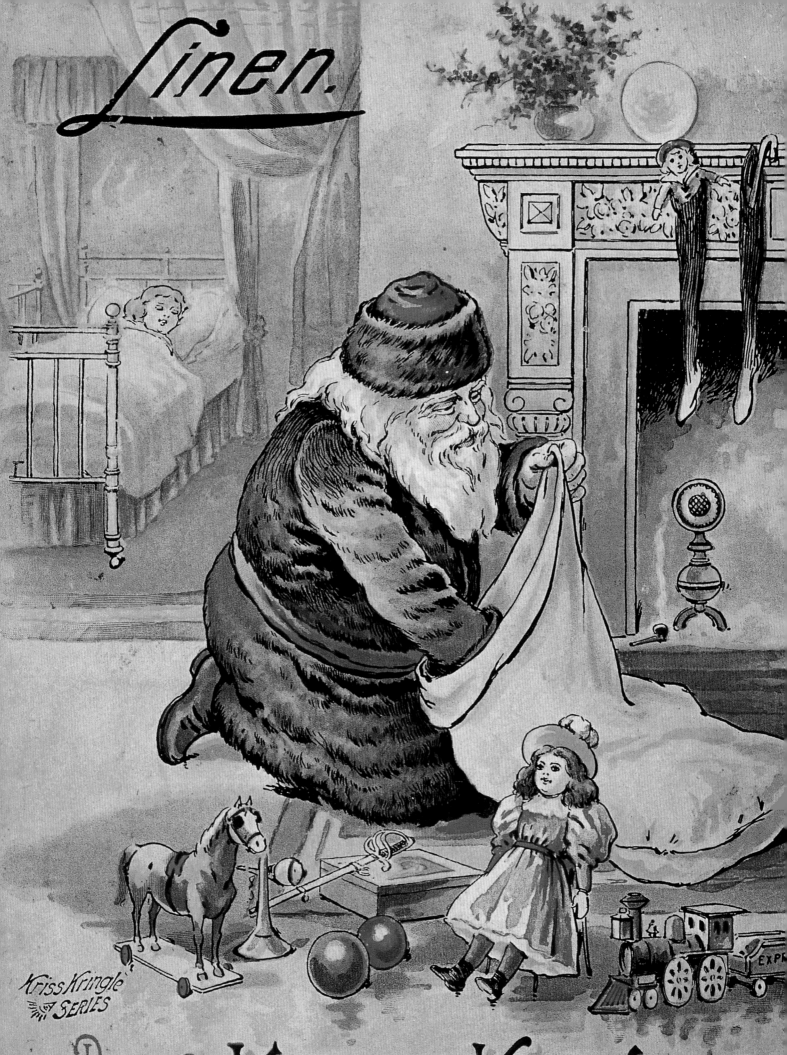

'TWAS THE NIGHT BEFORE
CHRISTMAS BOOKS

MUCH of the imagery that has become inextricably associated with the American family Christmas—stockings hung by the fire, a jolly Santa Claus, and a reindeer-pulled sleigh filled with presents—may be traced to *A Visit from St. Nicholas*. This lyrical Christmas Eve call on good boys and girls was first published in the *Troy Sentinel* on December 23, 1823, one year after Clement Clarke Moore had read his joyful poem aloud to family and friends in New York City. The poem quickly became part of the popular imagination and helped to establish Christmas as a festive, child-centered family celebration.

In seventeenth-century New England, the Puritans had forbidden the celebration of Christmas, and few of the Dutch Protestants who settled New Amsterdam had carried Holland's tradition of a gift-giving Saint Nicholas with them to the New World. By the nineteenth century, most wealthy and middle-class Americans observed the day quietly. American children knew about St. Nicholas and Santa Claus but linked neither figure to the holiday. In *A Visit from St. Nicholas*, Moore blended the two characters, eliminating the ecclesiastical aspect of St. Nicholas, giving a joyful new image to Santa, and deploying merry rhymes to heighten the eager anticipation of receiving gifts on Christmas morning.

In the years following its initial publication, *A Visit from St. Nicholas* was steadily re-printed in newspapers and magazines, spreading its colorful images and associations to a broad audience and inspiring illustrators to give form and shape to Santa, his sleigh and reindeer, and the happy children who breathlessly awaited their Christmas Eve arrival.

LEFT

A VISIT FROM ST. NICHOLAS

Poem by Clement Clarke Moore

Illustrated by F. O. C. Darley

Published by James G. Gregory, New York

Copyright 1862

Felix Octavius Carr Darley (1822–1888), one of America's most popular illustrators during the nineteenth century, helped shape the visual vocabulary of *A Visit from St. Nicholas.* In a practice that would be followed by other artists who illustrated the poem, Darley deviated from Moore's text, depicting Santa Claus not as an elfin figure but as a rotund adult.

PAGE 140

DOINGS OF KRISS KRINGLE

Kriss Kringle Series

Published by McLoughlin Brothers, New York

Copyright 1897

Helping Christmas take root in the popular imagination was cartoonist Thomas Nast, one of the most prolific portrayers of Santa Claus. In books and on the pages of *Harper's Weekly,* he captured the essence of Moore's twinkling-eyed, rosy-cheeked elf and established the visual parameters of the Santa we know today. *A Visit from St. Nicholas* was printed countless times, illustrated with vibrant images of Santa Claus descending the chimneys of cozy middle-class homes to leave delightful gifts for sleeping children to find on Christmas morning.

The evolution of Christmas as a family holiday and a time for giving special gifts coincided with the rise of American consumerism. Books of all types, not only those with Christmas themes, became especially popular presents as the practice of exchanging store-bought gifts gained momentum: in December 1872, *The New York Times* noted, "As the holidays approach, the presses groan with the work of providing books which will prove acceptable presents to the young." Newspapers and magazines offered guidance in selecting just the right book. Highly recommended were collections of stories, poems, and pictures created especially for Christmas giving. Published for children as well as adults, these "gift books" came in editions ranging from economical to luxurious. The hand-written inscriptions on many volumes illustrated in *Once Upon a Time* indicate that they were Christmas gifts presented to children by loving relatives.

RIGHT AND OVERLEAF

**THE NIGHT BEFORE
CHRISTMAS, OR A
VISIT OF ST. NICHOLAS**

Published by McLoughlin Brothers

New-York

Copyright 1888

"He was dressed all in fur, from his head to his foot, And his clothes were all tarnished with ashes and soot;" is the description of Santa's costume poetically described by Clement Clark Moore. Those who illustrated the verse, however, took liberties with the poet's imagery and portrayed him wearing fur-trimmed garments of varying colors, like the green suit he wears here. It was not until the twentieth century, when advertisers wholeheartedly adopted Santa Claus for marketing purposes, that a red suit trimmed with white fur became Santa's signature outfit.

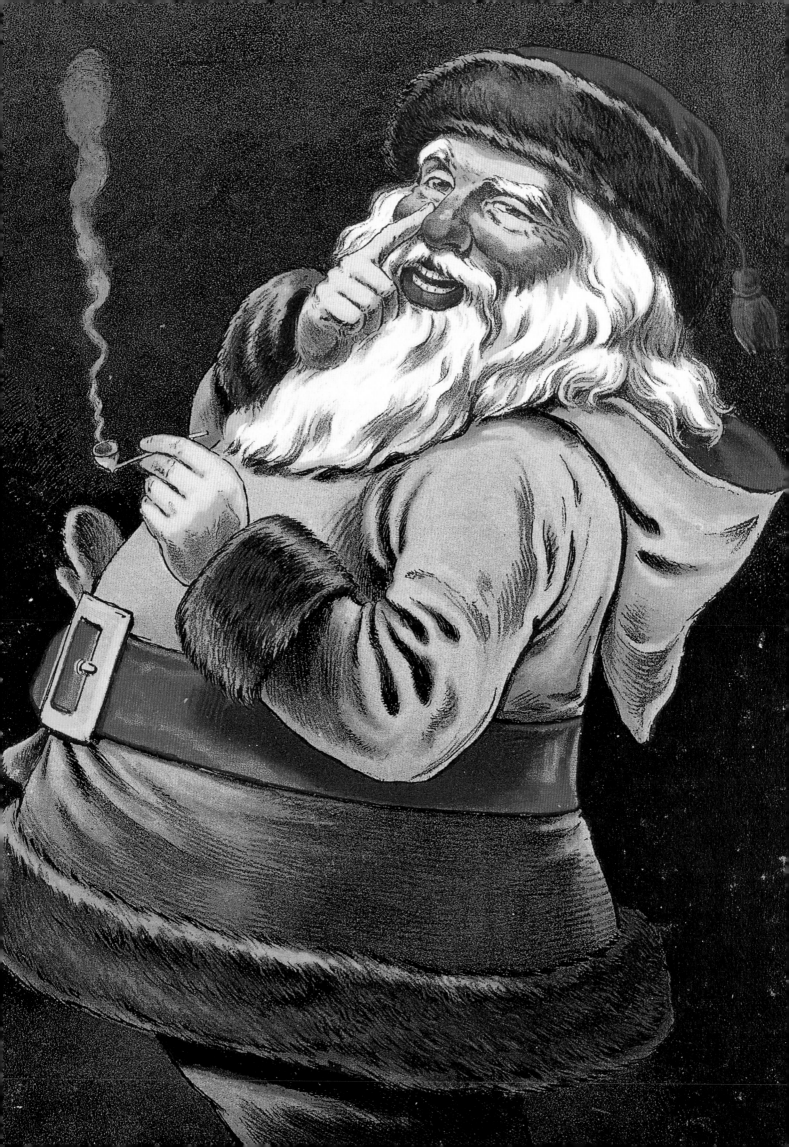

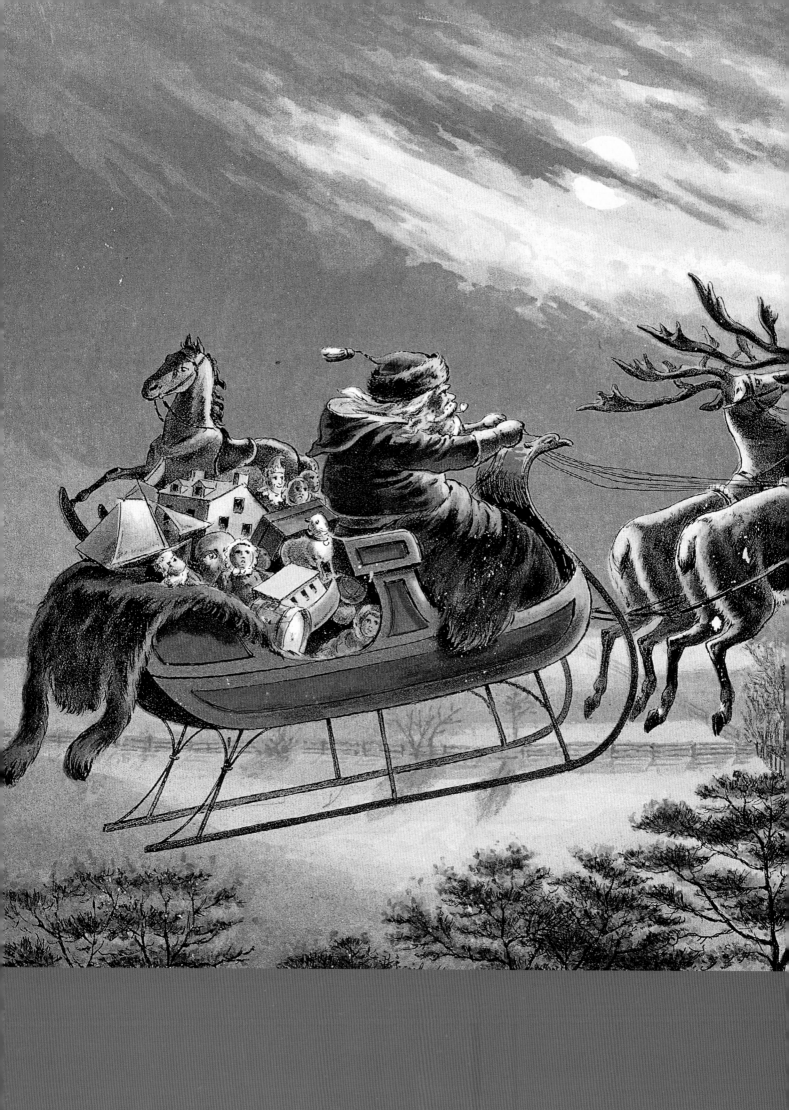

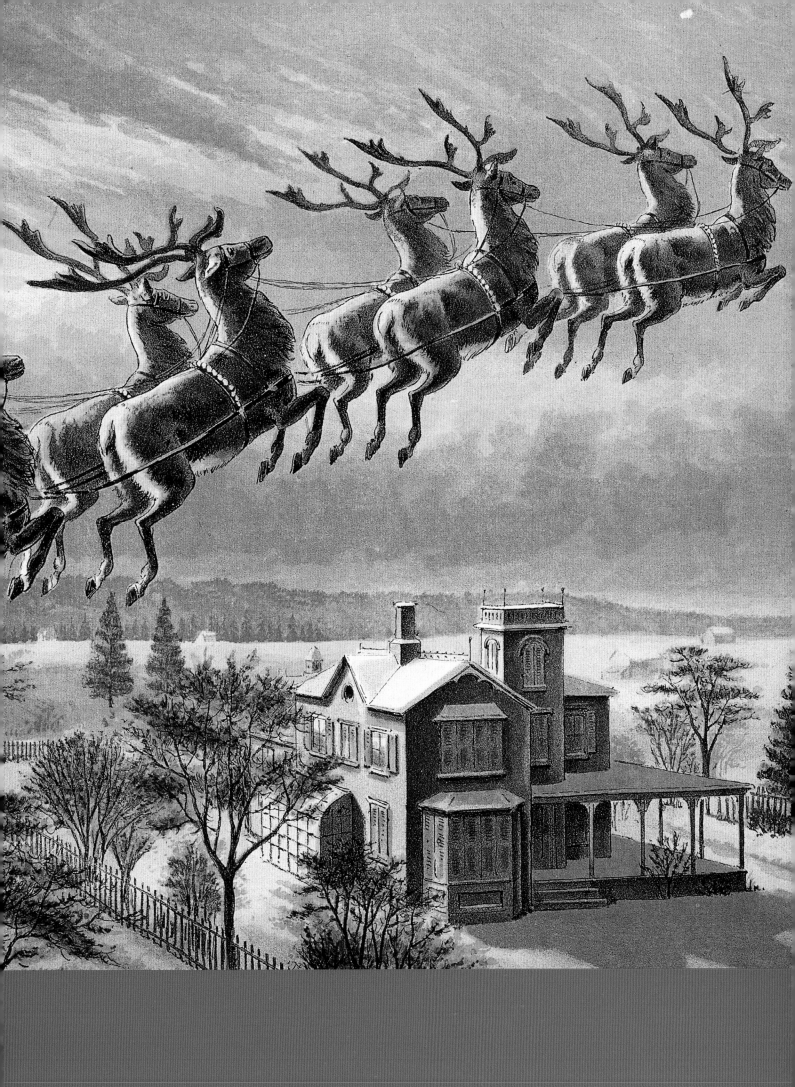

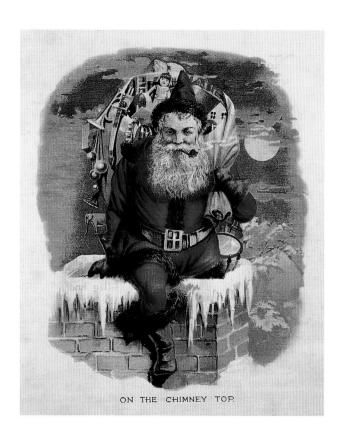

ON THE CHIMNEY TOP.

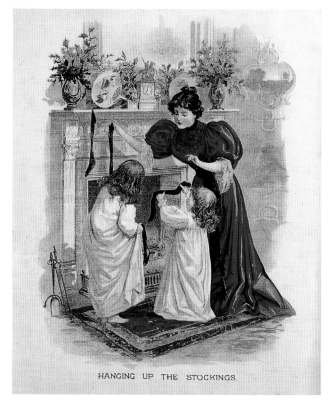

HANGING UP THE STOCKINGS.

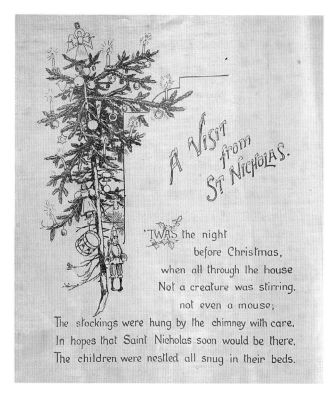

A Visit from St. Nicholas.

'TWAS the night
before Christmas,
when all through the house
Not a creature was stirring,
not even a mouse;
The stockings were hung by the chimney with care,
In hopes that Saint Nicholas soon would be there,
The children were nestled all snug in their beds.

**THE NIGHT BEFORE CHRISTMAS,
OR A VISIT OF ST. NICHOLAS**
Published by McLoughlin Brothers, New York
Copyright 1896

THE ROBIN'S CHRISTMAS EVE

Uncle Ned's Picture Books
Published by McLoughlin Brothers,
New York
ca. 1870s–80s

Cold and hungry, a little bird feasts on breadcrumbs put out for him by a kind-hearted sexton. Eventually, he finds warmth inside a church, symbolizing the religious nature of Christmas, rather than the consumerism that had come to dominate its celebration. This American book is an adaptation of an 1867 British version of the story by C. E. Bowen with illustrations by Winifred Warne.

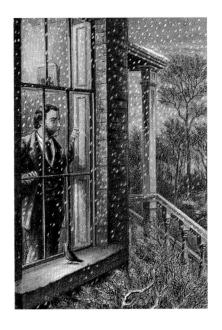

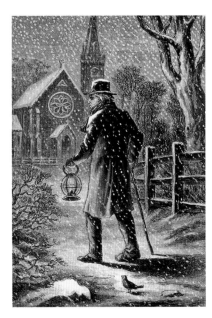

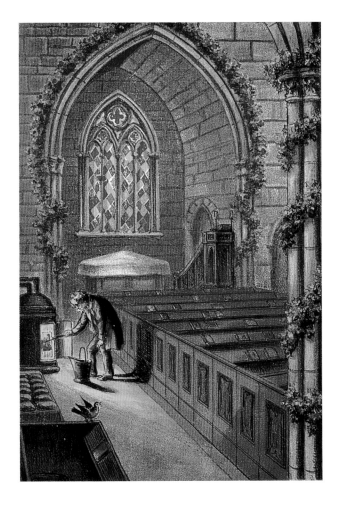

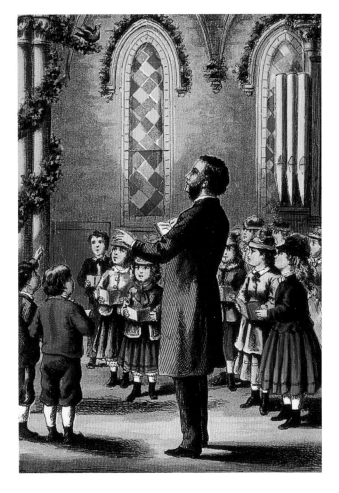

NELLIE'S CHRISTMAS EVE
Written by Miss Fanny Wight
Published by McLoughlin Brothers, New York
ca. 1880s

Nineteenth-century Americans yearned for a simple, non-commercial version of the family Christmas, even though the holiday had never quite existed as they imagined. Although its cover shows a happy family with toys and books beneath a Christmas tree, *Nellie's Christmas Eve* does not dwell on the gift-giving aspect of the holiday. Rather, it tells the story of an orphaned girl searching for heaven so that she might join her mother and the angels. Wandering for days, she declines many offers of help, in the hope that she will be reunited with her dead mother that much sooner. Fortunately, she faints in front of a welcoming home and is taken in by kind strangers.

A SLEIGH FULL OF TOYS.

CHRISTMAS STORY BOOK
Published by McLoughlin Brothers, New York
Copyright 1901

A handwritten note inside this book marks it as a gift from Santa Claus December 25, 1901. Its cover features a rare illustration of a child actually reading a book, and reveals that it contains a collection of stories that a child might enjoy hearing read aloud, and some that he might read by himself.

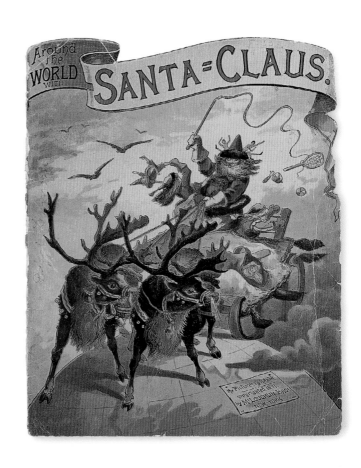

AROUND THE WORLD WITH SANTA CLAUS

Illustrated by R. André

Published by McLoughlin Brothers, New York

Copyright 1891

Reflecting a pervasive late-nineteenth-century interest in the exotic, each page of this book illustrates holiday celebrations in countries around the globe, while retaining key elements associated with American Christmas—Santa Claus, presents, and childhood delight. Whether in cold or tropical countries, Santa wears his iconic fur-trimmed suit. He does change his means of transportation, however, riding atop a camel in the desert of the Middle East, for example, instead of in a reindeer-drawn sleigh.

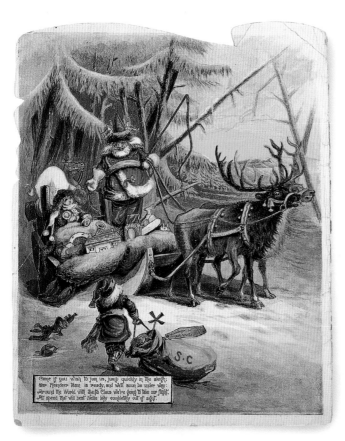

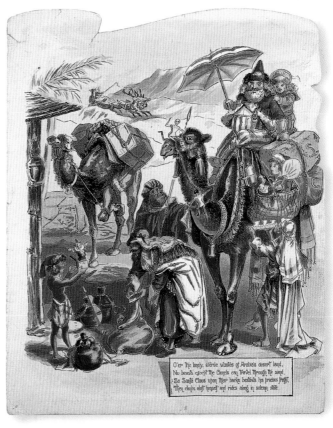

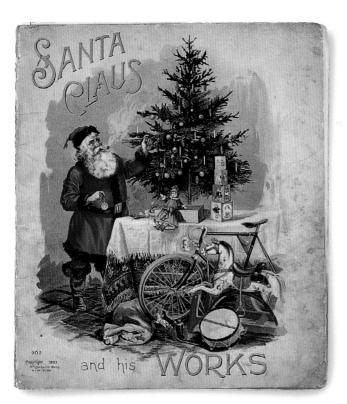

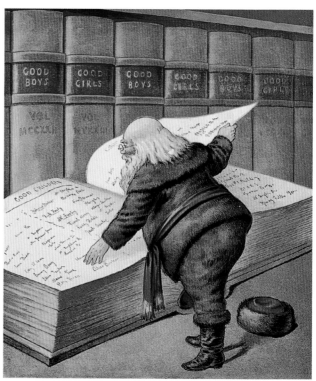

SANTA CLAUS AND HIS WORKS

Written by George P. Webster
Published by McLoughlin Brothers, New York
Copyright 1897

By the end of the nineteenth century, young readers did not
require the author's explanatory introduction to know that
"Santa Claus, Christmas, and toys" had become bound together.
A moral element was brought into this story with the descrip-
tion that Santa Claus "works and he whistles the moment away.
For he knows that in labor is happiness found." Although illus-
trations for many children's books depicted Santa Claus visiting
prosperous middle-class homes, this book notes that, "He looks
in the houses of the rich and the poor, Of those who have
plenty, and those who endure."

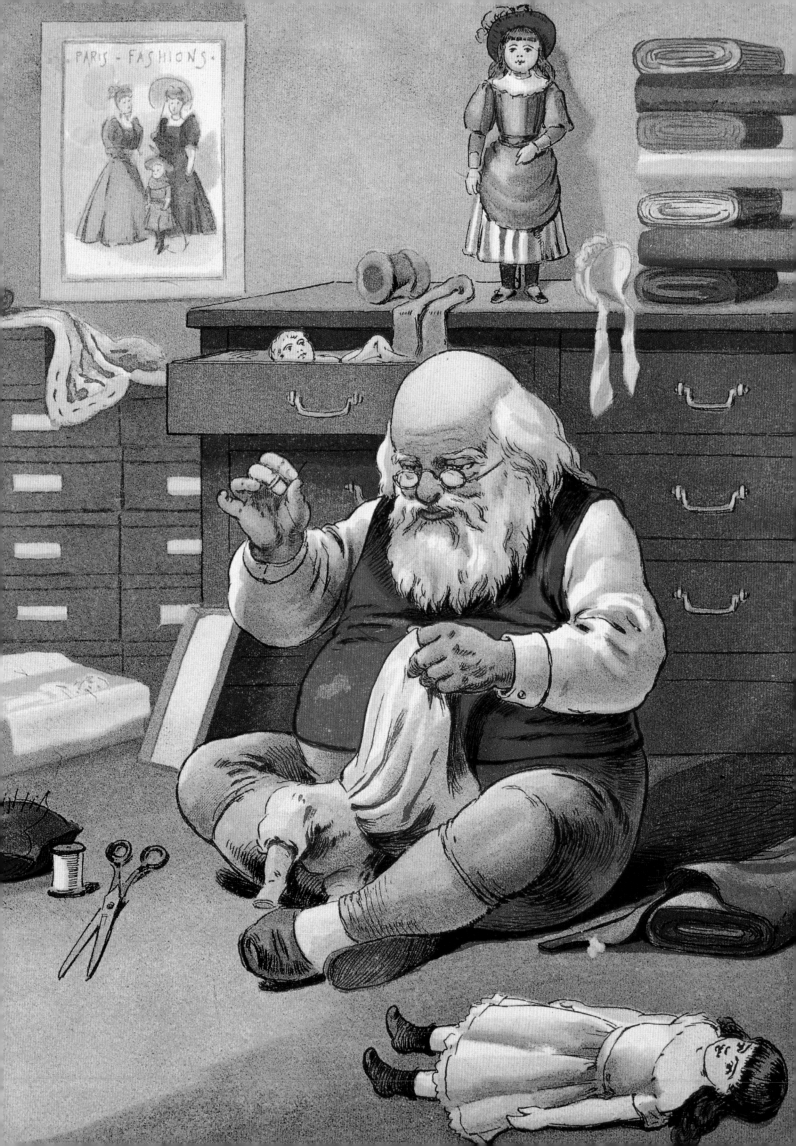

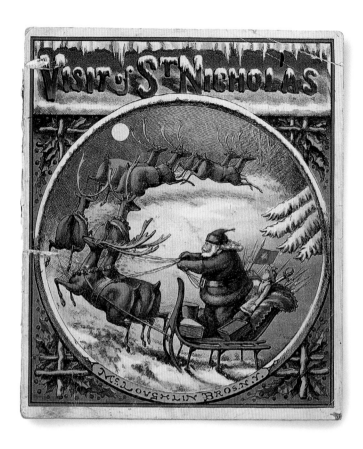

VISIT OF ST. NICHOLAS
Published by McLoughlin Brothers,
New York
ca. 1870s–90s

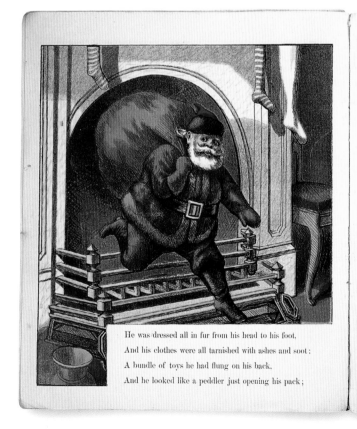

He was dressed all in fur from his head to his foot,
And his clothes were all tarnished with ashes and soot:
A bundle of toys he had flung on his back,
And he looked like a peddler just opening his pack;

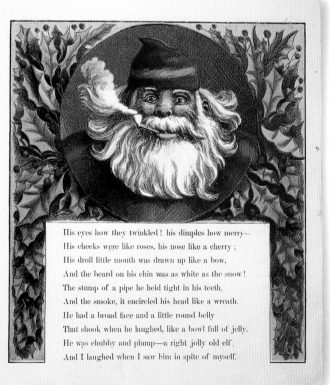

His eyes how they twinkled! his dimples how merry—
His cheeks were like roses, his nose like a cherry;
His droll little mouth was drawn up like a bow,
And the beard on his chin was as white as the snow!
The stump of a pipe he held tight in his teeth,
And the smoke, it encircled his head like a wreath.
He had a broad face and a little round belly
That shook when he laughed, like a bowl full of jelly.
He was chubby and plump—a right jolly old elf;
And I laughed when I saw him in spite of myself.

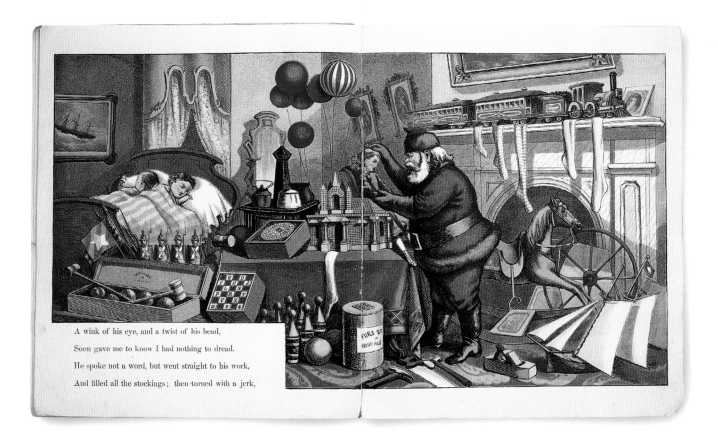

A wink of his eye, and a twist of his head,

Soon gave me to know I had nothing to dread.

He spoke not a word, but went straight to his work,

And filled all the stockings; then turned with a jerk,

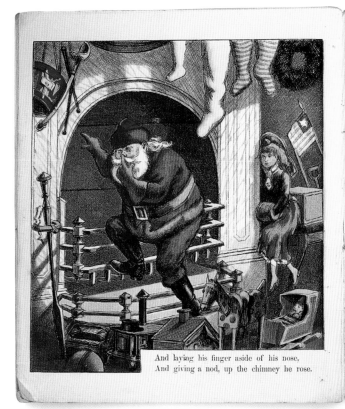

And laying his finger aside of his nose,
And giving a nod, up the chimney he rose.

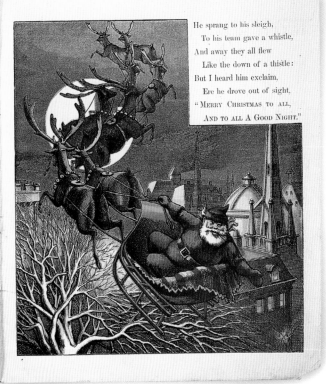

He sprang to his sleigh,
　　To his team gave a whistle,
And away they all flew
　　Like the down of a thistle:
But I heard him exclaim,
　　Ere he drove out of sight,
"MERRY CHRISTMAS TO ALL,
　　AND TO ALL A GOOD NIGHT."

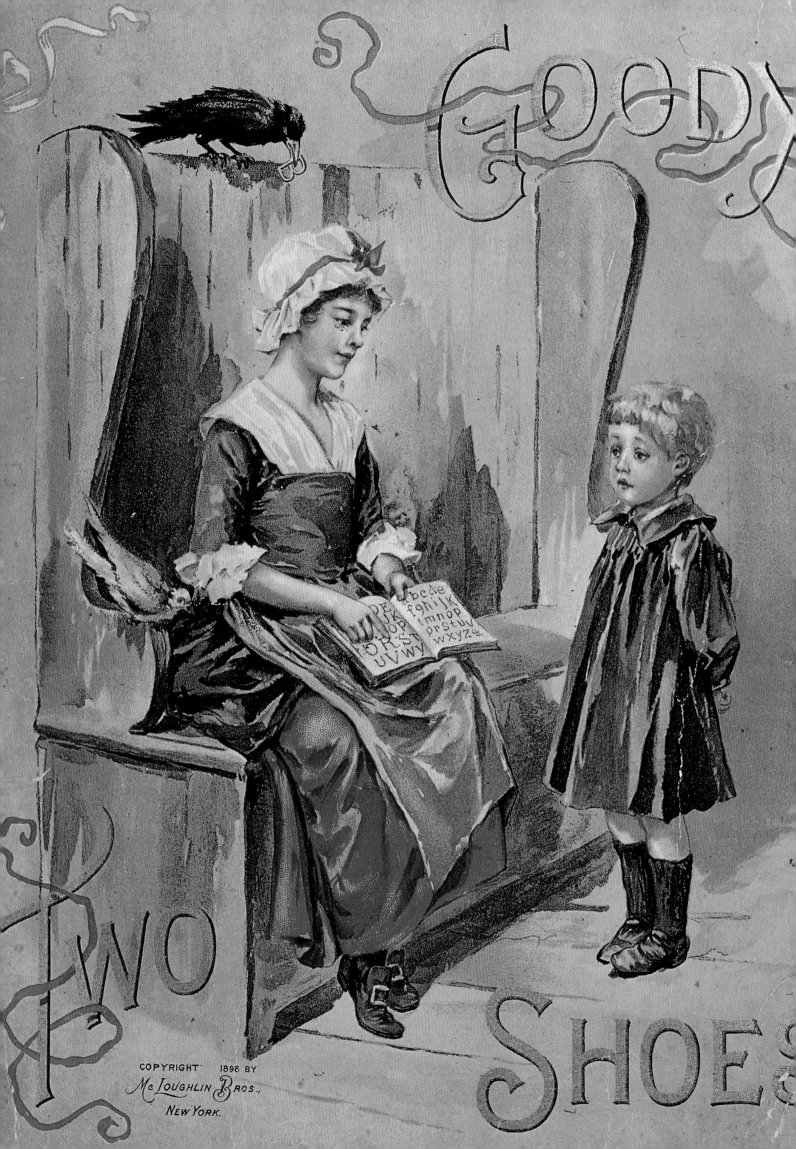

GOODY

TWO

SHOES

VIRTUE AND VICE
CAUTIONARY TALES FOR THE NURSERY

THE moniker "Goody Two Shoes" today carries with it a ring of contempt for the overly pious, but when the term originated in the eighteenth century as the name of a heroine in a John Newbery story it was a label of praise. The subtitle of Newbery's *Goody Two Shoes* reveals both the plot and moral of his story:

> *Otherwise called, Mrs. Margery Two-Shoes. With the Means by which she acquired her Learning and Wisdom, and in consequence thereof her Estate; set forth at large for the Benefit of those, Who from a State of Rags and Care, And having Shoes but half a Pair; Their Fortune and their Fame would fix, And gallop in a Coach and Six.*

Little Margery's good spirits and virtuous conduct in coming to terms with sudden poverty, learning to read, and teaching other impoverished children to love learning set the tone for many nineteenth-century American children's stories.

The moral tone of children's books was also influenced by the theories of philosopher Jean Jacques Rousseau, who theorized that children were imbued with an innate love of virtue, which, if fostered as they grew, would mature into a genuine obedience, love of nature, and love of reason. Whether through plot or subtext, such stories feature proper girls and boys who are well-behaved in school and church, share their toys and sweets, cheerfully do their chores, and always obey their elders. Although these prim children stretch the bounds of credulity today, they

To walk in the garden, little Mary was fond,
And early each morning would rise;
She would train the stray flowers, feed the fish in
the pond,
While the lark sweetly sang in the skies.

Gold fish were first brought from China. The sky lark,
when at liberty, sings only when it is flying, although it
builds its nest on the ground.

Drest out so trim and very neat,
See Mary shopping in Broadway;
A sweeter girl you scarce can meet,
If you should search a livelong day.

Going a shopping is a very favorite pastime for young
Misses, and is often apt to learn them to be too fond of
dress.

LEFT

MARY GOODCHILD
Dame Wonder's Series
Published by McLoughlin Brothers,
New York
ca. 1860s

Even well-mannered young girls must
be warned of the perils that await them
in the shops on Broadway, for "going
a shopping is a favorite pastime for
young Misses, and is often apt to learn
them to be too fond of dress." Readers
were encouraged to adopt worthier
leisure pursuits such as needlework
and drawing instead.

PAGE 154

GOODY TWO SHOES
Published by McLoughlin Brothers,
New York
Copyright 1898

This short version of the mid-
eighteenth-century English classic
retains the colorfully named main
characters that feature in Margery's
story: Farmer Meanwell, the heroine's
father who loses his livelihood and
savings at the hands of the lazy and
wicked landowner Sir Thomas Gripe;
and his overseer, the equally avaricious
and covetous Farmer Graspall. Mar-
gery's travails are radically compressed
in this American version of the story,
but her kindness and diligence are
rewarded with spiritual and worldly
comforts, as they are in the original.

were considered appropriate role models for young, middle-class readers
who needed to learn the rules of decorum demanded by their world.

More engaging and humorous, if also somewhat frightening, were
the cautionary tales that explicated (often in gruesome detail) the horrify-
ing fates that would befall boys and girls who sucked their thumbs,
refused to obey their parents, ate too many cakes, or captured baby
birds—a nadir of wicked behavior. Other stories employed graphic words
and pictures to teach important survival lessons; their depictions of chil-
dren being consumed by flames after playing with candles portrayed a
very real and horrifying danger in an era of candlelight, oil lamps, and
open hearths.

Many of these tales may be traced directly or indirectly to a collection
of mid-nineteenth-century German stories featuring a little boy named
Peter who refuses to wash his hands and face or comb his unruly hair,
earning him the nickname *Strewwelpeter*, translated variously as Shock-
headed Peter or Little Slovenly Peter. Written in verse and illustrated by
Heinrich Hoffmann as a Christmas present for his young son, the stories
about Cruel Frederick, Fidgety Philip, Little Suck-a-Thumb (who loses the
offending digit to great big scissors), and others like them were published
in Germany in 1848 and were soon translated for an American audience.

THE FARMER THREATENS DESTRUCTION TO THE GUESTS.
After dinner the guests promenaded together,
Talked of the fields, of the woods, of the corn, and the weather;
Some scratched holes in the ground, some basked in the sun,
When the farmer was seen with his two-barrell'd gun!
"Why Dick," said the farmer, "whatever's the matter?
For miles have the birds come in flocks here to chatter;
Just look round the fields, and I'll promise the lot
(If you find any damage) a taste of powder and shot!"

THE BIRDS COLLECT ON THEIR ROAD TO THE FEAST.
The day at last came, and as the birds flew along—
Some whistled, some warbled, some struck up a song;
The country folks guessed, by seeing such swarms together,
That no doubt there'd be, either wet or dry weather;
Some KNOWING ONES said that they certainly thought
Putting salt on their tails was how they were caught:
The little boys tried, and were then told the reason
They couldn't succeed—it was not the right season!

RIGHT

KING GOBBLE'S FEAST, OR
THE FATAL EFFECTS OF PRIDE
Dame Dingle's Series
Published by McLoughlin Brothers,
New York
Copyright 1869

Illustrating the biblical proverb that "pride goeth before a fall," a turkey, proud of his magnificent array of tail-feathers, falls prey to a shotgun. Geese, pigeons, and other birds around the farm take note and avoid his fate on the dining table.

McLoughlin Brothers and other publishers adopted the unruly characters for a series of books bearing Peter's name. Their plots and characters remained more or less true to their antecedents, if occasionally losing some of their charm from the overlay of puritanical severity.

Despite the popularity of these stories, their sinister view of children was at odds with much nineteenth-century thinking. Physicians and other childrearing advisers counseled a softer, though still firm, approach to raising virtuous, well-mannered children. Nevertheless, whether through positive or negative reinforcement or role modeling, all of these stories reinforced the code of social conduct that children were expected to internalize as adults. They offer a revealing glimpse not only into methods of childrearing but also the ideals and aspirations of American parents.

The genre of moral tales was embraced by John McLoughlin, whose sons John, Jr. and Edmund formed the McLoughlin Brothers partnership in the 1850s. His successful start in the publishing world began with the printing of small religious tracts for adults and children. The firm maintained this line of business throughout the nineteenth century, offering titles such as *Half Hours with the Bible* and *Illuminated Texts for Sunday School Rewards*, sometimes for as little as three cents each.

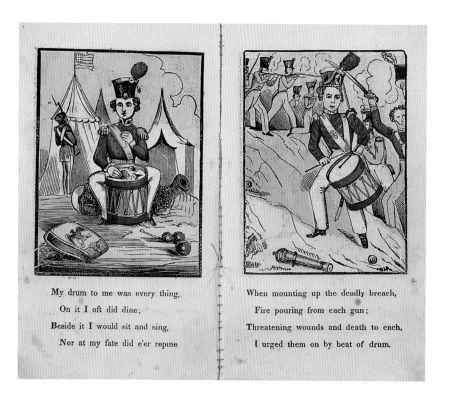

My drum to me was every thing,
 On it I oft did dine;
Beside it I would sit and sing,
 Nor at my fate did e'er repine

When mounting up the deadly breach,
 Fire pouring from each gun;
Threatening wounds and death to each,
 I urged them on by beat of drum.

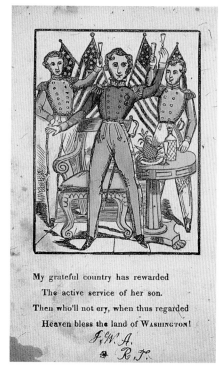

My grateful country has rewarded
 The active service of her son.
Then who'll not cry, when thus regarded
 Heaven bless the land of WASHINGTON!

ABOVE LEFT

THE LITTLE DRUMMER
Dame Wonder's Picture Books
Published by McLoughlin Brothers, New York
ca. 1860s

Published around the end of the Civil War, *The Little Drummer* trades on the magnetic lure of the military for boys. Boys as young as twelve years old volunteered to serve with the Union and Confederate armies as soon as war broke out. The youngest were musicians, sounding "calls" on their drums, bugles, and fifes; they also witnessed the horrors of battle as they assisted with the dead and wounded. Undaunted, the hero of this story proclaims, "And should another war break out, Will bravely fight for home and kin."

ABOVE RIGHT

DAME WONDER'S HISTORY OF THE SAILOR BOY
Published by John McLoughlin, New York
ca. 1850s

Readers of this "rags to riches" tale of virtue rewarded follow "Poor Jack" from an impoverished childhood working on the docks into a successful career in the Navy.

OPPOSITE

OLD DAME TROT AND HER COMICAL CAT
Published by McLoughlin Brothers, New York
Copyright 1905

Old Dame Trot probably predates Old Mother Hubbard, but she never gained that character's widespread following. Here, the storyteller's cat assumes the role of the child reader and learns that pride and vanity are conditions to be shunned: *"Dear Puss, said Dame Trot, 'tis the love of fine clothes, / That brings on good people one half of their woes, / And sooner or later you're certain to find / That pride has a fall of the very worst kind."*

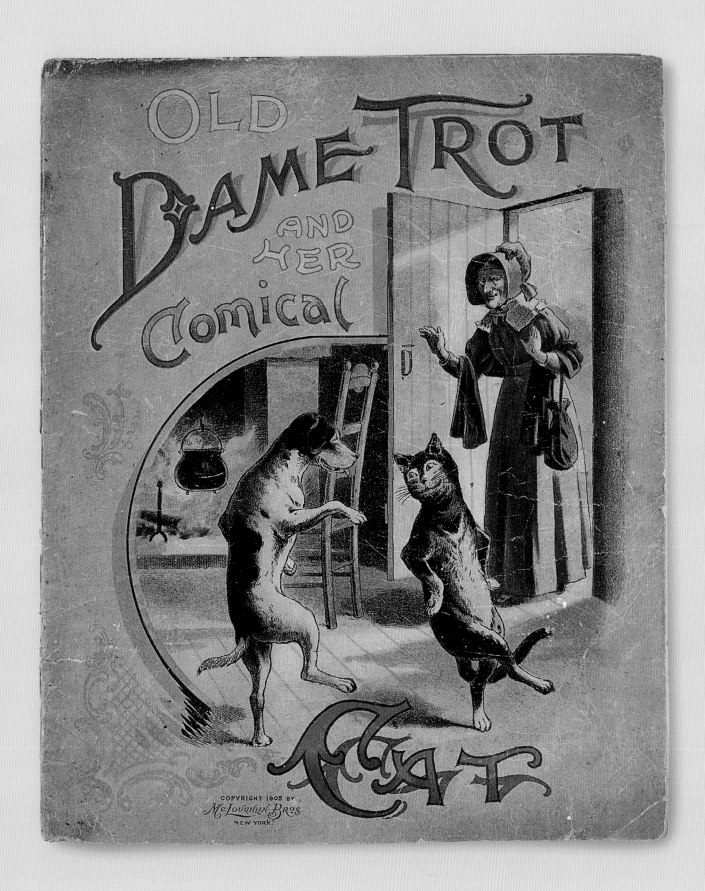

OLD DAME TROT
AND HER
Comical
CAT

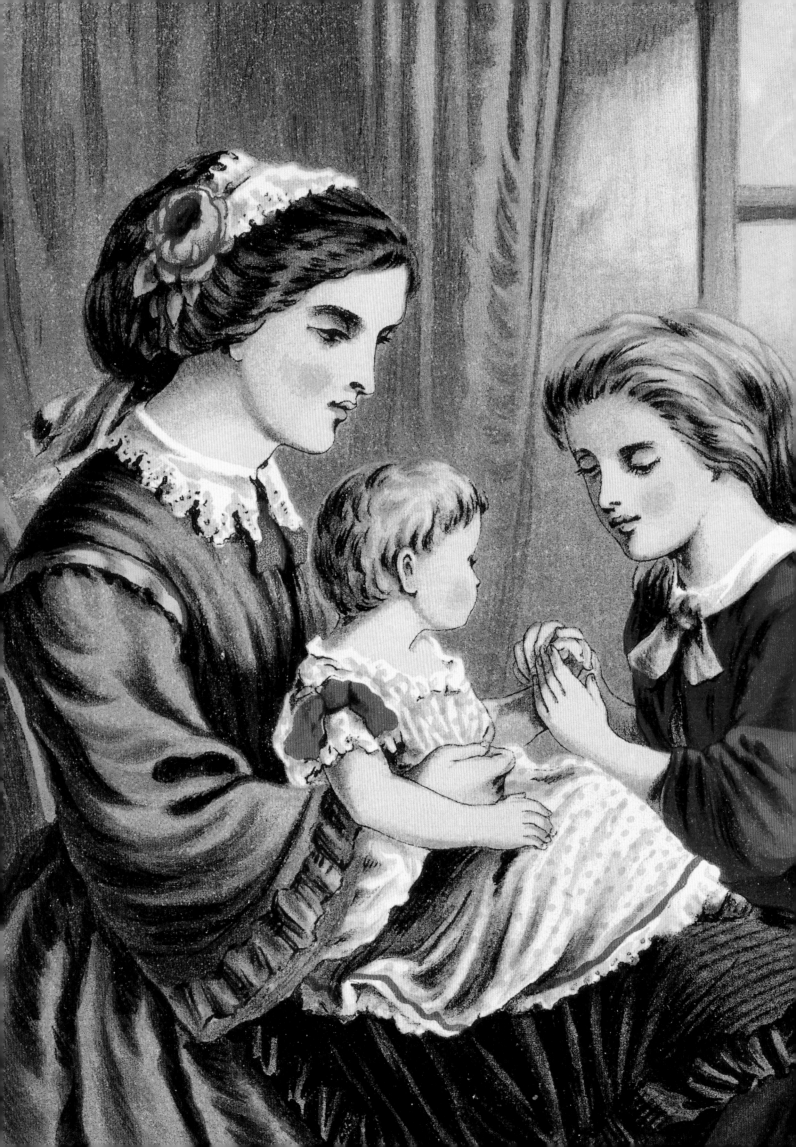

TOP

EMMA, MARY, AND OTHER TALES

Willie Winkie's Series

Published by McLoughlin Brothers,

30 Beekman Street, New York

ca. 1860s

Childhood fun and peril alternate on the pages of this book of short stories. George and Lucy "run and play" as a reward for quiet time at home, while an imprudent child pays the price for "playing with fire."

BOTTOM

EARLY CARES

Little Pleasure Series

Published by McLoughlin Brothers,

New York

Copyright 1895

Although the girls that populate this book's pages exhibit model behavior, they are also clearly human—no longer the prim and priggish characters of earlier children's stories.

OPPOSITE

HOME KINDNESS: A PICTURE GIFT BOOK FOR THE CHILDREN

Published by McLoughlin Brothers,

New York

ca. 1890s

As eighteenth-century views of children as "depraved" beings yielded to concepts of childhood innocence, pictures of children also became more sentimental. In this book, short verses and pictures of sweet-faced children illustrate the bonds of affection among family members.

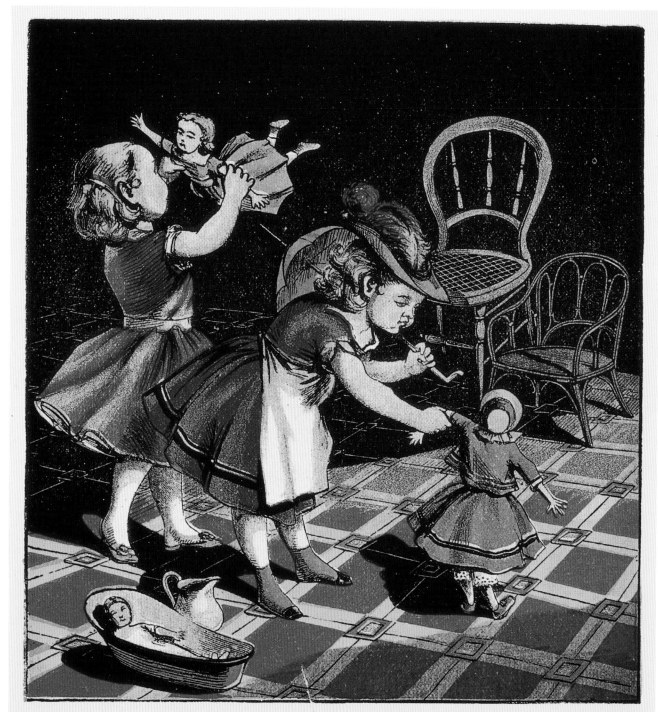

HERE WE ARE WITH OUR BABES.

THE THREE GOOD FRIENDS

Familiar Series

Published by McLoughlin Brothers, New York

ca. 1870s

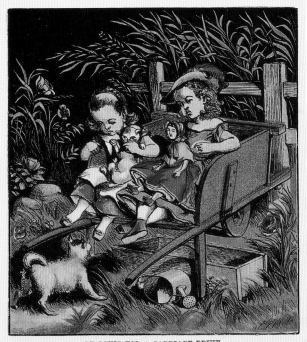

ALL GOING FOR A CARRIAGE DRIVE.

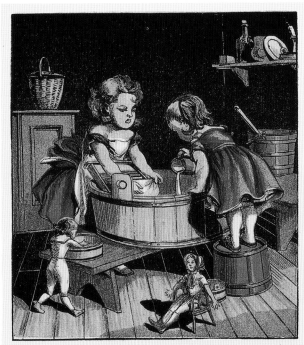

'TIS WASHING-DAY—WE'RE AT THE TUB.

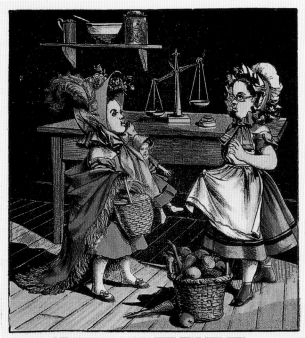

I WANT SOME POTATOES WITH VERY FEW EYES.

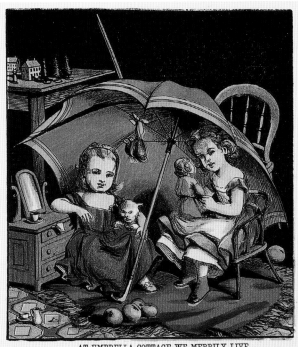

AT UMBRELLA COTTAGE WE MERRILY LIVE.

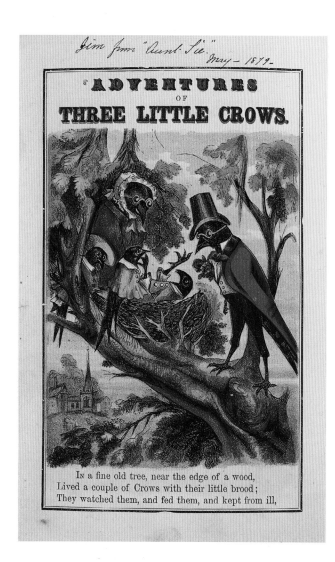

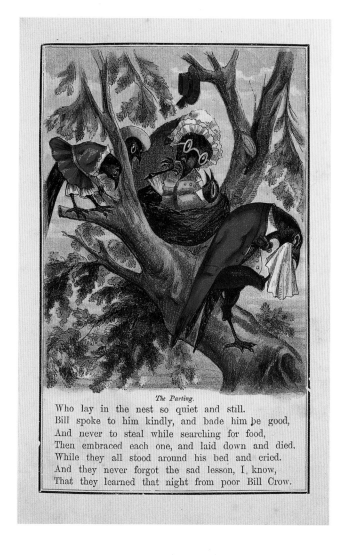

ABOVE

ADVENTURES OF THREE LITTLE CROWS
Cinderella Series
Published by McLoughlin Brothers, New York
ca. 1870s

In this story about a family of crows, Dick is the sensible, good child, while Bill is the wicked one. Caught taking food that was not his, Bill is shot and killed. Charley, the third brother, likes fun and mischief, but learns through his brother's mistake "never to steal while searching for food." The picture of Bill on his death-bed in the family's nest serves as a reminder not only of the consequences of criminal behavior but also of the reality of death.

OPPOSITE

LITTLE SUCK-A-THUMB
Little Slovenly Peter Series
Published by McLoughlin Brothers,
New York
ca. 1860s–70s

Ruined clothes and broken bones will befall the banister-sliding Jimmy Sliderlegs—the central character of the second story in this book.

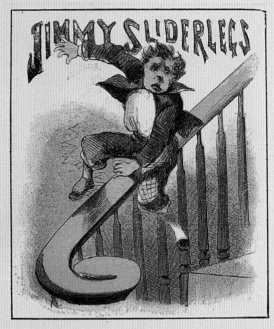

I GUESS there's not one little boy
 Of all who read these lines—
Who, to sliding down the bannisters,
 Won't own that he inclines—
They think it's like the steam engine,
 Or like a bird a flying,

Until they split their heads in two,
 And then they fall a-crying.
Now, all you sliders, hark to me—
 Listen, your uncle begs—
While he recites the story sad
 Of Jimmy Sliderlegs.
Jimmy was always on the stairs,—
 Mornings, evenings, noons,—
He wore out thirteen splendid pairs
 Of bran new pantaloons;

He bunged his eyes—he hurt his nose—
 His father lectured him quite strongly,
Gave him a beating of hard blows—
 But Jimmy went on sliding wrongly,
 And spoiled no end of costly clothes.
He stretched his legs so far apart
 By such a frequent strain,
That it took all the Doctor's art
 To get them back again.
One day his parents out had gone

To see a friend from France,
 And Jimmy being quite alone,
 Thought this at last his chance.
He mounted to the highest story,
 He clasped the bannisters around—
He gave a cry of "Hooray! Glory!"
 And on the rail jumped with a bound.
Down! down he went—now quick, now
 quicker—
 He went so fast, he could not see—

The turns first make him sick, then sicker—
 His head began to whirl! Ah me!
Just like a Windmill's sails a-turning,
 He twisted, tumbled, turned, and twirled.
His arms and legs flew far asunder!
 His body on the floor was hurled!
Some of his bones were broken quite;
 While on the stair,
 Much blood was there—
Ah, me! Oh, what a sight!

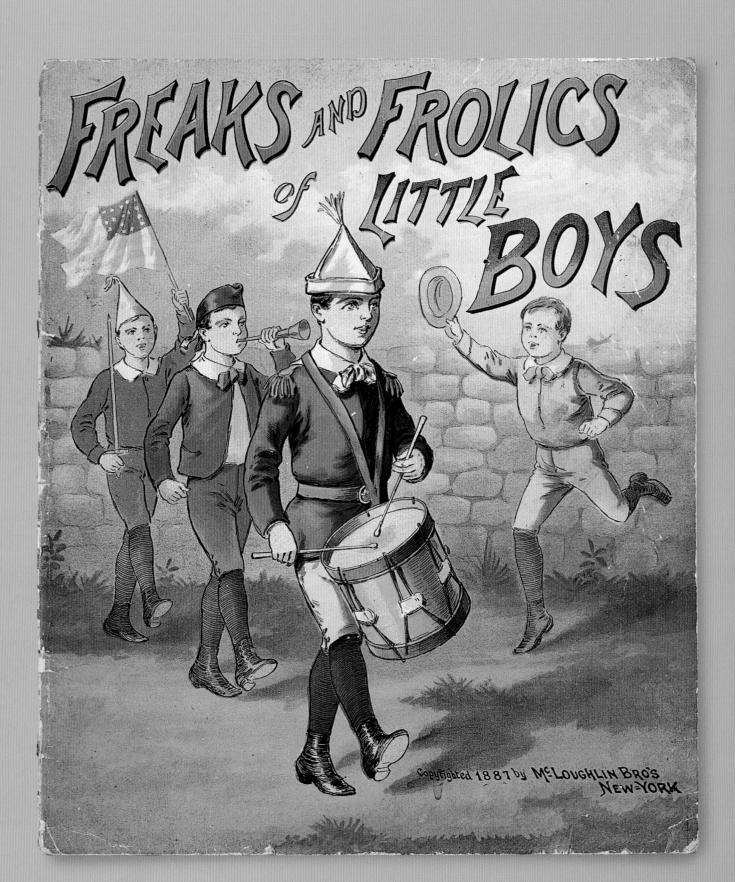

FREAKS AND FROLICS of LITTLE BOYS

Copyrighted 1887 by McLoughlin Bro's New=York

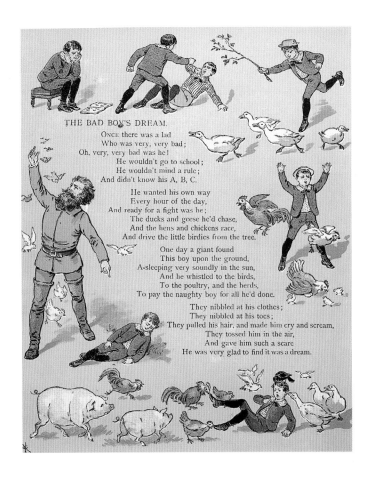

FREAKS AND FROLICS OF LITTLE BOYS

Published by McLoughlin Brothers, New York

Copyright 1887

This collection of stories about the bad behavior of little boys (aptly named Teasing Tom, Gunpowder Jim, Climbing Will, and Lazy Sam) carries on the tradition of Little Slovenly Peter but allows a greater latitude for acceptable behavior; by the late 1880s, the notion that "boys will be boys" had gained some currency. Here, for instance, the antics related in "Monkey Tricks" occasion only the wry observation, "everybody said such boys as Ben were nicest when securely tucked in bed."

Girls are pictured here as well, quietly amusing themselves with books and having their pigtails tied to the backs of chairs. They became the subject of their own *Freaks and Frolics*, described by McLoughlin Brothers as picturing "little girls in all manner of sports" and showing "the mishaps that befall those who are careless."

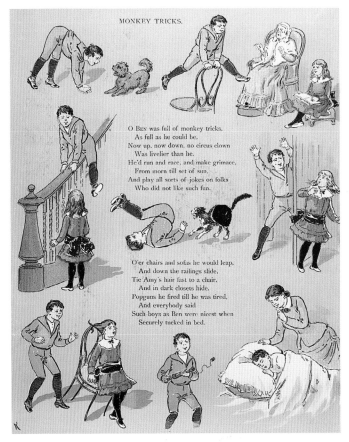

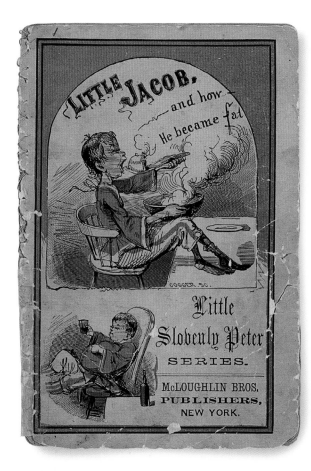

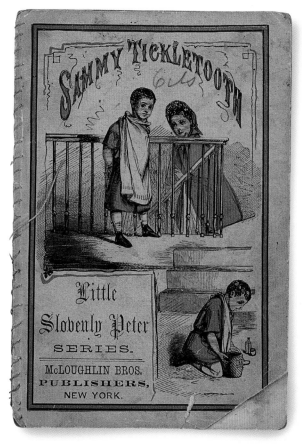

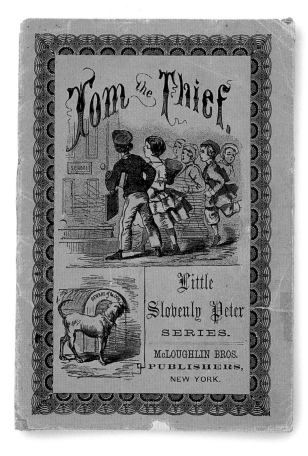

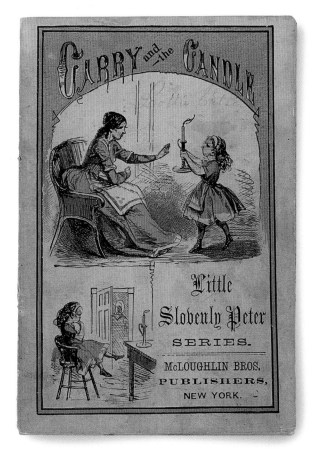

LITTLE JACOB AND
HOW HE BECAME FAT
Little Slovenly Peter Series
Published by McLoughlin Brothers,
New York
ca. 1860s–70s

Readers of *Little Jacob and How He Became Fat* are advised, "Be this story true or false, Sure gluttony's a sin." Jacob, a skinny little boy, is encouraged to eat heartily by well-meaning parents, eventually growing so fat that he bursts into two.

SAMMY TICKLETOOTH
Little Slovenly Peter Series
Published by McLoughlin Brothers,
30 Beekman Street, New York
ca. 1860s

Sammy has a sweet tooth and secretly eats so much cake batter that the expanding ingredients make him blow up like a balloon. Similarly, the central characters of *Tom The Thief*, *The Dirty Child*, and *Carry and the Candle* each suffer the unique consequences of their bad deeds.

TOM THE THIEF
Little Slovenly Peter Series
Published by McLoughlin Brothers,
New York
ca. 1860s–70s

CARRY AND THE CANDLE
Little Slovenly Peter Series
Published by McLoughlin Brothers,
30 Beekman Street, New York
ca. 1860s

THE DIRTY CHILD
Little Slovenly Peter Series
Published by McLoughlin Brothers,
New York
ca. 1860s

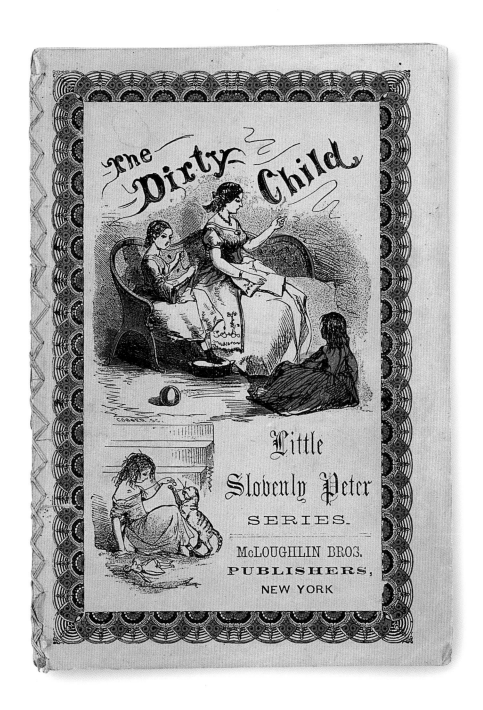

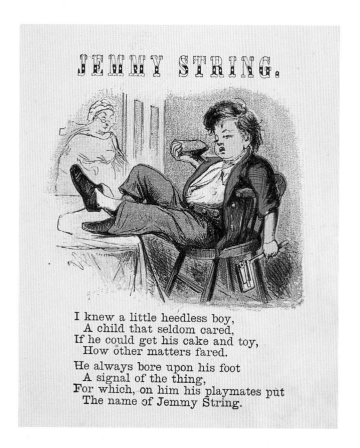

I knew a little heedless boy,
 A child that seldom cared,
If he could get his cake and toy,
 How other matters fared.

He always bore upon his foot
 A signal of the thing,
For which, on him his playmates put
 The name of Jemmy String.

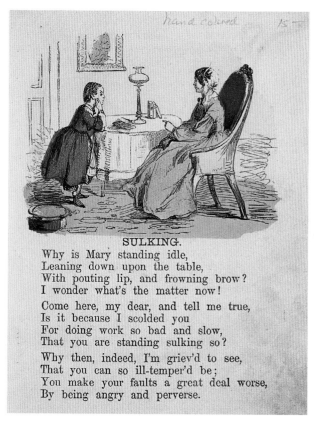

SULKING.

Why is Mary standing idle,
 Leaning down upon the table,
With pouting lip, and frowning brow?
 I wonder what's the matter now!

Come here, my dear, and tell me true,
 Is it because I scolded you
For doing work so bad and slow,
 That you are standing sulking so?

Why then, indeed, I'm griev'd to see,
 That you can so ill-temper'd be;
You make your faults a great deal worse,
 By being angry and perverse.

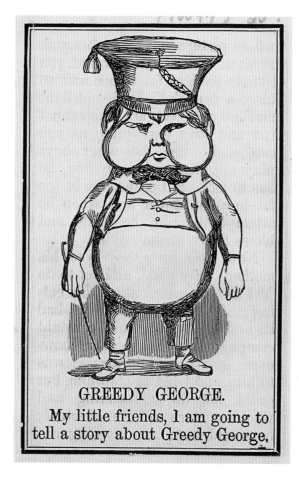

GREEDY GEORGE.
My little friends, I am going to
tell a story about Greedy George.

ABOVE LEFT

JEMMY STRING

Father's Series

Published by McLoughlin Brothers, New York

ca. 1860s–70s

Jemmy String neglects to tie his shoelaces, with predictable results.

ABOVE RIGHT

SULKY MARY AND OTHER TALES

Published by McLoughlin Brothers, New York

ca. 1860s

LEFT

GREEDY GEORGE

Aunt Mary's Little Series

Published by McLoughlin Brothers, New York

ca. 1850s–60s

Candy is Greedy George's constant companion, rendering him unable to "run and skip and jump as you can, and when the other boys play marbles and leap frog, he has to look on, because he is too fat to stoop down and when he attempts to run, he puffs and blows like a steam engine." The story concludes, "Be temperate in eating as well as drinking, for both lead to ruin."

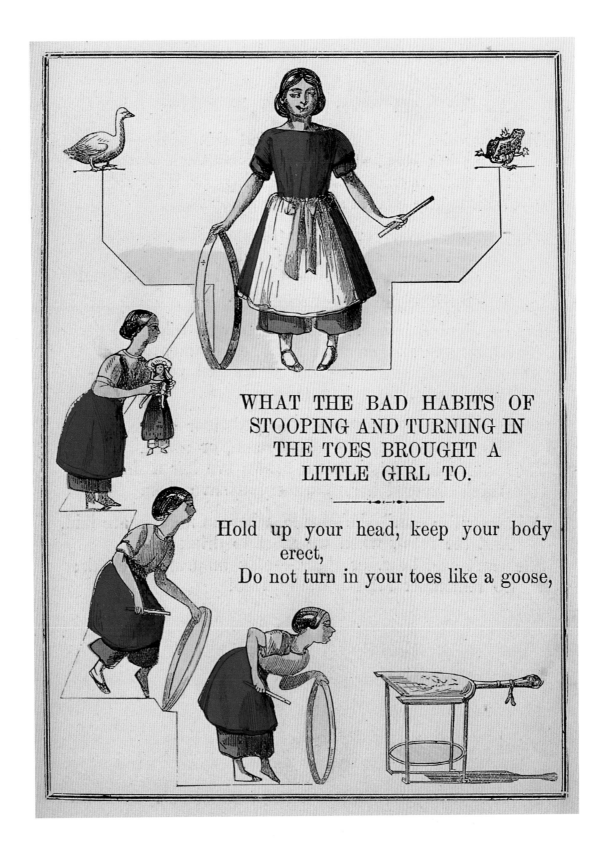

WHAT THE BAD HABITS OF STOOPING AND TURNING IN THE TOES BROUGHT A LITTLE GIRL TO.

Hold up your head, keep your body erect,
Do not turn in your toes like a goose,

THE STORY OF THE SPOILED FROCK
Aunt Oddamadodd's Series
Published by McLoughlin Brothers, New York
ca. 1860s–70s

THE INDUSTRIOUS BOY.

Ernest is reading Virgil,
 And loves the grand old bard;
His studies are a pleasure,
 And bring their own reward.
The boy men call a bookworm,
 Holds in his youthful hands,
The spell that by its magic,
 The rule of Earth commands.
"To know is to be powerful."
 Young studious boy, read on!
A rich reward the future
 Will bring, when youth is gone.

THE KIND LITTLE GIRL.

Look at little Anna
 Feeding all her pets;
Many a nice beakful
 That white pigeon gets!
Cock and hens and chickens
 Come to her for food;
Pretty little maiden!
 Kind and wise and good.

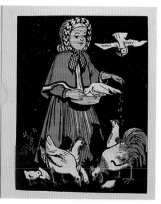

THE NOISY BOY.

This darling gravely tells us,
 "He's join'd the Volunteers,
And that, should foes assail us,
 We have no cause for fears!"
If noise could keep them from us,
 We need not doubt his word;
For surely such a clatter
 No ear has ever heard!

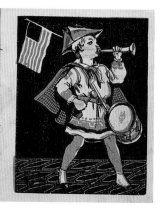

THE QUIET BOY.

Hush! the noise is over!
 Arthur is asleep,
Close in balmy slumber
 His tired eyelids keep.
See! his drum is broken—
 It shall sound no more—
At his feet the cock'd hat
 He so proudly wore.
He is quite exhausted,
 With his grand boy's play,
In the shining sunlight,
 Of this summer day,
And, for the sweet silence
 Which his slumber makes,
We'll forgive his noises,
 When again he wakes.

THE MEEK GIRL.

In the old church pew
 Little Mary stands,
Reading from the Prayer-book
 Open in her hands,
How God loves the humble,
 How He helps the weak,
Putteth down the mighty,
 Raiseth up the meek.
And her sweet voice stealeth,
 Very low and clear—
In each verse responsive—
 On the list'ning ear;
Meekly thus she standeth,
 In the holy place—
A lily in God's garden—
 Clothed with meekest grace.

TOP LEFT AND RIGHT
INDUSTRIOUS BOY
Young America Series
Published by McLoughlin Brothers, New York
ca. 1860s

MIDDLE LEFT AND RIGHT
THE NOISY BOY
Young America Series
Published by McLoughlin Brothers, New York
ca. 1860s

BOTTOM AND OPPOSITE
DISORDERLY GIRL
Young America Series
Published by McLoughlin Brothers, New York
ca. 1860s

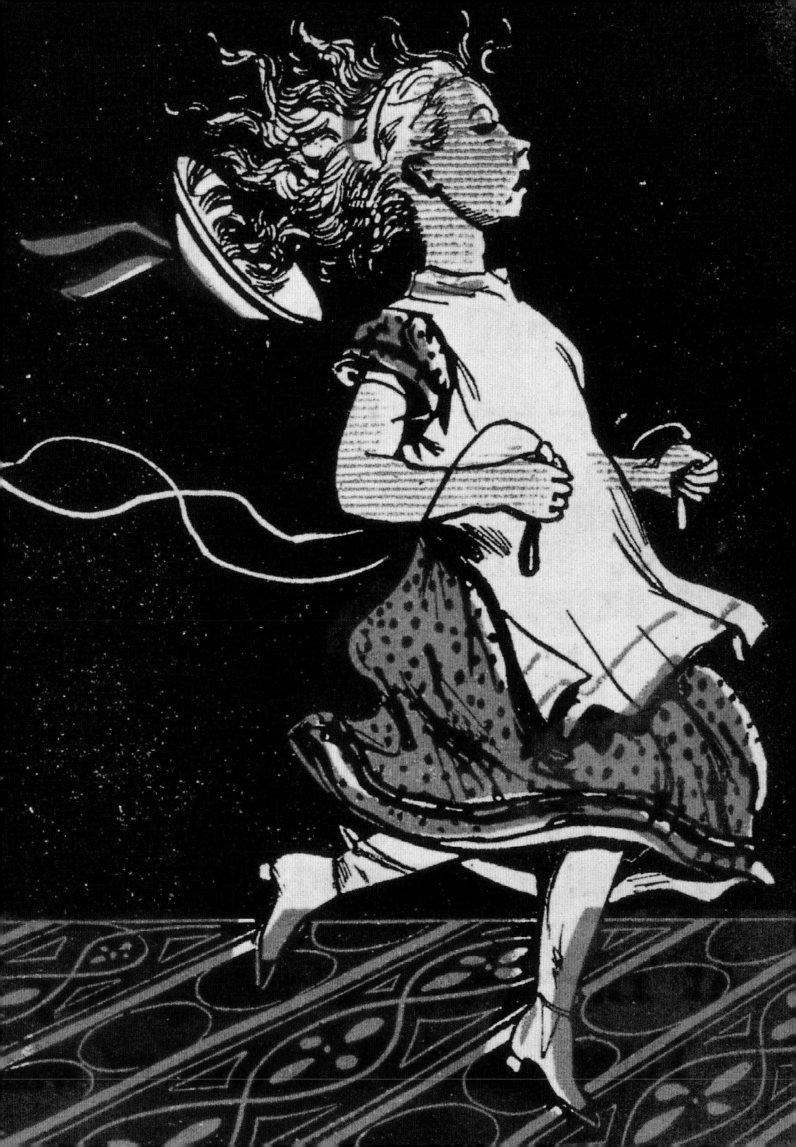

NAUGHTY PUPPIES

Little Peasewell's Series
Published by McLoughlin Brothers, New York
ca. 1860s

"Punishment follows folks who play tricks," including puppies who fight with the turkey, scare the hens, chase the cat, and make a mess. Papa is a "grave, respectable dog, faithful and full of affection." Charged with keeping the farmyard safe, he dutifully punishes his young offspring by withholding dinner for three days, in an effort to teach them to mend their ways.

AGAINST EVIL COMPANY.

WHY should I join with those in play
 In whom I've no delight;
Who curse and swear, but never pray;
 Who call ill names, and fight?

WATTS' DIVINE AND MORAL SONGS.

I hate to hear a wanton song:
 Their words offend my ears:
I should not dare defile my tongue
 With language such as theirs.

Away from fools I'll turn my eyes,
 Nor with the scoffers go:
I would be walking with the wise,
 That wiser I may grow.

From one rude boy, that's used to mock,
 They learn the wicked jest:
One sickly sheep infects the flock,
 And poisons all the rest.

My God, I hate to walk or dwell
 With sinful children here:
Then let me not be sent to hell,
 Where none but sinners are.

WATTS' SONGS AGAINST EVIL:
WATTS' DIVINE AND MORAL SONGS
Published by McLoughlin Brothers, New York
ca. 1870s

The work of the prolific British hymnist Isaac Watts (1674–1748) was widely published in the United States, and many of his hymns were especially favored by colonial- and revolutionary-era Americans. Writing about the value of music and verse in the education of children, Watts observed, "There is a great delight in the very learning of truths and duties this way. There is some-thing so amusing and entertaining in rhymes and metre that will incline children to make this part of their business a diversion." McLoughlin Brothers followed suit, offering its *Songs Against Evil* well over a century after Watts' 1715 publication of *Divine Songs Attempted in Easy Language for the Use of Children*.

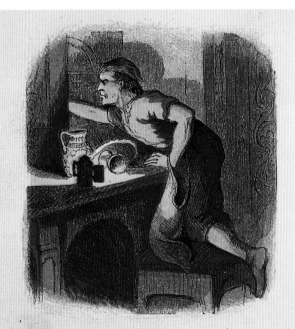

THE THIEF.

WHY should I deprive my neighbor
 Of his goods against his will?
Hands were made for honest labor,
 Not to plunder, or to steal.

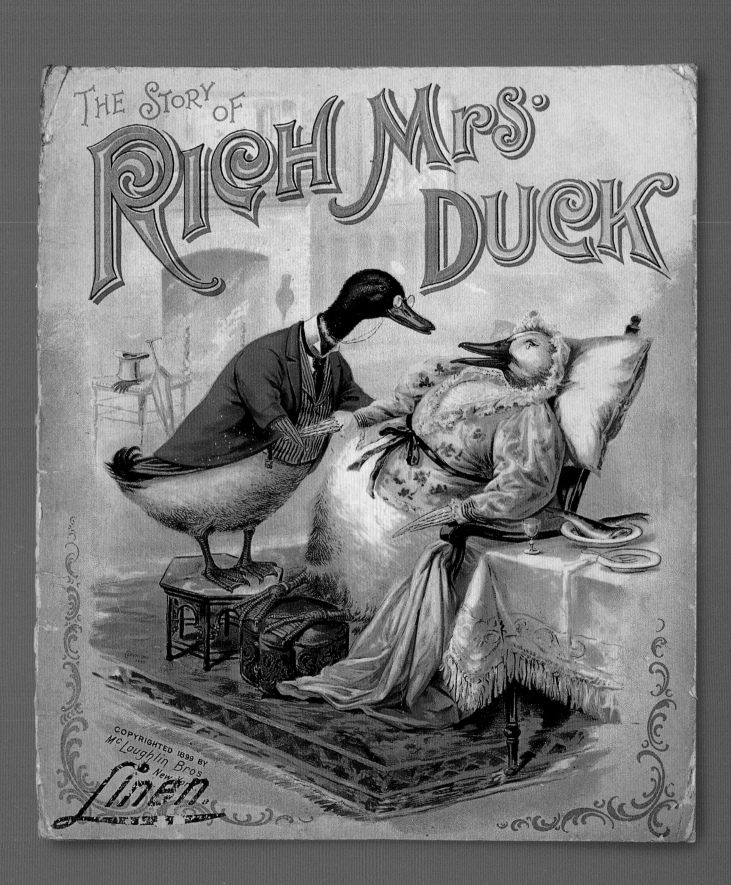

THE STORY OF RICH MRS' DUCK

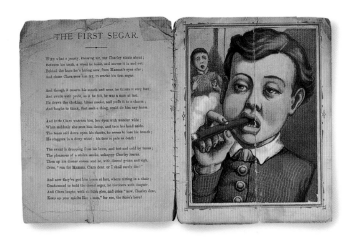

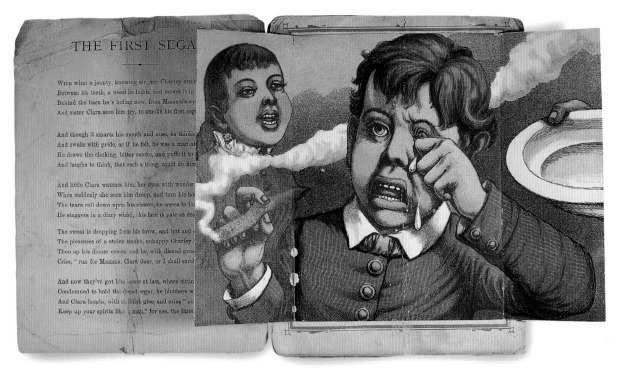

OPPOSITE
THE STORY OF RICH MRS. DUCK
Published by McLoughlin Brothers,
New York
Copyright 1899

Gluttony kills the wealthy and finely attired Mrs. Duck, despite Dr. Drake's efforts to treat her aches and pains. Her tombstone serves as a reminder to little ducks and young readers about the likely outcome of overindulging.

ABOVE
NAUGHTY GIRL'S AND BOY'S MAGIC TRANSFORMATIONS
Published by McLoughlin Brothers,
New York
ca. 1870s

"Transformations" here signals a double entendre: as the young reader turns the pages, characters such as Greedy Kate, Monkey Boy, and Cat Girl are "transformed" as punishment for their bad conduct. Polly Patter, who did "nothing but chatter," sprouts feathers and claws—"A punishment to those who wag their tongue too loud and free!" Here, sneaking a few puffs on his "first segar" brings tears to the eyes of a little boy, and soon "up his dinner comes."

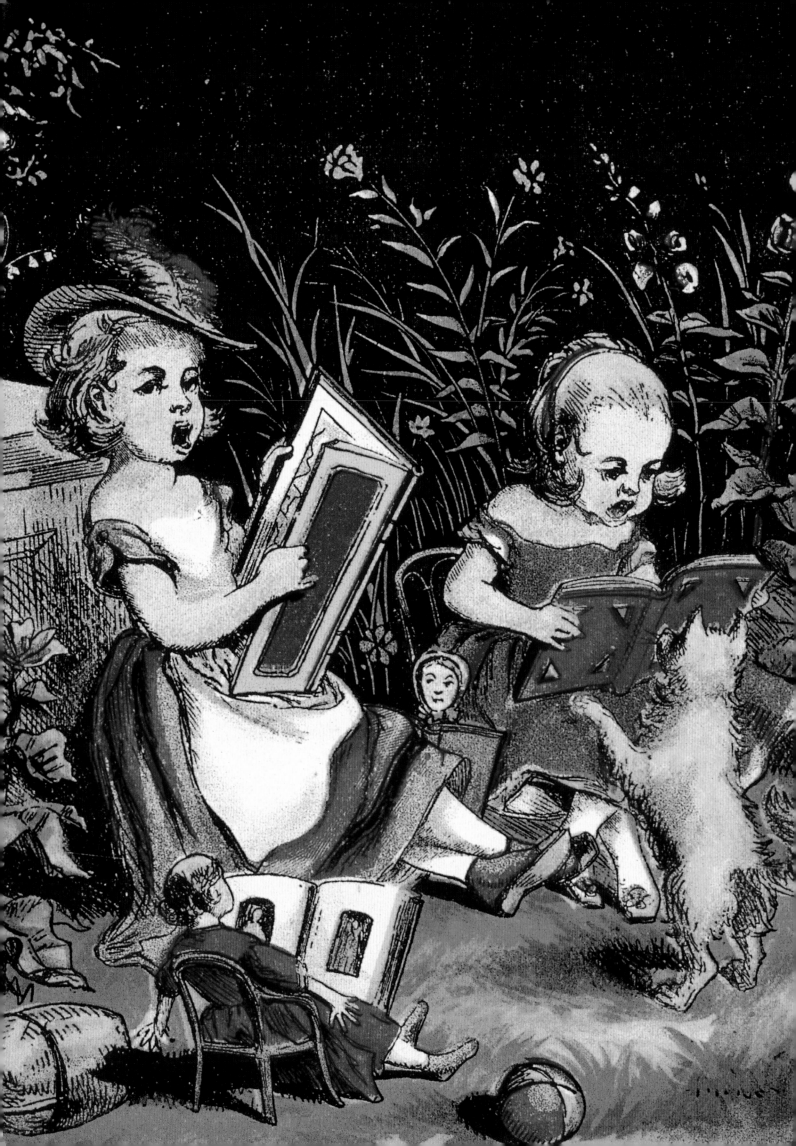

SUGGESTED READINGS

The American Antiquarian Society. http://www.americanantiquarian.org.

Avery, Gillian. *Behold the Child: American Children and Their Books, 1621-1922*. Baltimore, Md.: Johns Hopkins University Press, 1994.

Child, Lydia Maria. *The Mother's Book*. Boston: Carter & Hendee, 1831; reprinted Cambridge, Mass.: Applewood Books, 1989.

Crain, Patricia. *The Story of A: The Alphabetization of America from the New England Primer to the Scarlet Letter*. Stanford, Calif.: Stanford University Press, 2000.

Heininger, Mary Lynn Stevens. *A Century of Childhood 1820-1920*. Rochester, New York: Margaret Woodbury Strong Museum, 1984.

———. *At Home with a Book: Reading in America 1840-1940*. Rochester, New York: Margaret Woodbury Strong Museum, 1986.

Hofer, Margaret K. *The Games We Played: The Golden Age of Board & Table Games*. New York: Princeton Architectural Press, 2003.

Larcom, Lucy. *A New-England Girlhood: Outlined from Memory*, 1889. Boston and New York: Houghton, Mifflin Company.

McLoughlin Brothers. *Catalogue of paper, linen and indestructible toy books, half-bound and bound juvenile books: games, ABC blocks, picture and building blocks, backgammon boards, checker and chess boards, paper dolls, soldiers, &c., &c.* New York: McLoughlin Brothers, 1894.

———. *One Hundred Years of Children's Books: And a Presentation of Modern Style Trends in Juvenile Literature*. Springfield, Mass.: McLoughlin Brothers, Inc., 1928.

Nissenbaum, Stephen. *The Battle for Christmas*. New York: Alfred A. Knopf, 1996.

Pierpont Morgan Library. *Early Children's Books and Their Illustration*. Boston: D. R. Godine, 1975.

Opie, Iona and Peter Opie. *The Classic Fairy Tales*. London: Oxford University Press, 1974; reprinted 1995.

———. *The Oxford Dictionary of Nursery Rhymes*. Oxford: Clarendon Press, 1952. 2nd ed. New York: Oxford University Press, 1998.

The University of Mississippi. McLoughlin Brothers Papers at the de Grummond Children's Literature Collection. http://www.lib.usm.edu.